Hadrian's Wall
A study in archaeological exploration and interpretation

Hadrian's Wall

A study in archaeological exploration and interpretation

David J. Breeze

ARCHAEOPRESS PUBLISHING LTD
Summertown Pavilion
18-24 Middle Way
Summertown
Oxford OX2 7LG

www.archaeopress.com

ISBN 978-1-78969-167-2
ISBN 978-1-78969-168-9 (e-Pdf)

Cover image: Hadrian's Wall at Castle Nick looking east towards Crag Lough and Hotbank Crags. Photograph by Peter Savin

Printed in England by Holywell Press, Oxford

This book is available direct from Archaeopress or from our website www.archaeopress.com

For Beryl Elliott amicae fidelissimae

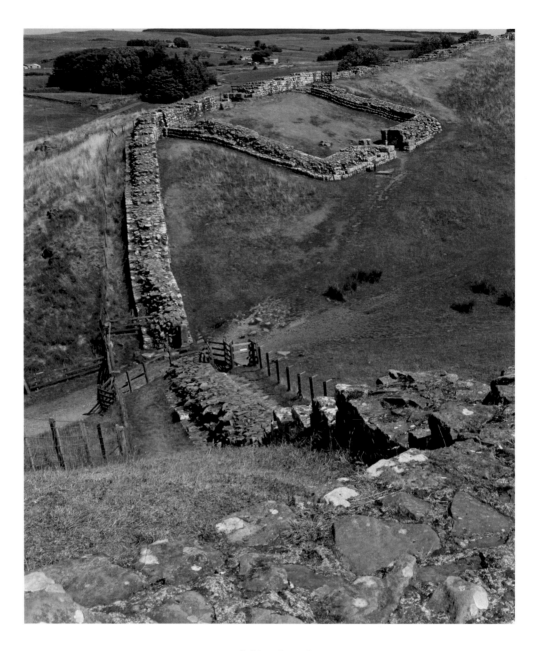

Cawfields milecastle

Contents

List of Figures

List of Tables

Preface

This book stems from the invitation of the Society of Antiquaries of Scotland to deliver the Rhind lectures in 2019, sponsored by AOC Archaeology Group. The lectures were endowed by Alexander Henry Rhind, the first being held in 1874, and with rare exceptions they have been held every year since. His legacy stipulates that six lectures have to be delivered. Until 1986 these were held over the course of one week from Wednesday to Wednesday, but in 1987 the pattern was changed and the lectures are now held over a weekend from Friday evening to Sunday afternoon. The first lecture of the series sets the scene and, as it is followed by a reception, is something of an occasion. The last lecture tends to be shorter than normal as it may be followed by questions. The subject of the lectures should relate to 'some branch of archaeology, ethnology, ethnography, or allied topic, in order to assist in the general advancement of knowledge'. I was asked to speak on an aspect of my research on Hadrian's Wall, the Roman *Limes* and army, and 'its wider international, practical and theoretical implications'.

The first two lectures – chapters in this book – provide the historiographical background to our present understanding of Hadrian's Wall. They start with John Collingwood Bruce, the leading authority on the Wall, from 1848 until his death in 1892, who gave the Rhind lectures in 1883 and whose influence continues to this day. Research on the Wall in the field and in the study from 1892 to the present day are covered in the second lecture. The third and fourth lectures consider the purpose(s) and operation of Hadrian's Wall from the first plan drawn up soon after Hadrian became emperor in 117 through to the final days of its existence as a frontier shortly after 400. Five distinct 'plans' for the Wall are promulgated. The fifth lecture examines

1

the impact of the frontier on the people living in its shadow and beyond. The last lecture reviews the processes which have brought us to an understanding of Hadrian's Wall and considers the value of research strategies, with some suggestions for the way forward. The chapters in this book reflect closely the lectures themselves with the main change being the addition of references. I am grateful to the Society for its agreement to publish this book to coincide with the lectures and for its support in its preparation.

In order to try to retain a relationship with the lectures I have restricted the number of references in the text. Quotations are always referenced. Detailed references to structures on the Wall may be found in the *Handbook to the Roman Wall* (Breeze 2006) while work during the last decade is reported in the handbook prepared for the 2019 Pilgrimage of Hadrian's Wall (Collins and Symonds 2019).

Hadrian's Wall has acquired its own terminology. At every mile there was a small enclosure called a milecastle (MC), similar to a fortlet (a small fort), which contained a small barrack-block and protected a gate through the Wall. In between each pair of milecastles there were two towers known as turrets (T) after the Latin for a tower, *turris*. On the Cumbrian coast, the equivalent terminology is milefortlet (MF) and tower (T). These structures on the Wall are numbered westwards from Wallsend and on the Cumbria coast westwards from Bowness-on-Solway. Behind the Wall is an earthwork known as the Vallum. It consists of a central ditch with a mound set back equidistant on each side. As the essential feature is the ditch, it should be termed the *Fossa*, but it was named the Vallum over a thousand years ago and it is too late to change the name. One issue is to differentiate easily between the Wall, meaning the whole of the frontier complex, and the linear barrier, here called the curtain wall.

1848. The year of revolutions, on Hadrian's Wall as well as on the continent

The activities of the revolutionaries on continental Europe in 1848 forced a Newcastle schoolmaster to abandon his planned trip to Rome. Instead he undertook a tour along Hadrian's Wall. That schoolmaster was John Collingwood Bruce and the tour was to change not only his life but also the study of the Roman Wall, as it was then called. Bruce had visited Hadrian's Wall before, as a schoolboy and a student and also as a Presbyterian preacher, but now, at the age of 42, he was to begin the work for which he is still justly famous (see Bruce 1905 for details of his life).

The 1848 expedition

The party which set out westwards from Newcastle on 19 June 1848 was five strong. Bruce was accompanied by his son Gainsford, a lad of 14 – later an MP and a High Court Judge – and by two brothers, Charles and Henry Burdon Richardson. Henry was the drawing master at Bruce's school, the Percy Street Academy in Newcastle. He and his brother were members of a family of painters, publishers and schoolmasters (Hall 1982: 277-284). The fifth member of the group was Bruce's groom who drove the carriage; we only know his first name, William (Figure 1).

Five people are depicted in the coloured engraving of the party at Limestone Corner, beside the most northerly tip of Hadrian's Wall. Bruce is clear in the left foreground and Gainsford sits atop one of the massive stones the Roman soldiers failed to remove from the ditch. From the north side of the ditch they

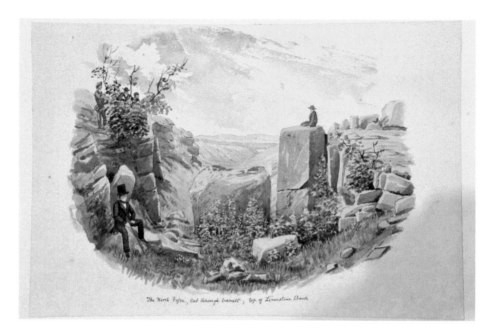

Figure 1. John Collingwood Bruce and his party at Limestone Corner in 1848

are observed by three men. One has a bag over his shoulder and we might surmise that he is Henry Richardson, the more prolific of the painter-brothers. Perhaps the central figure with the wide brimmed hat is his brother Charles and the more distant figure the groom. The caption at the bottom is in Bruce's handwriting but he did not go so far as to identify the figures.

It is unfortunate that we cannot identify the three figures because we owe so much to Henry Richardson who created four dozen paintings of Hadrian's Wall that summer and a further 14 in the following years but of whom we do not have a certain likeness. It was his skills as Bruce's drawing master that led him and his brother to be part of the group. Their task was to record the Wall. Writing to his wife on the evening of the first day of the tour, Bruce stated that 'Richardson has made two or three very useful and one very beautiful sketch' (Bruce 1905: 111). The same letter introduces us to the local social hierarchy. Bruce and his son were given lunch by Miss Clayton at Chesters; where the Richardson brothers ate is unknown, while William, the groom was presumably with the servants (Figure 2). The tour lasted from 19 June for about 10 days until Bowness-on-Solway was reached. Bruce took notes and Henry Richardson made 'sketches of the most important points of view' (Bruce 1905: 112). He was described as having 'a conspicuous facility in sketching rapidly and accurately', which was just as well as he completed 47 sketches in ten days, nearly five a day.

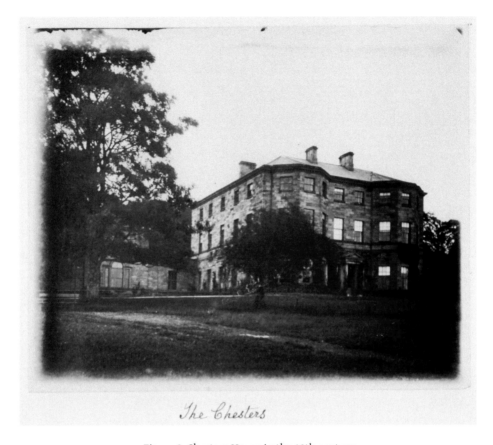

The Chesters

Figure 2. Chesters House in the 19th century

The writing of *The Roman Wall*

That autumn, from 15 November onwards, Bruce gave five lectures to the Literary and Philosophical Society in Newcastle. In his second lecture Bruce put Hadrian's Wall into its wider context, comparing it to the frontier in Germany and to Graham's Dyke, that is the Antonine Wall, in Scotland. The two core lectures, the third and fourth, were a description of the Wall, illustrated by Henry Richardson's sketches to which he had subsequently 'added slight washes of colour' (Anon 1906: 80).

The lectures were well received and from the accolades sprang two actions. The audience was surprised that 'so magnificent a monument of the power of Rome existed within easy reach of their homes and had remained comparatively unobserved and unnoticed' (Bruce 1905: 114). This is not surprising considering the difficulties of transport in those days. It was to be another year before Queen

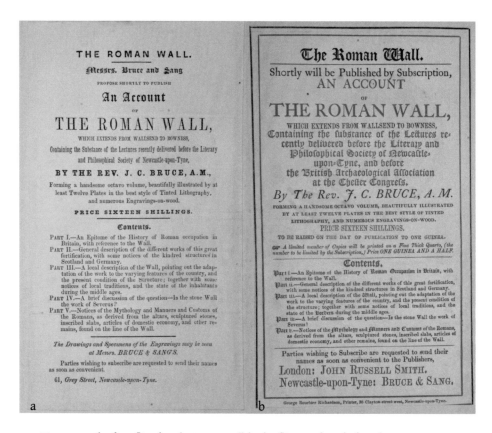

Figure 3. a. the first flier for *The Roman Wall*; b. the flier produced after the BAA meeting

Victoria opened Newcastle Central Station. On their 1848 expedition Bruce and the Richardsons travelled by carriage, Gainsford on his pony.

Bruce responded to the lack of knowledge of the Wall demonstrated by his fellow Tynesiders by offering to lead a tour of the Wall to inspect its remains. This took place in June and July 1849 and subsequently became known as the first Pilgrimage of Hadrian's Wall, an event which continues to this day. The second action was that Bruce decided to write a book on the Roman Wall. It was advanced enough for flyers to be printed and circulated seven months later at the annual Congress of the British Archaeological Association meeting in Chester when Bruce addressed the Association on the subject of the Roman Wall, illustrated by some drawings, presumably those of Henry Richardson (Breeze 2017) (Figure 3).

The book, imaginatively entitled *The Roman Wall*, was published at the very beginning of January 1851; Bruce completed the preface on 1 January and sent

the first copy of the book to his wife on the following day (Figure 4). It was followed by a second edition in 1853 and the definitive third edition in 1867. In the meantime, he had produced a synopsis, a guide-book, first called *The Wallet-Book of the Roman Wall*, in 1863, with subsequent editions in 1884 and 1885 entitled, *The Hand-Book to the Roman Wall*, the latter just in time for the second Pilgrimage of Hadrian's Wall in 1886 (Bruce 1851a; 1853; 1863; 1867; 1884; 1885). Also, in 1851 he published *Views on the line of the Roman Wall in the North of England*, containing the engravings used in *The Roman Wall*, with just 21 copies printed (Bruce 1851b).

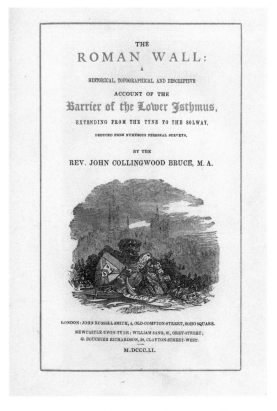

Figure 4. Title page of *The Roman Wall*

The career of John Collingwood Bruce

Bruce's rise had been swift, not to say meteoric. His research into Hadrian's Wall had started in the summer of 1848 and within five years he had led a tour of the Wall, introduced some of the senior British archaeologists to it, spoken at the British Archaeological Association meeting in Chester, published two editions of his book and been elected a Fellow of the Society of Antiquaries of London (Breeze 2017). His position on Hadrian's Wall was now unassailable, and although some tried to challenge him, they failed. For forty years, Bruce was king of the Wall. How can we account for this?

Part of the answer lies within Bruce himself and his personality. He had trained in Glasgow and Edinburgh to be a Presbyterian minister though he gave up his vocation to follow his father into teaching in the Percy Street Academy. What a wonderful training not just for an accomplished lecturer, but also an author capable of marshalling his facts and writing in an accessible style.

Bruce also had considerable energy; the sixth edition of his book on Hadrian's Wall was published when he was eighty and the following year he was Chief Pilgrim on the 2nd Pilgrimage of Hadrian's Wall. His energy was recognised by his contemporaries who pushed projects in his direction. Already in November 1849 he had been encouraged by the duke of Northumberland to publish the Roman inscriptions in Alnwick Castle.

This leads us to another important aspect, luck. Bruce was exceptionally lucky in the support he received from more senior figures in British archaeology, and in the times in which he lived. First, the people. These included two successive dukes of Northumberland who financed archaeological work in their county (Figure 5). This included the excavation of the Roman fort at High Rochester in 1852 and 1855 which Bruce wrote up, and the survey of Hadrian's Wall undertaken by Henry MacLauchlan 1855, which was used in all Bruce's publications from 1867 onwards and the *Handbooks* through successive editions

Figure 5. Algernon, 4th Duke of Northumberland
(1792-1865)

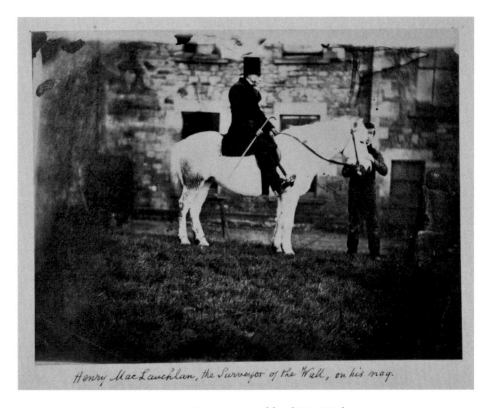

Henry MacLauchlan, the Surveyor of the Wall, on his nag.

Figure 6. Henry MacLauchlan (1792-1881)

until 1947 (Bruce 1857b; MacLauchlan 1858) (Figure 6). The duke took advice on such archaeological matters from Albert Way.

Albert Way, born the same year as Bruce, 1805, was incredibly well connected, numbering a prime minister and MPs in his extended family (Figure 7). If not quite on the same social level as a duke, he was not far from it. His archaeological credentials were also impeccable. He had been director of the Society of Antiquaries of London and was a founder of the British Archaeological Association in 1843 and then of the break-away Archaeological Institute in 1845. Crucially for Bruce, Way was archaeological advisor to the duke of Northumberland. It is clear from reading the surviving letters that several of the ideas for archaeological projects emanated from Way who promoted them to the duke with the suggestion that Bruce was the man for the job. This is clear from a letter written by the duke to Bruce on 27 November 1849: 'Mr Way thinks ... and I should be happy to pay', in this case for the production of woodcuts of inscriptions in his museum at Alnwick Castle (Bruce 1855). Bruce acknowledged his debt to Way in the preface to *Lapidarium Septentrionale*, published the year after Way's death.

Figure 7. Albert Way (1805-1874)

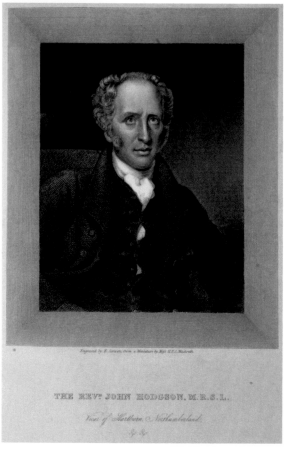

Figure 8. John Hodgson
(1789-1845)

The third great influence was Charles Roach Smith, secretary of the British Archaeological Association. In contrast to Way, Roach Smith was a self-made man. He was two years younger than Bruce and they died within two years of each other. It was to Roach Smith that Bruce wrote to offer a lecture to the Chester Congress in 1849. Roach Smith, the more experienced archaeologist and publisher, was to be of material help to Bruce as he progressed his career as a writer, offering advice and checking proofs, as Bruce acknowledged in both the 3rd edition of *The Roman Wall* and in *Lapidarium Septentrionale*.

The date of the building of Hadrian's Wall

The other element of luck was the times in which Bruce lived. It was only in 1840 that John Hodgson, a local clergyman and Secretary of the Society of Antiquaries of Newcastle, had finally demonstrated that the Roman Wall had been built on the orders of the Emperor Hadrian (Hodgson 1840: 149-322) (Figure 8). Looking back, it seems amazing that it took so long for this to be determined, and indeed it is amazing.

Knowledge of Hadrian's Wall had never been lost. Gildas in the 6th century and Bede in the 8th wrote about it, as did later medieval chroniclers and mappers (Shannon 2007). The Renaissance led to a revival of interest in the classical sources and the invention of the printing press allowed the dissemination of the ancient texts. Two scholars studied the sources relating to Roman Britain and came to the correct conclusion that the Roman Wall had been built by Hadrian. One was Hector Boece, the first principal of Aberdeen University, writing in 1527 and the other the Italian humanist scholar Polydore Virgil in 1534. Their conclusions were rejected by English writers such as John Leland who preferred to believe other ancient statements that the Emperor Septimius Severus built the Wall. Why? Bill Shannon has persuasively argued that Boece was dismissed by the English because he was a Scot and Virgil because he was Italian and a Roman Catholic to boot (Shannon 2007: 15). Needless to say, the Welshman Humphrey Lhuyd, writing a little later, was also ignored. English zenophobia won the day and the world had to wait another 300 years before John Hodgson analysed the literary and epigraphic evidence and came to the same conclusion as Boece, Virgil and Lhuyd.

These scholars worked from the literary sources, but within a few years antiquarians were visiting the Wall, recording their tours and creating their own theories. They could only formulate their theories on the basis of their interpretations of the literary evidence and their observations in the field. Nevertheless, their observations became increasingly sophisticated,

culminating in John Horsley's magnum opus *Britannia Romana* published in 1732, perhaps the most important book ever written on this subject.

The difficulties for these early observers lay in the complicated nature of the remains they were trying to interpret. The Wall itself was the most obvious element. It was appreciated that it ran from Wallsend on the Tyne to Bowness on the Solway. Along it there were forts, but the relationship or relationships between the forts and the Wall were not known. There were also smaller stations, noted by Christopher Ridley as early as the 1570s and first recorded in the literature as milecastles in 1708 when it was stated that they were built at mile intervals (Birley 1961: 3-4). Christopher Ridley also named towers, later to be called turrets from the Latin *turris* meaning a tower, though we should acknowledge that towers were also mentioned in the 10th century Anglo-Saxon Chronicle of Aethelweard. The range of structures had been correctly identified, but the relationship between them was not understood for another 300 years.

So much for the Wall, but the greater complication was that behind it lay a great earthwork which has been known since the time of the Venerable Bede writing in 731 as the Vallum (Bede, *History of the English Church and People*, ch. 5) (Figure 9). Bede would appear to have viewed the upstanding parts of the earthwork, the mounds to each side of the central ditch, as the most important element of the monument, or perhaps simply as the most visible, but archaeology has demonstrated that the important element was the ditch so the Vallum should

Figure 9. The Vallum at Cawfields looking east painted by Henry Burdon Richardson in 1848

really be called the Fossa; it is, however, too late to change the name.

Antiquarians tied themselves up in knots trying to disentangle the Vallum and its relationship to the Wall (Birley 1961: 1-17). In 1600 William Camden offered his interpretation (Camden 1600: 710-724) (Figure 10). The Vallum was Hadrian's frontier while Severus built the visible stone Wall. The reasoning was straightforward. There were several ancient references to Severus building a Wall but only one citing Hadrian (Birley 2005: 195-203). As Hadrian's frontier was earlier, it was presumably the earthen barrier and not the stone wall. But if the Vallum had been Hadrian's frontier, why was there a mound in front of the ditch? Sandy Gordon compared it to the Antonine Wall where there

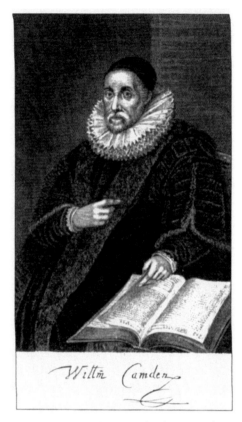

Figure 10. William Camden (1551-1623)

was also a mound on the north side of the ditch and argued that this was normal Roman practice (Gordon 1726: 85). Horsley suggested that the north mound was a road constructed under the governor Agricola about 80; he wasn't far wrong because there was a road running along the north mound, but it was later in date. The forts were also assigned to Agricola. There was sense in this because it could be seen that the curtain wall ran up to and butted against the corners of the fort at Housesteads (Figure 33). Stukeley was closest to the truth suggesting that the visible stone wall was set upon the same line as Hadrian's earth wall, which was later to be discovered to be the case for part of its length (Stukeley 1776: 59). He dismissed the idea that the Vallum was Hadrian's Wall arguing that it was a contravallation.

The genius of John Hodgson lay in setting out the literary references and combining them with the inscriptions from the frontier to demonstrate that it was the Stone Wall that had been erected by Hadrian (Hodgson 1840: 149-322). He went on to conclude that the Wall from Wallsend to Bowness, together with the milecastles and towers and many of the forts along its line,

together with the Vallum, were all planned and executed by Hadrian. It was left to subsequent generations of archaeologists to prove the veracity of this statement.

Hodgson was to live only another five years after his epoch-making statement. The man who picked up the mantle was Bruce. Actually, this is to overstate Bruce's position. He was not an original thinker like Hodgson; he was an interpreter and publicist and he benefitted greatly from the new view he inherited. He accepted Hodgson's statements and never wavered from them, in spite of the challenges which were occasionally raised, and which continued up to and beyond his death 40 years later. It is to Bruce that we owe the fact that Hodgson's two statements, that Hadrian built the Wall and that his solders erected all its elements, survived and flourished. Bruce simply failed to acknowledge his source, as some contemporary reviewers pointed out.

The paintings and engravings of Hadrian's Wall

We owe another debt to Bruce, Henry Burdon Richardson's paintings (Breeze 2016). These became the iconic views of Hadrian's Wall through their publication in Bruce's books. Earlier depictions of the Wall are few in number. One such view was by Thomas Miles Richardson, who published a drawing of the Wall at East Denton in 1823 (Breeze 2016: 46). Thomas Miles had also been drawing master at the Percy Street Academy (Figure 11). In this post he was succeeded by three of his six sons, Thomas Miles junior, Edward and Henry. All six sons were painters and three of them, Thomas Miles junior, Henry Burdon and Charles all drew Hadrian's Wall, together producing a portfolio of at least 77 paintings and drawings, most by Henry (Breeze 2016: 14-17).

The links between the Richardsons, John Collingwood Bruce and Hadrian's Wall were strong. Yet, in spite of this, Henry and Charles received little by way of acknowledgement from Bruce in his several books. Henry's name usually appears beside the printed drawing together with that of the engraver, but he received no thanks in the general acknowledgements. The discrepancy between this lack of courtesy and the fulsome thanks to C. J. Spence for his drawings used in the later editions of the *Handbooks* is noticeable (Bruce 1884: iv). I can only presume that as Henry Burdon Richardson was an employee of Bruce his contributions did not require acknowledgement. It is therefore of considerable satisfaction that reviewers of *The Roman Wall* drew attention to the 'skilfully-drawn lithographs' (*Journal of the Belles Lettres*, 26 April 1851).

Ironically, the lithographs, or engravings as we would now call them, were not directly the work of Richardson but of John Storey (Breeze 2016: 19-22). Bruce's

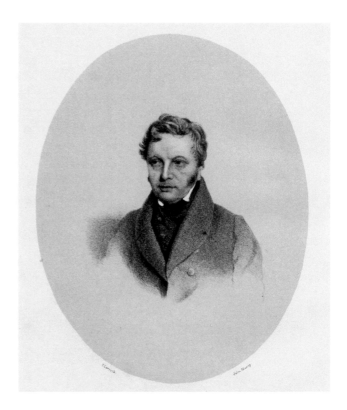

Figure 11. Thomas Miles
Richardson senior
(1784-1848)

son and biographer Gainsford recorded that his father 'devoted great attention to the pictorial illustrations of the book, and had many lithographs executed from the drawings by Mr Henry Richardson, which were not only remarkable for their fidelity, but were beautiful as works of art' (Bruce 1905: 125).

Comparison of the published engravings by Storey with the original paintings of Richardson reveals significant differences. This can be seen, for example, through comparing the painting and engraving of the milecastle at Cawfields (Figure 12). The drawing that formed the basis of the engraving was executed in 1848 during the tour of that year. In the previous year John Clayton – who we have yet to meet – had bought the milecastle and started its excavation. That clearly continued after the visit of Bruce and his party because the engraving, published in the first edition of *The Roman Wall* in 1851, shows more of the Wall visible to the west of the milecastle than was recorded in 1848.

Even more striking is the comparison of the depictions of the minor west gate at Birdoswald (Figure 13). The painting of 1848 shows the north side of the gate tumbled down, but the engraving reveals a tidy arrangement. What had occurred between the visit and the publication was the excavation of the gate by Henry Glasford Potter in September 1850.

Figure 12. a. Henry Richardson's 1848 painting of Cawfields milecastle;
b. John Storey's engraving

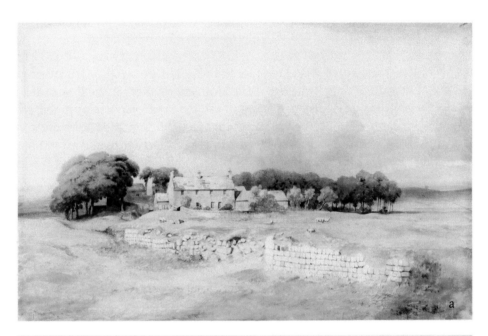

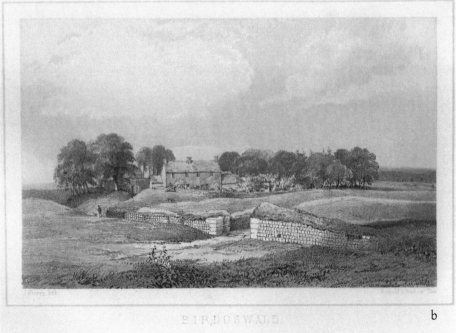

Figure 13. a. Henry Richardson's 1848 painting of Birdoswald; b. John Storey's engraving

The conclusion to be drawn from comparison of Richardson's paintings and Storey's engravings is that Bruce chose which paintings to publish and then sent Storey into the field to execute versions that could be turned into engravings. The process is acknowledged by Bruce in 1867 when he stated that he dispatched Storey to Byker to update Stukeley's sketch of 1776 (Bruce 1867: 96). Bruce had only 11 of Richardson's 47 drawings turned into engravings for the first edition of *The Roman Wall* in 1851, though some were made into woodcuts, and others were used in later editions. All the engravings in the first edition were created by John Storey, who also redrew the view of Peel Crag earlier published in John Hodgson's *History of Northumberland* and contributed a further two engravings of his own.

John Storey was another member of the small group of people who helped to create the late 19th century images of Hadrian's Wall (Hall 1982: 326-327). A contemporary of Henry, he was a pupil of Thomas Miles Richardson senior. In 1849, when the project to prepare the woodcuts of the inscriptions for the projected catalogue of Alnwick Museum was mooted, Storey was the man chosen for the job. He appears to have been Bruce's preferred choice of engraver, at least in the early years and it is his engravings which were reproduced in *Views on the line of the Roman Wall* which Bruce published in 1851. Indeed, it is Storey's clear and crisp style, described by Gainsford Bruce as works of art, that created the iconic images (Bruce 1905: 125).

It was not just the words of John Collingwood Bruce but the sketches, drawings and paintings – the terms were used interchangeably at the time – as well as the engravings that provide us with a view of Hadrian's Wall in 1848 and the years following, as it was becoming better known through the publications of Bruce and the excavations of John Clayton in particular.

John Clayton of Chesters

John Clayton was a substantial landowner, lawyer and entrepreneur – the only man, it is said, who helped to develop Grainger Town in Newcastle and did not go bankrupt – and an archaeologist (Figure 14). His father, Nathaniel, had bought the Chesters estate at Chollerford in 1796. He was a lawyer and served as Town Clerk of Newcastle, passing the post on to his son John, an office he held for 45 years. Nathaniel sought to create a park at Chesters and to enhance his view he levelled the upstanding Roman buildings in the adjacent fort. It is as if his son John later set out to compensate for this act of destruction by the excavation of the fort and other sites along the Wall. He did more than this for, from 1834 until 1885, when, incidentally, he was in his 90s, he bought up stretches of the Wall, eventually owning 24km and five forts (McIntosh 2019).

Figure 14. John Clayton (1792-1890)

He put his men to excavate the Wall itself and its forts, milecastles and turrets as well as bath-houses, the sanctuary known as Coventina's Well and Chesters bridge abutment.

Clayton's actions can appear contradictory. As his men cleared the Wall, he instructed them to replace the fallen stones onto the Wall core, though without the use of mortar: today the stones have been back-pointed to hold them in position. He thus created a reconstruction. At the other extreme, after the excavation of a building, he might allow his tenants to remove the stones for their own use. Although he would ensure that the building was planned, he did not always locate it on a map.

Clayton went further than excavation and restoration for he sought to create what today we would call an archaeological park. Where a farm steading stood on the line of the Wall, or too close to it as at Housesteads, he built a new farm and demolished the old. The farm of Shield-on-the-Wall lay beside MC 41

Figure 15. Shield-on-the-Wall painted by Henry Burdon Richardson in 1848

and used its enclosure as an allotment (Figure 15). This was demolished and a new farm erected with the name of Shield-off-the-Wall, though this did not survive long before the former designation came back into use. Clayton's new buildings are easily recognisable today as they were designed in a neo-Tudor style (Woodside and Crow1999: 86).

Clayton's actions were recorded by Henry Burdon Richardson who painted Shield-on-the-Wall while the farm still stood there, while his brother Thomas Miles painted in a very different style the farm at Housesteads before it was moved to its present location (Figure 16).

Elsewhere the Richardson brothers provided us with records of parts of the Wall which have been subsequently destroyed or submerged, in particular by the expanding Tyneside, a development which is recorded in the successive editions of Bruce's books. Wallsend has changed dramatically since 1848, when it was an open field, but its south rampart then survived as a mound and was recorded by both Henry and Charles. The ditch at Stote's Houses, the site of MC 1, remained for some decades, as did the nearby windmill (Figure 17). To the west of Newcastle, the site of Elswick windmill is now close to the centre of the city. When Richardson recorded it, both the ditch and the Vallum were visible.

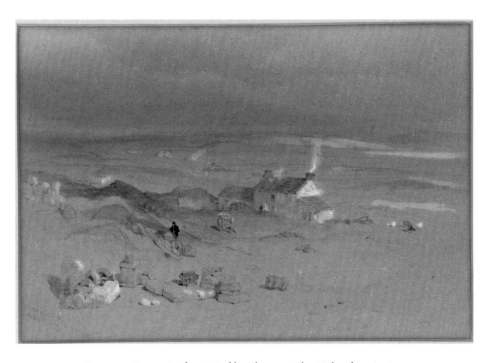

Figure 16. Housesteads painted by Thomas Miles Richardson junior

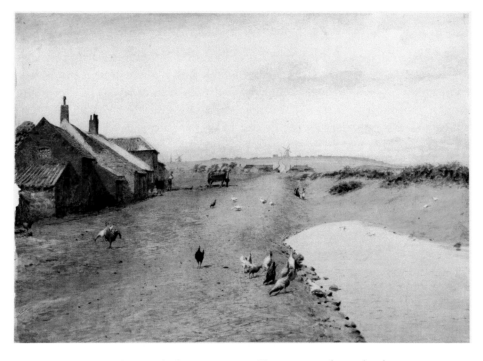

Figure 17. Stote's House looking west painted by Henry Burdon Richardson in 1848

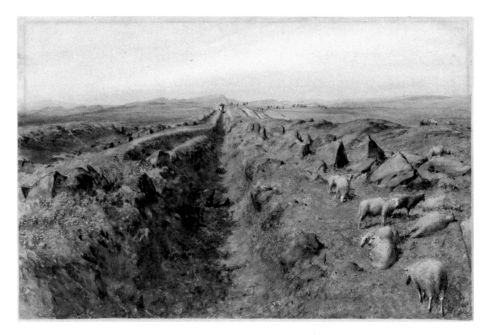

Figure 18. The Vallum at Limestone Corner looking west to Carrawburgh painted by Henry Burdon Richardson in 1848

At Denton Hall, within the Newcastle western by-pass, the earthworks of the Vallum were clearly visible.

One question to be asked is how accurately did Richardson record the visible remains? He was certainly charged with achieving realistic truth, and we can confirm that by comparing his paintings with the Wall today. At Down Hill, for example, Richardson correctly recorded the crossings of the Vallum ditch and the gaps in the mounds; the significance of these features were not realised for another 70 years or more. At Limestone Corner, Castle Nick and at Cawfields, he faithfully recorded what we now call the marginal mound on the south lip of the Vallum ditch; subsequent field survey and archaeological excavations have indicated that this was a later element of the earthwork (Figures 9 and 18). There appears to be no reason to doubt the veracity of Henry Burdon Richardson's recording of Hadrian's Wall.

The importance of the year 1848

We see in 1848 the combination of three great events in the modern history of Hadrian's Wall, in fact marking the point at which the modern history of Hadrian's Wall can be said to have begun. These are: the detailed note-taking by John Collingwood Bruce during his perambulation which formed the foundation of his series of books on the frontier; the faithful depiction of the visible remains

by Henry Burdon Richardson through his four dozen sketches and paintings of the Wall which led to the creation of the engravings; and the uncovering and recording of the remains by John Clayton and in some cases their restoration.

The actions of Clayton's workmen in uncovering – excavating implies a relationship with archaeological investigations which did not exist – the Wall and its structures were recorded by the Richardson brothers. We have already seen MC 42 (Cawfields), but Henry also drew MCs 37 (Housesteads) and 39 (Castle Nick), helpfully including a figure for scale at Housesteads. At Castle Nick the way that the milecastle was uncovered, with the external walls followed, was faithfully recorded.

The excavation of forts was also recorded, for example, at the north gate of Housesteads with the 'honest Walter Rutherford' at work (Breeze 2016: 98-9). At Chesters, the bridge abutment and the bath-house were drawn as soon as they were uncovered. The surviving *opus signinum* plaster in the bath-house was depicted while the method of conservation, the use of turves to protect the tops of the walls, is shown. The east gate at Chesters was drawn as it was being excavated as is revealed by the crispness of the edges of the trench. Bruce often visited work in progress, writing to his wife from Chesters in December 1867 that it was bitterly cold; 'nothing very striking has turned up at the diggings; still I like to watch the work' (Bruce 1905: 155). Two years later he was again at Chesters where David Mossman was 'drawing away all day at the newly excavated gateway, and I have been a good deal with him'. The drawings are sometimes the only record that we have of an excavation (Figure 19).

The remains uncovered by Clayton's workmen had the ability to challenge current orthodoxy on the purpose and operation of the frontier. The purpose of Hadrian's Wall is, of course, one of the basic questions about the frontier, with a long history of debate behind it. In the 4th century AD, an anonymous biography of Hadrian stated that the Wall was built to separate the Romans and the barbarians. For later commentators, it role was obvious: it was designed for 'defences against the enemy' as Horsley put it in 1732 (Horsley 1732: 116). Indeed, it was perceived as more than that: the lack of known gates through the Wall did enforce a separation between Rome and its northern neighbours. The discovery of a north gate at MC 42 (Cawfields), followed by those at MC 37 (Housesteads) and MC 39 (Castle Nick) completely overturned that position. The discoveries led to the view that the people north of the Wall were not very formidable; before that it had been assumed that these people were very fierce and to protect themselves the Romans had created an impermeable barrier.

Figure 19. Chesters east gate painted by Henry Burdon Richardson in 1867

Bruce understood the implications of the discovery of gates through the Wall. In his magisterial 3rd edition of *The Roman Wall*, published in 1867, he stated that 'if the Wall had been intended to form the boundary of the empire, it would not have been provided with nearly a hundred gateways leading through it. The fact of such an arrangement shows that the territory north of the Wall was not given up to the enemy, and that the Wall itself was not a mere fence, but a line of military operation, intended to overawe a foe, whose assaults were chiefly expected from the north' (Bruce 1867: 73-74). A greater subtlety had entered into the discussion.

We owe a great debt of gratitude to the revolutionaries of 1848. Without their actions, Bruce would have gone to Rome, and he would perhaps have emerged as an interpreter of its remains; he did manage to visit Rome in 1861. As it was, he explored Hadrian's Wall. Without his background as a teacher, that expedition would have been different. Bruce inherited from his father and his uncle, the founders of the Percy Street Academy, the editing of school text books on history and geography. Bruce himself kept meticulous lecture notes. His approach to teaching history extended beyond the class room, taking his students to look at historic buildings and learn history through them, a rather modern attitude. It was this interest in buildings and what can be learned from them that led

him to take an interest in the castle of Newcastle, which had been under threat from the development of the railways. In 1847 he wrote a guide-book to the castle. Luck also was on his side for at the dinner held in August 1848 to mark the completion of the restoration of the keep, he met Algernon, 4th duke of Northumberland, for the first time, the start of a fruitful relationship.

So the 1848 tour was a combination of Bruce's interest in historic buildings and monuments, his careful note-taking, and the fact that he employed a drawing master at his school who was on hand to record the monument. These led inexorably to the publication of *The Roman Wall* just two and a half years after the tour.

Reactions to Bruce

There was a snag, however. The editing of school text books does not require much by way of acknowledgement of sources and Bruce found himself in hot water through the lack of acknowledgements in his first academic book, particularly of Hodgson. He also annoyed Henry Glassford Potter excavating at Birdoswald (Miket 1984: 252-253). Potter wrote to Bruce to complain that the information he had supplied had not been acknowledged and that Bruce must not use this information in a new edition or he should state his source. If Bruce did not comply Potter would attack him in the newspapers. Bruce hastened to add an acknowledgement in the 2nd edition which was so far advanced in the press that it had to be placed in an appendix. Bruce meantime excused himself to Potter on the grounds of his inexperience and that he had been advised not to make 'too frequent personal allusions to my friends' as this would 'bring upon myself the ridicule of the critics' (Bruce 1855). He had, however, learnt the lesson and is more effusive in the 3rd edition of *The Roman Wall* and in *Lapidarium Septentrionale.*

The reference by Glasford Potter to the newspapers is interesting – one might have expected him to threaten legal action – but it is not surprising perhaps in view of the considerable interest the local papers had in Hadrian's Wall. Bruce's 1848 and subsequent lectures in Newcastle were extensively quoted in the local newspapers while that to the British Archaeological Association was reported in the *Chester Chronicle* and in the *Times*; these are useful sources of information in correcting several erroneous statements about the event by Gainsford Bruce in his 1905 biography of his father (Breeze 2017).

But newspapers went further than reporting lectures. The discussion about who built the Wall, which we, looking back, might have thought had been determined by John Hodgson in 1840, was partly undertaken through the medium of the

local press, often with the protagonists arguing their case in the form of letters to the papers. And the argument was not just between the respective cases for and against Hadrian and Severus. The Reverend Thomas Surridge entered the fray, arguing that two of the advance forts to the north of Hadrian's Wall had been built during the lifetime of Julius Caesar.

Letters and reports in the newspapers were supplemented by pamphlets, some signed, others anonymous, such as that entitled *Mural Controversy. The Question, 'Who Built the Wall'? Illustrated*, by A. Cumbrian. The *Newcastle Chronicle*, the *Newcastle Courant*, and the *Northern Daily Express*, all took sides and for a week or so in 1857 the readers of these newspapers were treated to the unedifying sight of the public throwing of mud. Bruce responded by revising his earlier pamphlet on the building of the Wall. Would that we could achieve such publicity today.

By 1857, Bruce was secure in his position. He was the acknowledged authority on Hadrian's Wall and he enjoyed the support of the great and the good. He counted John Clayton as a friend. As we have seen, he was often at Chesters. Although in the early days Clayton published the excavations undertaken by his workmen, he gradually withdrew from this activity, leaving to Bruce the task of writing up the new discoveries. Nor was this only at Chesters. In 1883, Clayton's men cleared the turret we now call 45b (Walltown West). Unfortunately, it was about to be destroyed by quarrying (Bruce 1885b). Bruce fulminated against this but could do nothing to prevent its destruction. But he did measure it, C. J. Spence drew it and someone photographed it, thereby providing information which we can re-interpret today (Figure 20). Bruce also had the support of Algernon, 4th duke of Northumberland, and other members of the Percy family. In 1852 the duke sought the approval, through Albert Way of course, of Bruce before he invited Henry MacLauchlan to undertake his survey of the Wall.

The end of an era

What of the Richardsons? Henry died in 1874, Thomas Miles junior in 1890 and Charles in 1908. By this time both Thomas Miles junior and Charles had been long settled in southern England, the former from the 1850s and the latter from the 1870s, though Charles did return to Hadrian's Wall to paint the newly excavated bath-house at Chesters in the 1880s. Other members of the family had travelled further afield. George Bouchier Richardson, their cousin and the printer of the first edition of *The Roman Wall*, followed his father to Australia in 1873. This was doubly unfortunate because George was particularly interested in the archaeology of Newcastle and produced one of the earliest reconstruction drawings of the city in Roman times, which was immortalised in Bruce's publications where it was often used as the frontispiece. Although Thomas Miles senior had six sons, I have

Figure 20. Photograph of Turret 45b (Walltown West)

only been able to trace one grandchild, who died unmarried. That family which had given so much to Hadrian's Wall died out.

John Clayton died in 1890 at the age of 98. His will was proved at £728,000; at today's prices by one calculation this may have been the equivalent of about £70m. It is not surprising that he could afford to buy so much land and then move his tenants into new farms. He had not married and his estate passed to his nephew, eventually being inherited by John Maurice Clayton who sold the whole estate including the forts, milecastles, turrets and 24km of the Wall in 1929 to pay his gambling debts. The cottage at Chesterholm and the adjacent fort, were bought by a young post-graduate named Eric Birley, who we shall hear more of later.

John Collingwood Bruce died in 1892 at the age of 86. He was buried in Jesmond Old Cemetery, in a simple grave. His funeral, however, was anything but simple. A long line of carriages extended up the North Road from the Hancock Museum. That road and Jesmond Road, along which the cortege passed, was lined with people. The Mayor and Sheriff attended together with representatives of other public bodies; the duke sent his apologies. Bruce had left instructions for the form of the service; it was to be in the open air as he appreciated that the

Figure 21. The memorial to Bruce in Newcastle Cathedral

cemetery chapel would be too small to hold the congregation. At the cemetery gates, the cortege was met by the ladies of the Infirmary Singing Choir intoning 'I am the Resurrection and the Life'; the choir had been established by Bruce to give succour to the ill in hospitals. The Minister began his eulogy by stating that 'Newcastle today is burying her best known, and perhaps most distinguished, citizen' (Bruce 1905: 383-384). Four years later a monument to Bruce, the Presbyterian Minister, was unveiled in the Church of England's Cathedral of St Nicholas in Newcastle, and the eulogy delivered by the Earl of Ravensworth (Figure 21). Not bad for an archaeologist, even if his study of Hadrian's Wall was but one element of his claim to fame. His contribution was immortalised by the open copy of *The Roman Wall* at his feet, rendered in stone.

The achievements of Bruce

How, looking back after a century and a quarter, do we assess the achievements of Bruce? For archaeologists and historians his greatest achievement surely was to promote the two great statements of John Hodgson, that Hadrian did indeed build the Wall and that the Wall, forts and Vallum were contemporary. There remained unbelievers even at the time of Bruce's death, but Hodgson's views were proved right so Bruce was on the side of the angels in promoting them.

His other great achievement was to put Hadrian's Wall on the map. His books offered the first serious guide-books to Hadrian's Wall. Previously John Warburton

had published a guide in 1753, but this was a scissors-and-paste job shamelessly regurgitating the work of his predecessors and betters. Hadrian's Wall had, of course, appeared in other publications on Roman Britain. Bruce's achievement was to write a book solely on the Wall and combining its history with a guide.

A further distinction was that his publications and lectures were recorded and reviewed in local and national newspapers. His books, if not best sellers – Gainsford Bruce stated that, in spite of the duke, Clayton, Albert Way and others contributing illustrations, the first edition of *The Roman Wall* was not produced 'without some pecuniary loss' - were widely bought and recognised as the authoritative statement on the frontier (Bruce 1905: 126). Bruce did not just publish his Wall material in these books, but they were underpinned by his academic papers, reports of the excavations on the Clayton estate and by that other great tome, *Lapidarium Septentrionale*, a corpus of inscriptions from northern England, and a catalogue to the museum at Alnwick Castle. In short, he knew his stuff.

Even today, it remains impressive to read through all six editions of his books on Hadrian's Wall and appreciate how he extended his knowledge over their span. At first, he was heavily dependent on John Horsley's *Britannia Romana*, but he gradually developed his own views as we can see in his statements on the operation of the Wall. He also appreciated the changes to the landscape through which the Wall ran, in particular on Tyneside, and adapted his text to suit. There are two singular legacies to his credit, the *Handbook to the Roman Wall*, which continues to keep information on the Wall up-to-date and is now in its 14th edition and the Pilgrimage of Hadrian's Wall, which is about to undertake its 14th expedition and, of course, is a very Bruce way of communicating information.

Bruce's activities also encouraged an interest in drawing and painting the Wall. We have discussed the activities of the Richardson family at some length, but they were not alone. In June 1851, Charles Roach Smith undertook a journey along the Wall in the company of Bruce (Figure 22). He subsequently published two accounts of his visit (Smith 1851), one illustrated by sketches of Walltown Crags prepared by William Henry Brook, his illustrator. It is significant that Walltown Crags were chosen for the illustrations for in the second half of the 19th century, before the ravages of quarrying, this sector offered the iconic view of Hadrian's Wall; its place was to be taken by Cuddy's Crags and latterly by Kevin Costner's tree at Sycamore Gap.

Another artist linked to Bruce was David Mossman who we have already met at Chesters. Born in Edinburgh in 1825, he was variously described in census

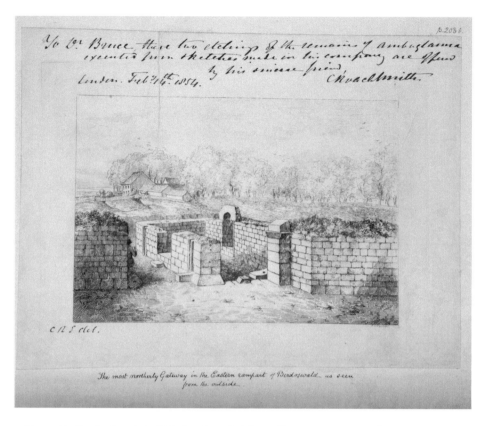

Figure 22. Charles Roach Smith's drawing of Birdoswald east gate presented to Bruce in 1854 following their joint visit to the Wall 3 years before. Note the door head, no longer *in situ*, and the farmhouse before it was castellated

returns as an artist and miniature or portrait painter, successful enough to employ three servants in his Hampstead home. Mossman was at work drawing Wallsend, Birdoswald and Bewcastle in 1857, when he was probably still living in Newcastle, Chesters bridge abutment in the early 1860s and the excavation of the east gate of Chesters after he had moved to London. Mossman was still at work on the Wall in 1893 when he painted Walltown Crags (Breeze 2017: 147). He was with Bruce at the so-called watch tower on the Maiden Way in the 1860s when Bruce's caption records that they were alarmed by the cows (Figure 23). This and other paintings by Mossman were used as engravings or woodcuts in several of his publications on the Wall. Bruce also used some of Mossman's paintings to illustrate his lectures, for example, one delivered in Newcastle in 1870. Unfortunately, the relationship between Bruce and Mossman is not better known. No paintings by the artist are included in the 1886 list of paintings in Bruce's ownership, though some smaller items survive interleaved in Bruce's own copy of his 1867 edition of *The Roman Wall*.

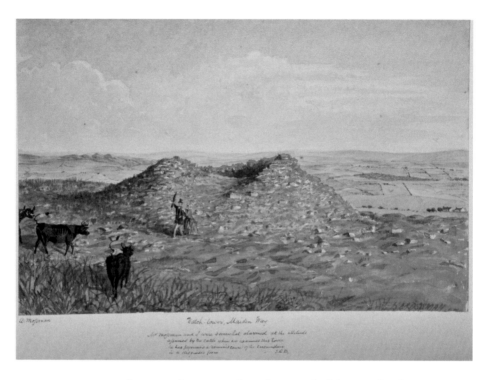

Figure 23. David Mossman's painting of Watch Cross which he visited with Bruce

To live to a great age is an achievement. To live to such an age and retain one's faculties is another. To live to a great age and allow challenges to your own views is an even greater achievement. Bruce was not in this category. In his obituary of John Pattison Gibson in 1912, George Neilson, Past President of the Glasgow Archaeological Society, quoted Chancellor Ferguson of Carlisle, who, when asked whether the current opinion on the Wall was final, replied 'that there were young bloods at Newcastle only waiting till Dr Bruce died to awake the slumbering problems of the Wall' (Neilson 1912: 39) Neilson continued, 'not antagonism to him in any sense, however, but the truest homage to his much-honoured memory quickened the spirit of enquiry after his death in 1892, and prompted those numerous excavations and explorations, with consequent and ever more definite re-discussions, which splendidly reinforced the store of fact and monument recovered, and have signally advanced the cause of British archaeology.'

The twentieth century: the age of archaeology

Roman remains have long attracted the interest of scholars and archaeologists, and not just that select band. The Kaiser funded the replica Roman fort at the Saalburg in Germany, built there because the scenery reminded him of visits to his grandmother, Queen Victoria, at Balmoral. Hadrian's Wall has not benefitted from such favour, but it has a more useful claim on the attention of archaeologists because unlike any other frontier, except the Antonine Wall, the various parts touch each other. This gives Hadrian's Wall the distinct advantage that we can create a relative chronology for its construction. The understanding of these relationships was the great achievement of Wall archaeologists from 1892 to 1945.

In 1890, John Collingwood Bruce, for so long the king of the Wall, was 85. He was still active, chairing meetings of the Society of Antiquaries of Newcastle, for example (Figure 24). But there was a darker side to his declining years. As we have seen, George Neilson quoted Chancellor Ferguson of Carlisle, who 'said that there were young bloods at Newcastle only waiting till Dr Bruce died to awake the slumbering problems of the Wall' (Neilson 1912: 39). The young bloods in Newcastle waited until after the death of Bruce to awaken these sleeping problems of Hadrian's Wall, but those living beyond the long shadow cast by Bruce were more impatient. As a result, the new theories did not, at first at least, emanate from Newcastle, but from Glasgow, whence Nielson's contribution, Oxford and even Berlin.

The first sign of unrest was a paper by J. R. Boyle in 1889, but this, a critique of Bruce's views, could have been written at any time in the last forty years (Boyle

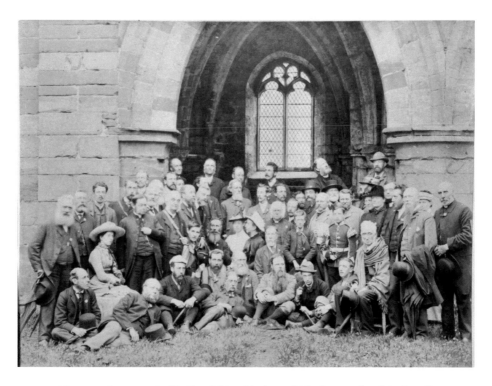

Figure 24. Bruce, seated to the right, with the 2nd Pilgrimage of Hadrian's Wall
at Lanercost Priory in 1886

1889). Two years later appeared George Nielson's *Per Lineam Valli, A New Argument touching the Earthen Rampart Between Tyne and Solway* (Neilson 1891). While lacking the punchy titles favoured by Bruce, it marked a return to the serious business of observing and analysing the visible remains. But without the information yet to be provided by excavation, the conclusions were necessarily limited.

John Pattison Gibson

That same year, 1891, John Pattison Gibson was out walking along the Nine Nicks of Thirlwall when his 'attention was attracted by a square joint between two stones in a hole scratched by a rabbit' (Gibson 1903a: 13). He returned the following year to explore further and found himself excavating Mucklebank turret, number 44b in the numbering system created by Collingwood in 1930 whereby all milecastles and turrets were numbered westwards from the eastern end of the Wall at Wallsend (Collingwood 1930). Sometimes actions within a single year add a particular poignancy to a story. This was certainly the case on the Wall, and the year was 1892, the year when John Collingwood Bruce died and John Pattison Gibson commenced his career as an archaeological excavator.

Gibson did more than that for he began the long sequence of archaeological explorations of the Wall which has continued to this day.

In the same year, 1892, that Gibson excavated Mucklebank turret, Francis Haverfield, from his base in Oxford, published his first contribution to Wall studies on the epigraphic evidence for the dating of Hadrian's Wall (Haverfield 1892; Freeman 2007: 247-249). And it was not just for British frontier studies that 1892 was so important for this was the year that the Reichs-Limes-Kommission was established to investigate the Roman frontier in Upper Germany and Raetia. It completed its task 45 years later. It is to the shame of Hadrian's Wall archaeologists that we have no equivalent in Britain.

If I had to choose a hero, it would be John Pattison Gibson (Figure 25). A chemist by profession, he undertook excavations which are still referenced today. As we have seen, his first excavation occurred almost by chance, certainly as a result of a serendipitous observation. His complete excavation of Mucklebank turret, was a

JOHN PATTISON GIBSON, F.S.A.

Figure 25. J.P. Gibson (1838-1912)

Figure 26. Mucklebank Turret from the east

landmark in the history of archaeological investigations of Hadrian's Wall. This was for several reasons, though not all became clear until over a century later (Figure 26). The primary reason for its importance is that Gibson produced, for the time, a decent report with a description of the structure and the internal layers with some information on their contents and an interpretation (Gibson 1903a).

His excavations revealed three levels of stone flooring, separated by burning which he related to 'two great epochs of disaster'. At this point he made the useful observation that such evidence had been found at forts along the Wall; Bruce had made a similar observation in 1857 in relation to Housesteads: 'it is surprising to see how constantly, in all the buildings of the Wall, these proofs of the vigorous onslaught of the Caledonians ... occur' (Bruce 1857a: 234).

Gibson recorded in the turret several stone slabs 2 feet square and 3-4 inches thick (about 600 mm square and 80 mm thick) as if fallen from an upper level, though not the roof as they were too heavy and were not pierced for nails. However, he did recover many large iron nails. The turret is the only one so far known which stood in a corner of the Wall, though a turret a mile on, unfortunately destroyed in the 1880s, was probably similarly placed (Figure 20). The turret was unusually small as was demonstrated by subsequent investigations of other turrets. Finally, we learnt much later that this turret was not in its measured position but moved from that presumably so as to control better the re-entrant in the crags to its west. Ironically, Gibson had excavated a turret with features which have not been

replicated in the investigation of other turrets. But it was the first excavation which might warrant the use of the word 'scientific' and the report bears re-examination today, which is one of the hall-marks of a good publication.

The interpretations which we can now put on Gibson's findings are that this was one of the latest turrets to have been built on the Wall, at a time when an element of reality was asserting itself in the face of the rigidity of spacing of the original plan, hence its being placed in a location which offered a wide view rather than in a crevice, such as MC 39 (Castle Nick) (Symonds and Breeze 2016: 7-8). The large slabs and the many nails, not generally found in any numbers in turrets, imply a different form of superstructure from other turrets. It is unfortunate that the pottery and other finds do not survive but occupation was clearly not of short duration and the excavations yielded a coin of Valens, emperor from 364 to 378. In other words, the turret was not abandoned after two phases of occupation like most other turrets in the central sector of the Wall, another reference to the importance of its geographical location.

Gibson next turned his attention to the nearby fort at Great Chesters (Gibson 1903b). His report is remarkable for the day in that it starts with a discussion of why this particular fort was chosen for excavation. Those sites suffering from the depredations of agricultural activities and humans were ruled out, as were those which had already been partially excavated, while the territory of the neighbouring archaeological society in Cumbria was excluded. The result was the choice of Great Chesters. Gibson supervised two seasons at the fort and learnt a powerful lesson, 'that no work should be done except under personal supervision', the previous general approach having been to leave a foreman in charge of the excavation with the director visiting weekly, if that (Gibson and Simpson 1909: 220).

At Great Chesters, Gibson revealed his intelligence in another way for he repudiated the actions of his predecessors who had removed the later blocking walls in fort gates and, as a result, left us a gate which still reflects its life history (Figure 27). Today, it does not look pretty, but it holds a lot more information than, say, the west gate of Housesteads cleared out in the 1830s. Gibson described the west gate in detail, noting the differences between the north and the south towers and recording the stratigraphy carefully, relating the levels within the towers to the blockings of the gate passages. He linked the blocking of the passages here and at other sites along the Wall to 'disasters' even suggesting that the Roman army had been expelled from the fort. And he noted a deterioration in the quality of the stonework, presaging the detailed examination of the standard of craftsmanship on the Wall explored by Peter Hill a hundred years later (Hill 2004: 149-151).

Figure 27. The west gate of Great Chesters, grass grown, but as it was left a hundred years ago

For its day, the report was exemplary, and it underpinned the current model for the Wall, namely that the frontier had been overwhelmed on two occasions. The first was tentatively assigned by Bruce in 1857 as being the recorded attack on the Wall in the early 180s at the beginning of the reign of the Emperor Commodus; the second disaster was as yet undated.

Gibson also made another very important point. This was that the 'close proximity of mile castles to the eastern ramparts of [Carrawburgh] and [Carvoran] tends to show they were erected without any consideration for their relative position to the [forts]' (Gibson 1903b: 35). In other words, the planning and location of the forts was a different exercise to the planning and location of the minor structures. Here, is the first modern acknowledgement of what has become a basic tenet of the building of the Wall, that the first plan was for a series of milecastle and turrets on to which was superimposed a series of forts which followed a different spacing plan and therefore perhaps a different strategy. It was also an acknowledgement of a feature which we can recognise on the Antonine Wall as well on Hadrian's Wall. On both frontiers, work was undertaken on different elements at the same time but without any relationship

between the two. Thus, on both frontiers the divisions between the gangs building the linear barrier did not occur at the installations – forts, fortlets or towers – which were being built at the same time but in between them, which we would not have expected.

There is one other important point to make about the excavation report and that is its introduction by a 12-page account of the literary evidence for the layout of Roman military installations (Hodgkin 1903). The Northumbrians were looking beyond their own frontier and gathering the evidence which they hoped would aid its understanding. This was reflected

Figure 28. Oskar von Sarwey

too in the relations which were being forged with their colleagues in Germany. Gibson's excavations coincided with the visit to Hadrian's Wall of Oskar von Sarwey, military director of the Upper German and Raetian Limes (Freeman 2007: 251) (Figure 28).

Francis Haverfield

One member of the several groups which introduced von Sarwey to Hadrian's Wall was Francis Haverfield (Figure 29). In our year *annus mirabilis*, 1892, Haverfield moved from being a schoolmaster at Lancing College to a tutorship at Oxford (for Haverfield generally and his work on Hadrian's Wall see Freeman 2007: 247-298). He had already established relationships across the North Sea having started a correspondence with Theodor Mommsen a decade earlier and subsequently had been invited to contribute on inscriptions found in Britain to the *Corpus Inscriptionum Latinarum*, the empire-wide catalogue of Latin inscriptions. Haverfield was to acquire the accolade as the founder of the study of Roman Britain, but that was in the future. In 1892 he was still finding his way.

One way forward was through the German connection. Haverfield visited Germany frequently and wrote up his observations. His lively correspondence with Mommsen continued in which they discussed new discoveries (e.g. Haverfield 1894). These included a small ditch parallel to and in advance of the

Figure 29. Francis Haverfield and his workmen

frontier line in Germany first observed in 1893. Haverfield's entry point to Hadrian's Wall, however, was through the recording of inscriptions. This led him to review the epigraphic evidence for the date of the building of Hadrian's Wall, a source of evidence 'in no way dependent on personal bias', and this stimulated an interest in excavation (Freeman 2007: 249). But Haverfield was different from most of his predecessors and his contemporaries who, like Gibson in 1892, dug a site because he had found it, or, like Clayton, bought it. Haverfield had questions to answer; in particular, he wanted to understand the monument. He disbelieved the interpretation of the Wall and Vallum being contemporary advanced 50 years before by John Hodgson and espoused by Bruce, which he viewed, not unreasonably, as little more than guesswork. He saw that the best way forward was through a concerted and directed campaign of excavation with the whole Wall as his field of investigation. His was a new approach, in which he demanded proof of a theory.

Haverfield's review of the epigraphic evidence for the date of the Wall had confirmed its allocation to Hadrian, but he could not fit the Vallum into his scheme not least because it had yielded no inscriptions, so his primary aim was to seek dating evidence for that earthwork. His initial position was that the Vallum was earlier than the Wall. In this he was reverting to the belief prevalent before Hodgson.

In his first year, 1894, he did little more than feel his way, sectioning the Vallum and learning about its structure (Haverfield 1895). The second season, however, produced something entirely different, a new Wall. In his *History of*

Northumberland published the same year, 1895, the wonderfully named, and rather rich, Cadwallader Bates had prophesised the existence of a Turf Wall lying underneath the visible Stone Wall throughout its entire length (Bates 1895: 28-29). In his work at Appletree, to the west of Birdoswald, where the Turf Wall and its later replacement in stone run on different lines, Haverfield had noted the existence of an extra ditch between the Vallum and the Wall and, with the recent discovery of the small ditch in Germany in mind, he sectioned it. His long trench also embraced the rampart of the Turf Wall which, however, he failed to recognise. Both he and his workmen denied that the visible three or four black lines were other than natural and it took all Bates' perseverance to encourage Haverfield to excavate more trenches before he and his workmen accepted the discovery (Haverfield 1896: 187-9). Haverfield's subsequent excavations failed to find any other section of the Turf Wall, so that remained a problem for the future.

In his third season, Haverfield pursued his exploration of the Vallum and was forced to admit through work at Birdoswald and Carrawburgh forts that 'the Stone Wall, forts, and Vallum are of the same age', a complete reversal of his earlier position and vindication of John Hodgson's 1840 conclusion (Haverfield 1897: 418-420) (Figure 30). At Chesters no Turf Wall was found below the Stone Wall. Haverfield's later investigations at Birdoswald and Chesters demonstrated that the Wall ditch ran below the visible forts, a useful complementary discovery to Gibson's observation on the milecastles and forts belonging to different plans, though this was not realised at the time. Haverfield introduced an entirely unhelpful suggestion, that there had been an early series of small forts attached to the rear of the Wall which were later extended northwards over the Wall ditch (Haverfield 1901: 87-88).

Haverfield's remaining seasons did not produce any more spectacular results and rather ran out of steam. The great man felt that he had met his aims. He did more than that. He introduced a question-and-answer approach to Wall studies. He identified hitherto unknown elements. He laid the foundations for understanding the chronology of the building of the Wall. Haverfield maintained his fruitful correspondence with colleagues in Germany which was to pay dividends. Yet, he was conscious of the different approaches between archaeologists on each side of the North Sea, a difference which exists to this day. He did, however, leave one major problem, the date of the Stone Wall.

Cadwallader Bates had argued that the Turf Wall stretched from sea to sea and had been built under Hadrian. Haverfield cautiously pointed out that it had only been found at Birdoswald (Haverfield 1899: 342-343), but he was drawn to the idea that Severus rebuilt the Wall in stone, together with enlarging the forts and repairing other structures. Again, he had reverted to a pre-Hodgson position.

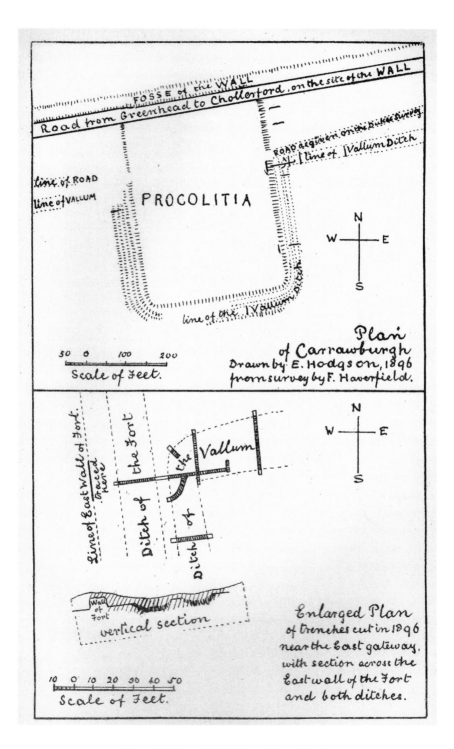

Figure 30. Haverfield's plan of Carrawburgh

If Haverfield was not entirely successful in his aspirations, the reason was largely because scientific archaeological excavations were in their infancy. His trenches were too narrow, his experience too limited, and I suspect his intuition too little developed, at least that is what a comparison between his reports and those published in parallel by one of his team, Mrs Hodgson, suggests for she understood and described what had been discovered better than Haverfield (Hodgson 1897; 1898; 1899).

A new partnership: J.P. Gibson and F.G. Simpson

Haverfield's last season on Hadrian's Wall was in 1903 and his interests turned elsewhere. Gibson, however, remained to take the study of the Wall forward. In 1907 he started a collaboration with F.G. Simpson which was to yield handsome dividends. Simpson was a marine engineer by training who acquired an interest in Hadrian's Wall while working in Newcastle (his daughter, Grace Simpson, chronicles his life and work in Simpson 1976: 1-23). His meticulous excavation plans reflect his background. In 1907 he joined Gibson in a project to examine sites on the Stanegate, the road behind the Wall running from Corbridge to Carlisle. They excavated the small fort at Haltwhistle Burn and determined a pre-Hadrianic date for its occupation, a most useful piece of information in later considerations of the genesis of the Wall (Gibson and Simpson 1909 (Figure 31).

Success eluded them when they sought the point where the road crossed the Poltross Burn on the Northumberland/Cumberland border. They decided instead to excavate the adjacent milecastle, now known as number 48. The excavation was remarkable. The whole of the enclosure was excavated, the structures were described, drawn and photographed in detail and the finds published in relation to their layers (Figure 32). The periods of occupation identified at the site were assumed to relate to the whole of the frontier (Gibson and Simpson 1911).

Gibson and Simpson's first period of occupation of the milecastle was divided into two phases, A and B, the gap reflecting the abandonment of Hadrian's Wall during the occupation of the Antonine Wall starting in the 140s (Table 1). This first main period ended in destruction. The excavators assigned this to the crossing of the Wall in the early 180s under Commodus which was

Period	Dates	
	Forts	Milecastle 48
I	c. 120-180	c.120-180
II	180-	180-270+
III	-368	before 300-330?
IV	370-383	

Table 1. The periods of Hadrian's Wall as stated by Gibson and Simpson in 1911

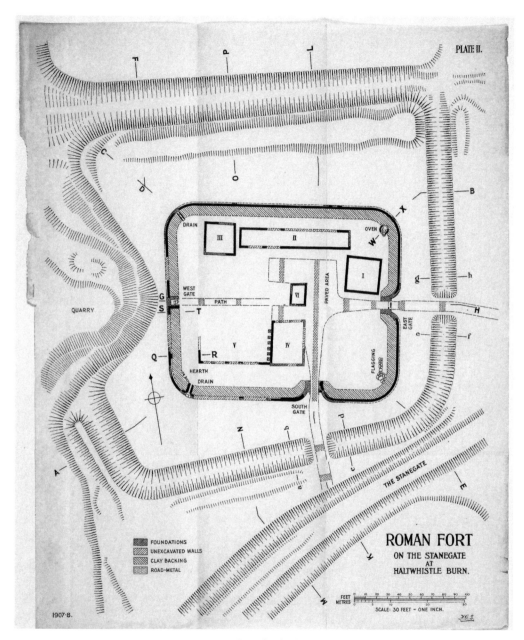

Figure 31. Simpson's plan of Haltwhistle Burn small fort

the prevailing orthodoxy. The destruction at the end of the second period was dated by the coin evidence to 270+. The third period started before 300 and the milecastle was abandoned as early as 330. This surprised the excavators as they knew that the occupation of the forts continued after the Barbarian Conspiracy of 367 ending in 383.

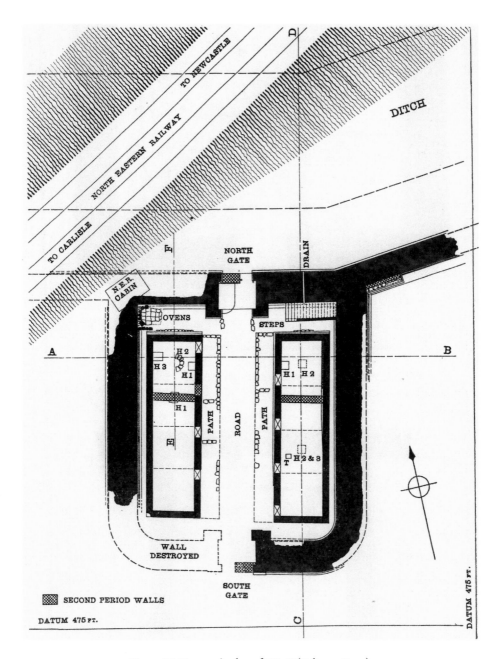

Figure 32. Simpson's plan of MC 48 (Poltross Burn)

What is also important for our story is that the milecastle was built in stone under Hadrian and no Turf Wall was found below it. Poltross Burn milecastle lay just east of the river Irthing. The collaborators next turned their attention

to following up Haverfield's work on the Turf Wall to the west of the Irthing, investigating the Turf and Stone Walls at Appletree which had been identified in 1895. They excavated a milecastle and three turrets on the Stone Wall and, through examination of the pottery, determined that the replacement of the Turf Wall by a stone wall in that sector occurred under Hadrian. This was the definitive rebuttal of Haverfield's argument the Stone Wall was Severan in date. Finally, the pre-Hodgson interpretation had been laid to rest, the Wall was Hadrian's after all.

What were the key results of these two decades of work by these three men, Gibson, Haverfield and Simpson? John Hodgson's 1840 assertion that the Wall, its forts and the Vallum were all one scheme created under Hadrian was confirmed. It was found that part of that Stone Wall, dated by him to Hadrian's reign, had a predecessor constructed in turf also Hadrianic in date and that at least part of this Turf Wall was replaced in stone during Hadrian's reign. The Vallum was later than the forts, though arguments about its purpose continued.

The other main triumph was the establishment, through the excavation of MC 48 (Poltross Burn), of a chronology for the history of the Wall which still has a relevance today. Also interesting was Gibson's astute observation that there were two separate plans for the Wall. This was supported by Haverfield discovering that the Wall ditch ran underneath two of the forts, Chesters and Birdoswald. Gibson and Simpson's excavation of the small forts at Haltwhistle Burn and Throp laid the foundations for an understanding of the precursors to the Wall. Much had been achieved.

Inter-war investigations

In 1914 the First World War broke out. Gibson had died in 1912, Haverfield followed in 1919. Into their place stepped R.G. Collingwood. Collingwood was a member of a charmed circle. A northerner, he was born in the Furness district of Lancashire, the son of W.G. Collingwood, amanuensis to John Ruskin. W.G. was an artist, son of an artist, an author, an archaeologist and a historian. After the end of the First World War he designed war memorials in the form of Celtic crosses which were widely admired. The Collingwood family was cosmopolitan. R.G.'s grandmother was Swiss, his sister married the Armenian surgeon Ernest Altounyan and their children were the models for Arthur Ransome's *Swallows and Amazons*; R.G.'s first wife was the sister of Angus Graham, former Secretary of the Royal Commission on the Ancient and Historical Monuments of Scotland. R.G. started his archaeological career in Cumbria before the First World War and in 1912 was appointed to a fellowship in philosophy at Oxford, in 1935 being adlected to Professor of Metaphysical Philosophy.

It was in 1921 that Collingwood burst onto the Wall scene with two papers. They were of very different natures. 'The Purpose of Hadrian's Wall' was a short article in an obscure journal in which he reviewed the evidence for the operation of the Wall and the style of fighting of the Roman army concluding that the purpose of the Wall was not defensive but that it served as an elevated sentry walk (Collingwood 1921a). The second, much more substantial, appeared in the *Journal of Roman Studies* (Collingwood 1921b). This was a review of the physical remains, the evidence provided by the literary sources, the theories offered since the Renaissance, and finally the evidence of excavations. It was also a manifesto. Collingwood stated the problem: what is the relative chronology of the Stone Wall, the Vallum and the forts? a question which could only be answered by digging. His paper also marked a change in approach to the provision of information. Hitherto, if an interested party wanted to know the current view of an aspect of Hadrian's Wall, they had to turn to the discussion section of an excavation report. Now Collingwood started a new trend, the provision of decennial statements. He did the same with the Pilgrimage of Hadrian's Wall, in 1930 producing a handbook in advance rather than relying solely upon subsequent reports of the event; and he created the numbering system for the structures still in use today (Collingwood 1930; 1931; 1933). His approach was a step change, bringing the study of Hadrian's Wall to a wider audience, but in a different way from that adopted by Bruce.

It may be felt that my discourse on Collingwood's background and his family rather superfluous to an account of Hadrian's Wall, but it is not. Collingwood's paper on 'Hadrian's Wall. A history of the problem' marks the dawn of the 'age of certainty', though 'arrogance' might be a better term. It is reflected in the language he used in his paper: Stukeley's scheme is imaginary; Horsley's theory was condemned by its own impossibility; Bates's proposed chronology was fantasy, and so on. The judgements are handed down from Olympus, or rather from Oxford.

There is one further point to note. Collingwood sketched out what he perceived to be the sequence of building the Wall (Collingwood 1921b: 59-66). In this scheme, the first plan was for a series of small forts like Great Chesters built across the isthmus in front of the Vallum which diverged round them to the south. In the face of raiding and smuggling, some forts were enlarged. Then Hadrian arrived and decided to build the Wall. This interpretation took account of the fact that the curtain wall abutted several forts like Housesteads and Chesters (Figure 33).

After he had elaborated his theory, Collingwood concluded, 'such has been, if I have followed it correctly, the argument which has worked out itself during

Figure 33. The north-west corner of Housesteads fort showing the curtain wall
butting against the fort wall

recent years in the mind of Mr. Simpson' (Collingwood 1921b: 66). In other words, the interpretation is not that of Collingwood, the theorist, but of Simpson, the excavator. Although Collingwood stated that the 'new theory appears to combine the merits of its two predecessors and promises to satisfy, for the first time, all the terms of the problem', he was not to be proved right.

On the ground, there was industrious activity. From now on, work on Hadrian's Wall continued on two parallel paths, one research excavation, the other rescue. The main threat was improvements to roads. This led to excavations at turrets, milecastles and forts providing

Figure 34. The Hadrianic inscription found at
Halton Chesters (*RIB* 1427)

much useful information, including new inscriptions, which would help in the details of understanding the building the Wall (Figure 34).

Simpson was involved in many of these excavations, but at the same time he retained his keen interest in solving the main issue, the relationship between the various elements of the Wall. An unfortunate season at Great Chesters took place in 1925 (Hull 1926). The results were over complicated, with the problems compounded by heavy rain and then Simpson's illness. These led to the abandonment of further work at the site and in 1927 Simpson turned his attention to the Birdoswald sector and started the campaign of work which would continue for the next nine seasons (published in *Transactions of the Cumberland and Westmorland Antiquarian and Archaeological Society* 28 (1928) – 36 (1936)).

Over that decade Simpson, joined by Ian Richmond in 1928, concentrated on investigating the eastern five miles of the Turf Wall and through that solved many of the problems relating to the building of the Wall. They worked at a hectic pace, producing what was little more than an interim report each year; interim, because but for the occasional instance none of the reports were accompanied by an account of the finds. Lindsay Allason-Jones, Ian Caruana and Derek Welsby have sought to remedy the deficiency by publishing what material does survive. Because these were interim statements, with the interpretations amended at the end of each season, we have no final report, just their views on what they had discovered when they turned aside to other sites. In addition, the excavated areas became smaller as they decided that all they needed to do was to sink a test pit at a turret in order to check their predetermined conclusions.

Their discoveries were significant. They excavated the Turf Wall and learnt about its superstructure. They confirmed that the milecastles on the Turf Wall were of turf and timber. The existence of a specific Turf Wall type of turret was recognised (Figure 35). The relationship between the stone milecastles and their turf and timber predecessors was investigated. The chance discovery of the fragment of a timber inscription at MC 50 TW demonstrated that it was built under Aulus Platorius Nepos, the governor of Britain from 122 (*RIB* 1935). They identified two phases in the replacement of the Turf Wall in stone (Figure 36). They appreciated that the points of reduction at turrets and milecastles indicated a narrowing of the Wall during its construction. They confirmed that the forts were an addition to the original plan. They confirmed that the Vallum was later than the Wall for the tightness of the landscape at MC 50 TW led to the Vallum approaching so close to the Wall that it had to diverge a short distance round the milecastle with the north mound omitted (Figure 37). Simpson and Richmond had rightly seen this sector as the key to understanding the sequence of building the Wall.

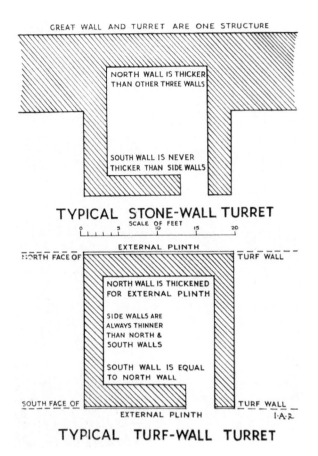

Figure 35. Stone Wall and Turf Wall turrets, drawn by I.A. Richmond

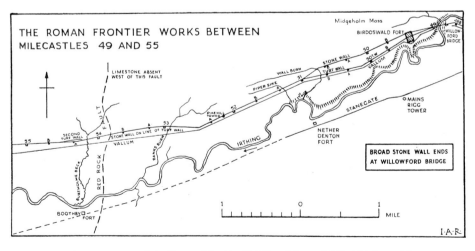

Figure 36. Map of the lines of the Turf Wall and Stone Wall at Birdoswald,
drawn by I.A. Richmond

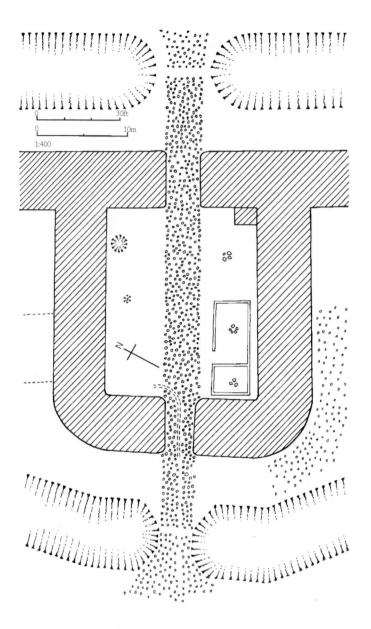

Figure 37. Plan of MC 50 TW, drawn by I.A. Richmond

Simpson and Richmond continued up to the outbreak of the Second World War, discovering a milecastle below the fort at Great Chesters, which helped to explain what had defeated Simpson in 1925, and then immediately after the war turrets below Chesters, Housesteads and Birdoswald (Richmond 1950) (Figure 38). They now realized that the first plan for the frontier called for a linear barrier, fronted by a ditch, with a small fortlet known as a milecastle at every

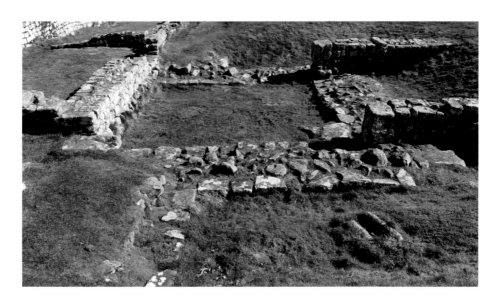

Figure 38. Turret 36b (Housesteads) recessed into the curtain wall looking east;
the higher walls date to the 4th century

mile with two turrets in between, a pattern only discovered in the 1880s. In the second plan, forts were added to the Wall, an action which required the obliteration of stretches of Wall, turrets and at least one milecastle. About the same time but certainly afterwards, a great earthwork known as the Vallum was constructed to its rear. It was also appreciated that the addition of the forts to the Wall – the fort decision – led to changes to the first plan including the narrowing of the Wall. Here, as in other aspects, it was the steady accumulation of details which allowed its building history to be better understood. It was, for example, appreciated that there were different sets of building signatures for milecastles and that these could be assigned to different legions.

The other result of work at Birdoswald was the unearthing in 1929 of two inscriptions which led to a tweaking of the periods of occupation of the Wall (Figure 39). The first recorded the restoration of a granary in the fort in 205-8, the second to the restoration of the commanding officer's house, the headquarters building and the bath-house a hundred years later (*RIB* 1909; 1912) (Table 2). These were seen as definitive dates for the end of Wall periods I and II. The first destruction of the Wall was moved from its traditional date in the early 180s and related to the bid for the empire by the governor of Britain Clodius Albinus in 197

Period	Dates
IA	c.120/125-c.140
IB	158-c.195
II	200/205-295
III	297/300-368
IV	370-c.383

Table 2. The periods of Hadrian's Wall as stated by Birley in 1930 and accepted by Simpson

Figure 39. The excavation at Birdoswald in 1929, from left to right John Charlton, Eric Birley, a student, F.G. Simpson, a student, Kurt Stade, Shimon Applebaum, R.G. Collingwood; the photograph was taken by I.A. Richmond

(Birley 1930). It was argued that he withdrew troops from the Wall to strengthen his army thereby allowing it to be sacked by the Caledonians and the Maeatae. The end of the second period in about 300, but which had not previously been dated, was linked to another abandonment of the Wall when troops were withdrawn to defend the breakaway British state from the central authorities seeking to re-establish imperial control in 296. Again, an abandonment of the Wall was postulated which led to invasion and destruction.

Now, while there was recorded trouble on the northern frontier in 197, when the new governor had to purchase peace from the Maeatae and the Caledonians, no attack on Hadrian's Wall is mentioned in our literary sources, unlike in the early 180s when it was recorded that the 'tribes in the island crossed the Wall that divided them from the Roman forts, doing much damage and killing a general and the troops he had with him' (Cassius Dio, *History of Rome* 72, 8, 2). However, a gap of 20 years between the 180s invasion and the rebuilding of the Wall, as evidenced by the inscription of 205/8, was regarded as too long so, in essence, an invasion in 197 was invented. Nor was there any literary evidence for an invasion in 296, merely an assumption that the renegade emperor in Britain had withdrawn troops from the Wall which had led to an attack and the destruction of Birdoswald which in turn led to the necessity to restore several buildings.

In 1950 Richmond published the fourth of a series of reviews of work on Hadrian's Wall. He opened with the statement that 'in the annals of archaeology on Hadrian's Wall the decade 1929-1939 will always stand out as the time when the principal periods in the history of the monument were firmly fixed and the complicated relationship between its component parts was securely defined' (Richmond 1950: 43). Note the use of 'firmly' and 'securely'; the new orthodoxy had been promulgated and it was not up for challenge.

Was there a downside to these years of disciplined research? We have already noted Haverfield's question-and-answer approach. This was followed by Gibson and Simpson who sought to understand the military installations on the Stanegate, and then the implications of the discovery of the Turf Wall. Simpson continued this approach in conjunction with Richmond from 1928, with Collingwood elevating this type of investigation to an almost moral level (Collingwood 1931: 61-63). The central, crucial problem though was that once this core group had answered their own questions, they considered the job done. And more than that, they were believed. For archaeologists the Wall periods became a straitjacket which stultified new thinking. The pace of research slowed and changed. Archaeologists working on the Wall found it difficult to create a new research programme and it is difficult for us looking back to discern a pattern to their field work. Planners saw no reason to fund

excavations. When the West Road leading out of Newcastle was widened in the 1960s little archaeological investigation took place I believe because the words of the eminent archaeologists of the 1930s had been heard and believed: the problems of Hadrian's Wall had been solved.

In all aspects we are creating our hypotheses on slender bases. Paul Bidwell has emphasised how little of Hadrian's Wall has been examined through excavation (Bidwell 2009: 40). Today, over 90% of its fabric is not visible, and only just over 5% has been consolidated and put on display. To take some examples. Simpson and Richmond examined milecastles and turrets in the eastern five miles of the Turf Wall in some detail, venturing only a little to the west in order to locate some turrets before deciding to confirm their conclusions by jumping over the next 20 miles to undertake a few investigations at the west end of the Wall. As a result, we know very little about the Wall itself and its installations from MC 54 through the 25 miles to MC 79 and we cannot even place most of the installations on a map.

The excavations themselves were focussed on the military remains; very rarely did any excavator look beyond their walls. There were clear hints that there was something beyond those walls: a temple at MC 19, for example, but only geophysical survey in recent years has demonstrated the existence of extra-mural structures (*RIB* 1421: Biggins *et al.* 2004). Our ignorance prevents us from placing the lives of the soldiers in these milecastles and turrets into their local context.

The hypothesis of the periods of occupation of the Wall was also based on slender evidence. Gibson and Simpson created a scheme, founded on the excavation of one milecastle, and the random evidence of a few other sites. The 1929 Birdoswald model rested upon two inscriptions which may have related to that fort only. Thereafter, not only was all new evidence squeezed into that straitjacket but the histories of other sites were re-written to fit into the new orthodoxy and guide-books suitably amended. More than that, archaeologists excavated on the basis that they knew what they would find, stratigraphical events which would neatly slot into one or other of the Wall periods.

New heresies

Of course, models do not last for ever. We have already seen that the 40-year reign of John Collingwood Bruce produced tensions towards the end of his long life. The issue was not so different in the case of the theories promulgated as a result of the campaign which started in 1892 (Breeze 2014a: 147). Richmond was only 34 when he decided that the main problems of Hadrian's Wall had been solved and started to excavate away from the Wall. For half of the decade

he was at work on the Wall he was holding the prestigious post of Director of the British School at Rome. He went on to a professorship at Newcastle and then Oxford. He published the Roman Britain volume in the Penguin history of Britain series. And he never appears to have changed his mind even when an error was pointed out to him.

Eric Birley was only 23 when he announced the new dating for the Wall in 1929, in the report on his own excavations elsewhere on the Wall, leaving the nominal director of the excavation at Birdoswald, Simpson, subsequently to issue a statement of agreement (Birley 1930: 164-174; Simpson 1930: 202-204). Birley never changed his position and to challenge it was dangerous. He succeeded Richmond as Professor of Archaeology in Durham.

The authority of Richmond and Birley was such that their views held the field for decades. All new information was slotted into their chronology for the history of the Wall, known in shorthand as the 'Wall periods'. The straitjacket was gradually tightened. What was initially conceived as an attack on the Wall became a major incident affecting the whole of the north of the province. In 1947 Richmond wrote that 'on the defeat [of Albinus] the barbarians had broken in, finding forts and fortresses virtually empty. This explains the systematic devastation not only on the Wall but as far south as York and Chester, involving the deliberate overthrow of walls and gateways on a vast scale' (Richmond 1947: 6, following Birley 1930: 167). Quite a melodramatic description. No one seems to have asked why the northern tribes would want to knock down Hadrian's Wall rather than follow the usual pattern of obtaining loot and captives. Meantime, imprimatur for the new interpretations came from above when Mortimer Wheeler stated that 'Hadrian's Wall ... has long ceased to matter as a major historical problem' (Wheeler 1961: 159).

It was from Birley's pupils that the challenges to the 1929 orthodoxy first came. John Kent was the first in the field in 1951, demonstrating from the coin evidence that the occupation of Hadrian's Wall continued into the 5th century (Kent 1951). Yet, nearly 70 years later, one can still buy a post card of the Wall stating that its life ended in 383 (Figure 40).

As so often happens, the main challenges to the earlier orthodoxy arose from excavations. An early challenge was from Michael Jarrett who concluded, on the basis of his excavations at Halton Chesters, that the occupation of that fort did not fit into the accepted scheme. The excavations were undertaken in the late 1950s, but his first dissent was not published until 1967 and then in German in a German journal (Jarrett 1967). Here was an echo of the last years of Bruce 80 years before when the initial challenges to his views in print came, not from

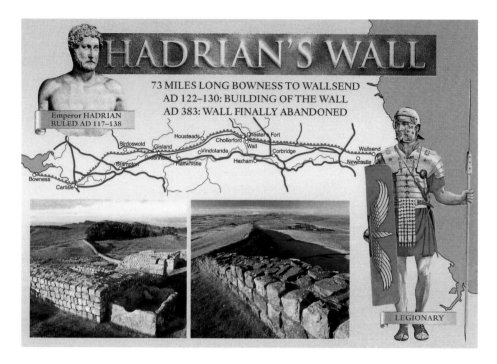

Figure 40. Postcard of Hadrian's Wall

Newcastle, but from Glasgow, Oxford and Berlin. Jarrett's crucial point was that the evidence from each site must be treated on its own merits and not squeezed into a preconceived framework.

The second major challenge was a result of excavations at Mumrills on the Antonine Wall from 1958 to 1960 by Kenneth Steer (Steer 1960/61). Three different types of pottery from the same deposit were examined by three different specialists, with two different dates offered. The samian ware was dated to 150-160, with a similar date given for the mixing bowls; the date assigned to the coarse pottery, however, lay in the period 170-85. In the immortal words of the coarse pottery specialist, John Gillam, there was a rabbit away somewhere. The report was published in 1963 but it was another decade before the discrepancy in the dating was tackled. It was Gillam who rethought his position, bringing his dating forward to fit in with the other evidence (Gillam 1974: 6-12). This was a direct challenge to the 1929 chronology, nor did it meet with universal approval. One professor declared the re-dating impossible because it would leave a typological gap in the pottery sequence for the period 180 to 200 (Frere 1987: 176-177, n. 4).

The momentum built up during the 1960s and into the 1970s, the key figure being John Gillam (Dobson 2008). The debate took place in seminars and publications,

aspects of the Wall long considered fixed in stone being challenged. In 1972 Brian Dobson offered his first analysis of the function of Hadrian's Wall, a subject hitherto rarely tackled (Dobson 1972). In 1976, Brian Dobson and I published our *Hadrian's Wall* (Breeze and Dobson 1976) (Figure 41). Today this may seem just another book on Hadrian's Wall, but it is actually the first book to have been published on Hadrian's Wall which was not essentially a guide-book. It broke the previous models, not by directly challenging them, but by presenting the evidence and our own conclusions drawn from it (Hodgson 2008: 11 described it as 'revolutionary'). Yet the publication was not without its own challengers. I was told that 'the time had not yet come to write a history of Hadrian's Wall'. Nor, of course, have all our colleagues working on Hadrian's Wall accepted all our interpretations. It may be noted that the Wall periods still featured in the 13th edition of the *Handbook to the Roman Wall* by Charles Daniels published two years later in 1978, and 197 for the destruction of Hadrian's Wall is still in the 4th edition of Frere's *Britannia* last reprinted in 2002 (Daniels 1978; Frere 2002).

Figure 41. The cover of *Hadrian's Wall* published in 1976

When it came to the building of Hadrian's Wall, the field was more open to debate. The sequence of phases in the building process has been largely accepted since the 1930s. Perhaps two aspects in particular have provoked detailed treatment. One was the implications of the centurial stones, those simple building stones slotted into the faces of the Wall to mark the work of centuries, cohorts and legions. C E. Stevens made a spirited attempt to make sense of them, but I suspect the main reason why his thesis was not fully accepted is that it was based upon too little evidence (Stevens 1966). Most of the centurial stones are from the central sector of the Wall the building of which was disrupted following the decision to add forts to the Wall. The paper by Joyce Hooley and myself in 1968 took the discussion in another direction, building upon the many observations of the various types of structures which allowed allocation of them to different legions, and through that a sort-of blue print for the plan for building the Wall was laid out (Hooley and Breeze 1968).

The second main area of continuing discussion is the Vallum. In spite of the seemingly obvious evidence that the Vallum was planned and executed after the fort decision, not least because it deviates round the forts, there remain attempts to argue that it was part of the original plan. I hope that the work of John Poulter on how the Wall was surveyed has put an end to this. He argues that the Vallum was laid out from the forts, thereby emphasising their prior existence (Poulter 2009: 74).

Poulter's work is significant in another aspect. About 12 years ago, after a conference, I said to John, who I knew was interested in surveying, that it must be possible to work out which way Hadrian's Wall was surveyed. We always talk about it changing direction on high points, but these points are generally not sharp triangles but whaleback in shape, thus a surveyor working from the east will change direction on the western end of the whaleback, and vice versa. John was not only able to answer the question but went far further. His conclusions were that 'long-distance alignments appear to have been set out first, and then deviations set out from these alignments where necessary to meet local objectives, such as the crossing of rivers' and that 'the directions of setting out seem to have been inwards from the extremities towards the crags' (Poulter 2009: 73). He also asserted that to the east and west of the crags, the Wall was not placed on the northern edge of the ridge or plateau along which it runs but the southern edge as if to aid the soldiers retaining contact with the military installations in the valleys to the south (Poulter 2009: 78). The implications of this for our understanding of the purpose of the Wall will be explored in the next chapter (Figure 42).

John Poulter has been able to demonstrate what a dedicated individual can still achieve. Until about 1970 most surveys and excavations remained small-

Figure 42. John Poulter's diagram showing the position of Hadrian's Wall in the landscape

scale, still often funded by the Durham University Excavation Committee which ceased its programme of work on Roman sites in the 1970s. Their excavations had run in parallel with the consolidation work of the Ministry of Works which started in 1933 at Corbridge (Leach and Whitworth 2011: 72). Soon, however, the Ministry team started clearing stretches of Wall and its structures, all without professional archaeological supervision, an approach which continued until the excavation of Sewingshields in 1978. At about the same time, the National Trust employed Jim Crow to excavate the stretch from Housesteads to Steel Rigg in its care in conjunction with consolidation, which led to the discovery of a new tower in Peel Gap (Crow 1991: 55). Before that, the Ministry had started a programme of excavation and display at Housesteads which ran from 1959 to 1981. The third element is more recent, cultural resource management, the examination of installations in order to determine their state of survival and thereby determine whether intervention measures were required (Wilmott 2009: 137-202).

The major changes came in the 1970s when large-scale redevelopment and the establishment of professional units coupled with what one might call tourism archaeology were to revolutionise the world of archaeology. Clearance of the houses in the northern third of the fort at South Shields in 1966 and 1967 was accompanied by excavation and followed by the campaign which has continued to this day (Dore and Gillam 1979: Bidwell and Speak 1994). Nearly the whole area of the fort at Wallsend was cleared of buildings in the 1970s, allowing Charles Daniels extensive areas to investigate. These two excavations have provided considerable information on the details of the planning and history of the forts (Hodgson 2003; Rushworth and Croom 2016). Tony Wilmott's first campaign at Birdoswald commenced in 1987, with the most important results relating to the later history of the fort (Wilmott 1997). The excavation and presentation of archaeological sites places most of the cards in the hands of others than archaeologists. Nevertheless, there is one project which shows us

what tourism archaeology in the hands of archaeologists can achieve, namely Vindolanda.

Finally, we may note a new approach to finds. The poor record of publication of the finds and pottery from the smaller structures of the Wall, already noted, has been replaced by detailed analysis. Lindsay Allason-Jones has led the way with the integration of small finds into discussions about the occupation and the operation of Hadrian's Wall (e.g. Allason-Jones 1984: 1988). This has brought into play a new category of evidence of material value in helping us grapple with the question of how the Wall worked.

In archaeology, the minutiae are important. It was through this observation of details that we can understand the changes which occurred to the Wall at several stages during its construction. These are not recondite facts but are pregnant with meaning. We can observe the changes; the next step is to seek the reasons for them, and thereby hope to understand the function of Hadrian's Wall and the way that it operated.

The purpose and operation of Hadrian's Wall under Hadrian

The great achievement of the two generations of archaeologists who worked on the Wall from 1892 until 1939 was that they disentangled the relationship between the different elements. In that way, Richmond and Wheeler were right to state that they had solved the great problems of the Wall. The signal advantage of their work was that it opened up possibilities for wider discussions on the operation of the frontier. In their work, and in our interpretations, we have all been helped by the fact that on Hadrian's Wall all the various elements touch each other at some point so that relationships could be perceived and thereby a sequence of actions could be determined. The next step was to consider the reasons for these changes and their implications. In this way, we can approach an understanding of the purpose, function and operation of Hadrian's Wall. The crucial point is that only archaeology can provide the answers.

The first plan for Hadrian's Wall

When the Wall was first planned, there was in existence a line of forts in the main river valleys of the Tyne-Solway isthmus linked by a road which we call by its medieval name the Stanegate (Figure 43). The road ran from Corbridge, then the lowest crossing point of the Tyne, to Carlisle, similarly placed on the Eden (Breeze and Dobson 2000: 16-24). Along this road lay a series of forts, seemingly all established in the late 1st century, Corbridge, Vindolanda, Carvoran, Nether Denton, and Carlisle (Figure 44). This was not a frontier line as other forts lay to the north. In the two decades after 103-105, when troops appear to have been withdrawn from more northerly forts, new military installations were placed

Figure 43. Map of the forts on the Stanegate

along this line. There was at least one fort, at Brampton Old Church, two small forts at Haltwhistle Burn and Throp and several towers which presumably acted as observation posts (Figure 45). To the west of Carlisle it would appear that a fort was now added at Kirkbride on the southern shore of the Solway Estuary. We know of no fort east of Corbridge apart from the undated site at Washing Well, Whickham, which faced east not north. The plan was not only to add Hadrian's Wall to this existing line of forts and other military installations but also extend it eastwards to the lower Tyne, possibly at Newcastle rather than Wallsend at this stage.

In the first scheme for Hadrian's Wall, there was to be a Wall from the Tyne to the Solway (Figure 46). From the Tyne to the Irthing it was to be built of stone and from the Irthing to the Solway of turf. In front, was a substantial ditch, except where the crags or the Solway made its digging unnecessary. At every mile there was to be a small military post, a milecastle in our terminology, through which access across the frontier could be obtained. In between each pair of milecastles were two towers, in our terminology turrets. Their spacing implies the existence of a tower over the north gates of the milecastles. The pattern of

Figure 44. The fort of Vindolanda on the Stanegate looking west. The straight line of the Stanegate is marked by field boundaries; the Wall lies on the ridge to the right

milecastles, called milefortlets, and turrets, referred to as towers, continued beyond Bowness-on-Solway for for about 40km (25 miles) down the Cumbrian coast though without a barrier.

The most striking feature of Hadrian's Wall was its size. A massive 10 Roman feet wide, the stone sector was unique, being at least twice the width of every other known Roman stone frontier barrier (Bidwell 2008a: 130-133) (Figure 47).

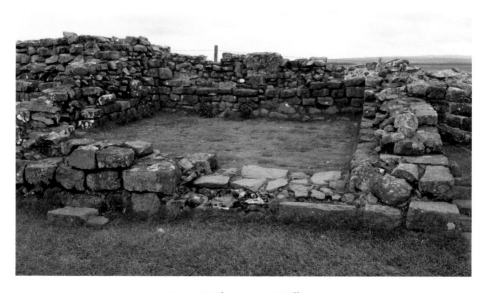

Figure 45. The tower at Walltown

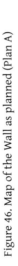

Figure 46. Map of the Wall as planned (Plan A)

The turf section, however, at 20 Roman feet wide, was a more reasonable width, comparable to the turf ramparts of forts which averaged 18 feet / 5.5 m wide (Jones 1975: 71). How to account for the considerable width of Hadrian's Stone Wall remains one of the continuing debates about the frontier.

Until 1921, there was no discussion of this issue for it was universally assumed that Hadrian's Wall was defensive and therefore topped by a wall-walk. In the first edition of *The Roman Wall*, Bruce wrote of a battlement along the top (Bruce 1851: 49). R.G. Collingwood in 1921 acknowledged the hitherto accepted view, that the Wall was seen as 'a military fortification like the wall of a town, designed to repel or at least check invading armies, not in this case, attacking the outskirts of any mere city but those of a province. The Roman troops have always been imagined lining the top of the Wall and from behind the parapet, entrenched as it were on the rampart-walk ..., repelling the attacks of Caledonian armies that attempted to carry the work by breach or escalade' (Collingwood 1921a: 4). Collingwood set out to challenge that view, and his argument remains relevant, as is demonstrated by Edward Luttwak in his *The Grand Strategy of the Roman Empire* (Luttwak 2016: 67-89).

Figure 47. Sections through Roman linear barriers: A. Hadrian's Wall; B. the clausura
in Tripolitania; C. conjectural reconstruction of the Raetian Wall; D. a section of the
wall in Upper Germany; E. a reconstruction of the Alpium Iulianum

Collingwood argued that the Roman soldier was not equipped to fight from
a defensive position. Provided with two spears and having thrown them, the
soldier 'would be simply put out of action' (Collingwood 1921a: 4-9). At this time,
Collingwood stated, there were practically no archers in the Roman army. Modern
specialists in Roman weapons allow for training in archery but accept that it was not
a major element in Roman military tactics at this time. Only one milecastle and two
towers have produced arrowheads. Spearheads are few in number, throwing stones
and sling shot even rarer. Of course, it is possible to argue that many turrets did not
have a long life, that soldiers took their weapons with them when they moved on,
that they were too valuable to lose, were recycled, or lie unrecognised in museums,
but the basic evidence is clear enough: little by way of military equipment has been
recovered from the smaller installations along the Wall (Coulston 1985: 283; Crow
1991: 61). And, it may be noted, only the fort at Housesteads on the Wall line is
known to have produced arrowheads and these date to the 4th century.

Collingwood accepted the existence of a rampart walk, though he saw it as an
elevated sentry walk. In 1969, John Mann challenged even that, pointing out
that there was no need for a sentry walk (quoted in Dobson 1972: 187). Indeed,
as we can see from other frontiers, not least the German palisade, that unless

Figure 48. A photogrammatic survey of the main gate of the fort at Gheriat el-Garba

the soldiers were in the Roman army acrobatic corps, they could not have patrolled along the top of the fence, even less fought from it.

Access to a putative rampart walk has rarely been discussed. We assume that access was through the turrets, but only two milecastles have produced any evidence for a stair. Bidwell has floated the idea of as yet undiscovered access points (Bidwell 2008a: 141). Recent work elsewhere, namely at Regensburg and Geriat-el-Garbia, has indicated that access from a gate tower to a fort's rampart walk was not always possible (Mackensen 2016: 90) (Figure 48). If this was the case at forts, can we extend it to Hadrian's Wall? Unfortunately, we will never know the answer to that, and to argue from a fort to a linear barrier is dangerous, but the evidence from these two sites challenges our assumptions and alerts us to other possibilities.

The existence of a wall-walk seems to be deeply embedded in our psyche. I suspect that there are two reasons for this: a fixation on medieval castle and town walls together with an assumption that Roman walls served the same purpose, which they did not; and a belief that a wide wall must have had a wall-walk. Luttwak has emphasised that a wall-walk on the top of Hadrian's Wall would have been 'too narrow to be a satisfactory fighting platform' (Luttwak 2016: 74). There seems to me to be little point in arguing about how wide a parapet would be required for daily use, but it is worth pointing out that if we are going to envisage a wall-walk we ought to consider not just a forward parapet but also one to the rear, bearing in mind that soldiers would be patrolling in the wind, rain and gloom some 15 feet / 4.5m above the ground, Such a wall exists in North Africa, though here the top was enclosed so that it clearly did not provide a fighting platform (Bidwell 2008a: 131-2) (Figure 47B).

The crucial question is, why was Hadrian's Wall so massive? The contemporary linear barrier in Germany was a stout fence, subsequently replaced by an

Figure 49. A reconstructed section of the German palisade; the timbers of the original were larger than these

earthen bank and ditch (Figure 49). It was manifestly impossible to patrol along the top of either. Other Roman frontier stone walls were all much slighter than Hadrian's Wall. Its unusual nature has led some to look further afield. C.E. Stevens suggested that Hadrian was inspired by travellers' tales of the Great Wall of China (Stevens 1955: 398-9). Jim Crow has proposed a closer influence, Greek long walls (Crow 1986: 725; 1991: 52-58; foreshadowed by Stevens 1955: 388). Hadrian was a Philhellene and would have been familiar with the Greek tradition of long defensive stone walls. To that may be added a further point. City walls were an aspect of urban life largely absent at that time in the western provinces of the Empire. As a result, when asked what sort of barrier he wanted, Hadrian would naturally have described what he already knew, not least Athens. Hadrian, of course, was interested in architecture and designed several buildings, and he was a man who knew his own mind and was not to be crossed. After a dispute, a philosopher once excused himself from correcting Hadrian by stating that you do not argue with a man with 30 legions at his back (*Historia Augusta, Life of Hadrian* 15.11). What Hadrian wanted, Hadrian got, and it is a reasonable assumption that in this case he wanted an unmistakable barrier (Figure 50).

Figure 50. A coin of Hadrian

But why did he want a barrier at all? Here we have to look at the construction of Roman artificial frontiers in a wider context. The largest extension of the empire since the time of Augustus occurred during the reign of Hadrian's predecessor Trajan. What we tend to forget is that Trajan sought to deal finally with two of Rome's old enemies, Dacia and Parthia, against which Julius Caesar had planned campaigns (Figure 121). For these wars Trajan had to plan carefully, not weakening one frontier too much in order to create the armies to fight on another. It should come as no surprise that the earliest linear barrier on a frontier occurred under Trajan when also the lower grade troops known as *numeri* first appear (Sommer 1999: 177-178). Hadrian continued the policy of protecting the frontiers but without seeking further expansion. We can see this as an acknowledgement of the realities of military and political life in which the continued expansion of the Empire was no longer a viable option. We might conclude that Hadrian underlined his policy by the creation of strong linear barriers, a palisade formed of great stakes in the case of the German frontier, so great as to be worthy of mention in ancient literature, and a massive wall in Britain.

There is another issue in relation to Hadrian's love of all things Greek, which is the contemporary attitude of some of the Greek intelligentsia. Appian of Alexandria practised law in Rome during the reign of Hadrian. In his *History of Rome*, written some years later, he stated that the Romans 'surround the empire with a great circle of camps' (Appian, *A History of Rome*, Preface 7). At the beginning of the next reign, the Greek orator, Aelius Aristides, delivered a speech in Rome before the imperial household in which he lauded the achievements of Rome. In this, he stated that the Romans had placed walls round the empire. 'An encamped army, like a rampart, encloses the civilised world in a ring', he declaimed, 'from Aethopia to the great outermost island towards the west', that is Britain (Aelius Aristides, *Roman Orations* 26, 80-84). Their statements were echoed by another Greek, Herodian, writing two generations later when he said that the Romans, 'fortified the empire by hedging it around with major obstacles, river and trenches and mountains and deserted areas' (Herodian, *History of Rome* 2, 11, 5). This perception found its physical expression in a sculpture of about the year 200 found in Rome which shows the imperial baton representing the imperial city surrounded by a wall and forts (Flügel *et al.* 2017).

These are the views which have come down to us from some members of the Greek elite: there were other such as Flavius Arrianus, who served in the Roman army and, in his case, wrote military treatises. We can only presume that the comments of Appian, Aelius Aristides and Herodian were shared by others and Hadrian, on his many visits to the Greek East, will have not only imbibed these opinions but, knowing the man, most likely have debated them with Greek philosophers. It would not be going too far to suggest that the Greek attitude to

imperialism together with the emperor's knowledge of Greek city defences may have lain behind his decision to protect the empire with walls as much as his appreciation of the manpower strains under which it was suffering.

Milecastles and turrets

To turn from the barrier to the installations along the frontier. There was a tower at every one third of a Roman mile and we therefore assume that there was one over the north gate of each milecastle so as to maintain a regular pattern (Figure 51). What was the purpose of these towers? They could be used as observation posts, bases for signalling, or perhaps simply for shelter. The generally accepted view has been that the turrets were provided for observation.

In 1989, David Woolliscroft brought a greater degree of sophistication to the table (Woolliscroft 1989). He noted that several milecastles were pulled slightly out of their measured spacing and argued that this was to allow the soldiers in their towers to retain contact with the troops in the forts behind the Wall on the Stanegate (Figure 52). This relationship was emphasised by John Poulter who pointed out that the Wall was not built on the forward slope of the ridges along which it runs, but on the southern edge so as to allow the soldiers in the towers to maintain contact with the military bases to the south (Poulter

Figure 51. Turret 7b (Denton) looking west

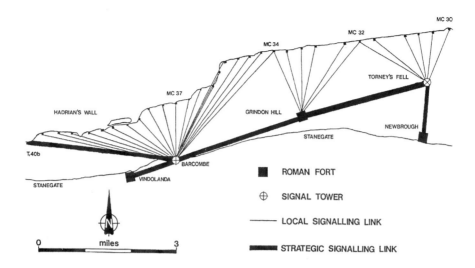

Figure 52. David Woolliscroft's diagram to illustrate communication on the Wall, the lines indicate the sightings between the installations on the Wall and those on the Stanegate

2009: 78-79) (Figure 42). The result of these observations is that we can now see the Wall in its original plan closely integrated with the existing forts to its south with the implication that the intention was to maintain a 24-hour watch. Hadrian's Wall was carefully planned.

Alberto Foglia has recently joined the debate. He has noted that the interval of 500 m between the towers is 'very close to the 450 m that is the maximum distance where military uniforms, and therefore friend / foe or civilian / militant, can be recognised' and concluded that their 'rigid spacing was probably designed to maximise the "resolution" of the observation screen' (Foglia 2014: 37, 43). It might be regarded that Foglia's conclusions damage the case for a wall-walk serving any purpose.

The milecastle not only provided a tower but also a gate through the Wall and protection for the soldiers on duty (Figure 53). The size of the two earliest milecastles to have been built, 47 and 48, appear to have provided sufficient accommodation for 32 men (Symonds 2013: 60-62). We do not know the source of these soldiers (Breeze 2003a). Each turret held perhaps 6, possibly 8, soldiers. The lower figure would have totalled 44 men each mile, 3500 for the whole Wall. Soldiers strung out along the Wall in this way were hardly a defence force. Mark Corby has informed me that a modern army would seek a defensive force of at least 200 infantry and 30 cavalry per mile. Instead, defence of the province lay in the hands of the army units based in the forts immediately behind the Wall and those further south in its hinterland. This distinction is of fundamental importance.

Figure 53. The north gate of MC 37 (Housesteads)

Frontier control

Collingwood distinguished between the role of the continuous wall and the role of a line of forts such as those on the Stanegate, 'for while the latter contained bodies of troops intended to cope with armed enemy forces, the continuous line was at first designed to serve simply as a mark to show where the Roman territory ended. With this primary function was combined the secondary function ... of being an obstacle to smugglers, or robbers, or other undesirables' (Collingwood 1921a: 9). Our appreciation of the linear barrier as an obstacle has been increased in the last decades by the discovery of pits on the berm in the eastern 20km of the Wall (Bidwell 2008b) (Figure 54). Each pit held two great posts, presumably the lower part of trees with sharpened branches, intended to impede the crossing of the frontier. Luttwak has emphasised that a linear barrier increased the reliability and effectiveness of surveillance by Roman soldiers and reduced the manpower required for protection against infiltration; the obstacle could be crossed, but not very quickly (Luttwak 2016: 75). The pits should be seen in this context.

Now, it might be thought to be totally over the top to build a barrier as massive as Hadrian's Wall to prevent smuggling, but there is no doubt that the Romans

Figure 54. The pits on the berm at Byker, Newcastle, looking east: the dark soil to the left
indicates the position of the ditch

liked to control access to their space. Fifty years before the building of the
Wall, during the Batavian Revolt of 69-70, a tribe living across the Rhine wrote
to their German compatriots who had seized Cologne to say that up to that
moment, 'the Romans have closed rivers and lands ... to keep us from meeting
together ... or to make us meet unarmed and almost naked, under guard and
paying a price for the privilege' (Tacitus, *Histories* 4, 64). Tacitus also recorded
the position of the Hermunduri north of the Danube, stating that as they were
loyal to Rome 'they were the only Germans who trade not on the river-bank but
inside the frontier ... they cross over at all points and without a guard. To other
people we only show our arms and our forts, to them we open our town houses
and country mansions' (Tacitus, *Germania* 41).

Moving a little later in time and further down the Danube, we are fortunate to
have details of four treaties between the Romans and their neighbours in the
170s and 180. These show that the Romans tried, not always successfully, to
force their neighbours to stay a certain distance from the Roman frontier. They
differentiated between the inhabitants of the neighbouring states, not allowing
some to attend markets in case they undertook spying activities (Cassius Dio,
History of Rome 72, 11). Finally, to these literary references we can add the
testimony of the travel permits on sherds of pottery, *ostraca*, from the Eastern
Desert of Egypt. These helped to control movement in the frontier zone. One

example will suffice: 'Q. Appius Optatus, to the four officers of the posts of the Claudianus route, let pass Asklepiades' (*O. Claud.* 48).

In the face of all this evidence for control, it is perhaps not surprising that the Romans erected the most secure form of control, a linear

Figure 55. A section of the East German frontier in the 1970s

barrier. People are still building these, in the United States, in Morocco, in Israel and across Europe (Figure 55). All these barriers are not to prevent the invasion of armies but the movement of individuals and the operation of modern bandits and raiders. This was surely the purpose behind the decision to build the linear barrier which was Hadrian's Wall.

Descriptions of military installations and their purposes rarely appear in the literary sources but inscriptions are more helpful. Inscriptions in modern Hungary records that in the 180s 'Commodus fortified the whole stretch of the river bank with towers built from the ground up and with garrisons stationed at suitable points to prevent surprise crossings by bands of bandits', that is, the Sarmatians living in the Great Hungarian Plain (*ILS* 8913) (Figure 56). It would be difficult to find a clearer description of the purpose of Roman frontiers.

IM P·CAES·M·AVR·COMMODVS·ANTONINVS
AVG·PIVS·SARM·GERBRT·PONMAX·TRIB·POT·
VI·IMP·IIII·COS·IIII·PP·RIPAM·OMNEM·BVRC·S
A SOLO EXTRVCTIS·ITEM·PRAESIDIS·PER·LO
CA OPPORTVNA AD CLANDESTINOS·LATRVNCV
LORVM·TRANSITVS·OPPOSITIS·MVNIVIT·
PER·b·CORNELIVM· FELICEM·
PLOTIANVM· LEG·PR·PR·

Figure 56. An inscription from Hungry recording the construction of towers and forts
(*ILS* 8913)

Raiders are recorded on every Roman frontier, and the Romans took action against them, for example, establishing fortlets for the protection of travellers or closing a route used by raiders (Breeze 2011: 188-189) . A document from the Eastern Desert of Egypt records an attack lasting two days on a Roman fort by 60 barbarians in which one soldier was killed and a woman and two children taken (*O. Kroc.* 87). In such circumstances, there would be Roman reprisals. In Britain an inscription from Kirksteads records successful achievements beyond the Wall, an altar from Corbridge the slaughter of a band of Corionototae while a dedication in Carlisle has been restored to refer to a similar action (*RIB* 2034; 1142; 946). Large scale invasions, as today, were rare. Luttwak is strong on the role of linear barrier in such an event. Then, the linear barriers were the last line of defence as 'their function was only to provide the jumping-off place for mobile operations' (Luttwak 1976: 69).

The final point Collingwood made in 1921 related to the fighting tactics of the Roman army. As Collingwood put it, 'when large forces from the north advanced upon the Wall and attempted ... to penetrate it, we cannot imagine that the Roman cohorts actually lined up on the rampart-walk to repel them, still less that Hadrian's engineers even contemplated such a proceeding. They threw open the north gates and marched out to fight them *more Romano*', in the Roman manner (Collingwood 1921a: 9). The Romans were an aggressive people who did not win their empire by sitting behind walls. Rather, they preferred to fight in the field where, mostly, they won. For me, this is the decisive argument. We may quibble about the existence of otherwise of a rampart walk, and in the most recent discussion Paul Bidwell has acknowledged that there is insufficient archaeological evidence to be sure either way (Bidwell 2008a: 142), but to argue that the Roman soldiers fought from the top of it is to fly in the face of all that we know of Roman fighting tactics.

In Collingwood's view, the military defence of the province lay in the hands of the army units spread across the hinterland of the Wall, 'the bodies of troops intended to cope with armed enemy forces' (Collingwood 1921a: 8). Collingwood perceived that the Wall embraced two functions, that of frontier control personified by the Wall, and military defence reflected by the forts. Collingwood's view also implies that the gates through the Wall at the milecastles were provided for military use, though that did not necessarily stop civilians using them.

A revised plan: Plan B

Consideration of the purpose of the gates leads us to a major change to Hadrian's Wall during its construction, in fact, not far into its construction. This major change was a decision to increase the strength of the military forces in

the frontier zone, including by constructing new forts astride the Wall. At this point, it is doubtful if any part of the linear barrier had been erected to full height, or even to the stage when scaffolding would be required, and for many miles only the foundations of the Stone Wall had been laid (Hill 2004: 139-46). It is difficult to determine what progress had been made on the Turf Wall, but it is likely that work had started on its construction.

As we have seen, there were only about seven forts across the isthmus from Corbridge to Kirkbride before the Wall (Figure 57). There were none down the Cumbrian coast, though inland there was a fort at Papcastle and a smaller installation at Caermote, together with other forts in the hinterland of the Wall on the roads leading south from Carlisle, Carvoran and Corbridge. The decision to increase the number of military units in the frontier zone, generally known as the fort decision, resulted in the construction of an additional 20 forts, 21 if Hardknott is included as being required to link Ravenglass to Ambleside, while at least four forts on the Stanegate were rebuilt (Figure 58).

The secondary nature of many of the forts is demonstrated by their relationship to the work already underway. At least three forts overlay demolished sections of the Wall and the Wall ditch, five over turrets and a milecastle which had been built or at least started while the measured position of a tower underlay one fort on the Cumbrian coast. The advance forts at Bewcastle, Netherby and Birrens were not attached to the Wall and so their relationship to other elements cannot be proved. I have argued that they were part of the first plan on the basis that there was a causeway across the ditch at MC 50 TW (High House) which was left to take the road to the fort to the north (Breeze and Dobson 2000: 46). The work of Humphrey Welfare in identifying other original causeways across the Wall ditch in front of milecastles has destroyed that argument (Welfare 2000). Now, I think that there can be little doubt that most if not all the advance forts are part of the revised plan (Figure 59).

It used to be thought that at this stage the existing forts on the Stanegate were abandoned and their units moved up onto the Wall line, but, while Brampton, Kirkbride and the two smaller forts appear to have been abandoned, Corbridge, Vindolanda, Carvoran, probably Nether Denton and Carlisle continued in occupation. The created a total of 25 forts along the frontier zone.

In manpower terms the fort decision saw a rise from perhaps 3500-4000 troops in the forts in the frontier zone at the beginning of Hadrian's reign to at least 15,000, the equivalent of three legions, and close to Corby's figures. Forts were abandoned across northern Britain and Wales to provide units for the new military deployment; about a third of the total number of auxiliary units in

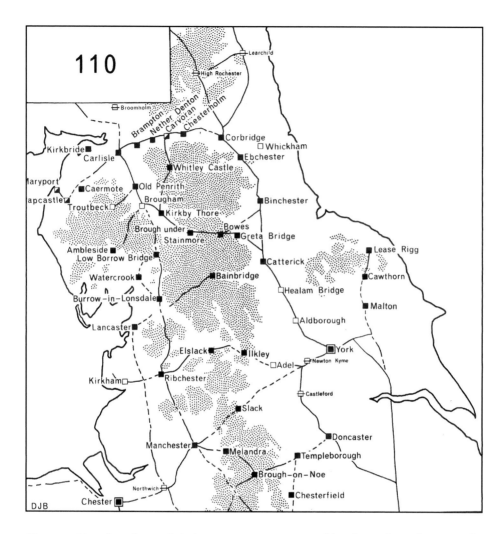

Figure 57. Map of northern Britain in 110. Open squares crossed by a line indicate forts recently abandoned; half filled squares uncertainly about occupation

Britain was on the move. This is a considerable step change. Hadrian's Wall moved from being a lightly held barrier with, to its immediate rear, a handful of regiments providing protection for the province to a strongly fortified corridor.

Why was this? What had happened to lead to such a change? This question is not easy to answer, but in order to explore it we must first examine both the new arrangements and the consequences for the original plan of this radical step.

What is interesting about the first series of new forts is that they were placed astride the Wall, a unique arrangement (Figure 60). The advantage of this

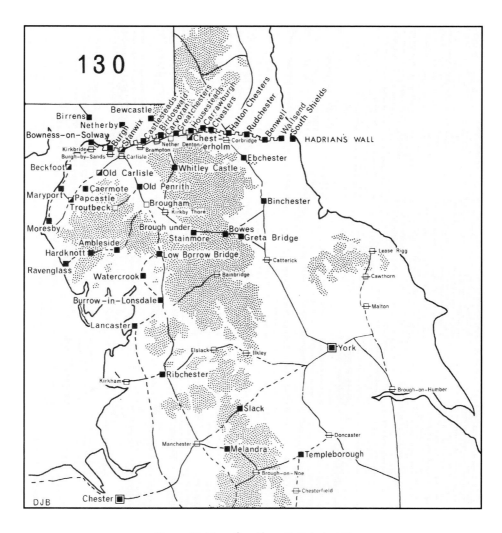

Figure 58. Map of northern Britain in 130

position is that instead of the army having to file through a single milecastle gate at any one point along the frontier to get to grips with an enemy, now there were six equivalently sized gates opening north of the Wall at each fort. The most obvious implications are that the army intended to operate north of the Wall and that this arrangement improved its mobility in the frontier zone. It would appear that this was important to the Romans for the placing of the forts astride the Wall involved reversing work already undertaken, as we have seen. To improve access behind the Wall, two new single portal side gates were inserted into the fort walls.

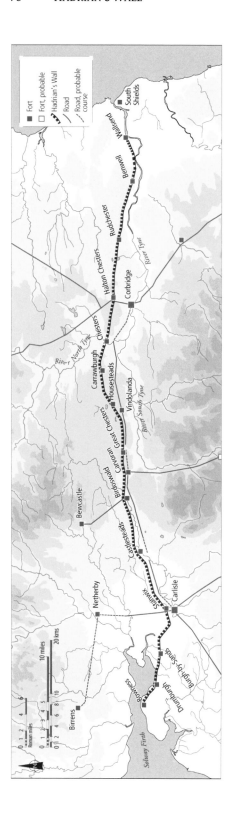

Figure 59. Map of the Wall as completed (Plan B)

The effect of Plan B

If the fort decision resulted in more troops operating to the north of the Wall, can we perceive any effect on the original plan? Matthew Symonds has already directed our attention to one, a change in the size of the milecastles (Symonds 2005: 68-78). As we have seen, the large MCs 47 and 48 were built early in the programme. All other milecastles on the Stone Wall are smaller with reduced accommodation facilities. Graafstal has placed these changes after the fort decision (Graafstal forthcoming). We can see that with so many forts on the Wall it might have been an appropriate action to reduce the number of soldiers based in each milecastle, this action leading to a reduction in the size of the enclosure. The effect of the milecastle decision was to halve the total number of troops in the milecastles and turrets along the Wall.

The other main change which would appear to date to after the fort decision was the narrowing of the Wall (Figure 61). The original intention was to construct a Wall 10 Roman feet wide, which was reduced a little by offsets above the footings. Before completion, this was now reduced by two feet or more, in some locations perhaps by as many as four feet (Figure 62). This leads to the question that if 10 Roman feet had been judged an

appropriate width for a wall bearing a patrol walk by the experienced Roman army, why was it reduced in width (Hill and Dobson 1992: 28-32)?

Various reasons have been offered for the narrowing of the Wall. These include the suggestion that a narrow wall would be more stable, a desire of the army to speed up work on a project which was increasing in complications and therefore duration, and that it was a useful saving in materials. One possibility which I do not think has been considered before is that the effect of placing the forts on the Wall, and in particular astride it, led to the decision that a wall-walk, always assuming that one was part of the original plan, could be dispensed with because there was to be a greater military presence in the land to the north.

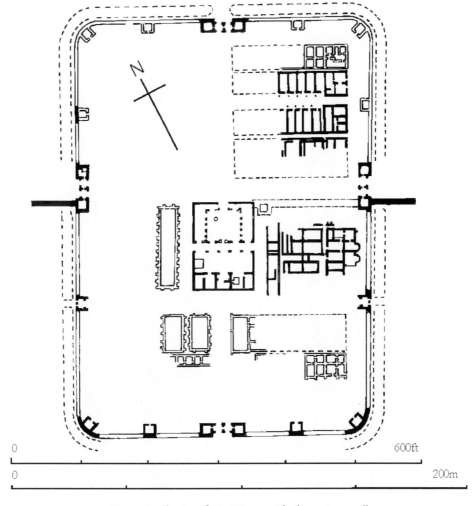

0 600ft

0 200m

Figure 60. Chesters fort sitting astride the curtain wall

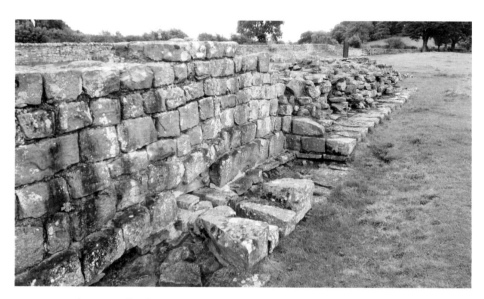

Figure 61. The point-of-reduction at Planetrees; note that the foundation had ben laid for the Broad Wall before it was narrowed.

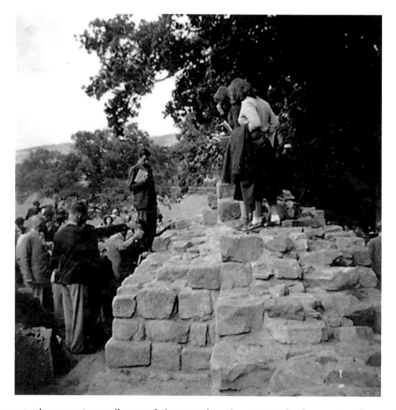

Figure 62. The east wing-wall at T 26b (Brunton) in about 1950; the figures standing on the Narrow Wall emphasise its narrowness

Nevertheless, security along the Wall line remained a concern. This presumably accounts for the construction of an extra turret at Peel Gap to provide observation of dead country immediately to the north (Figure 68). A different arrangement was made at Walltown where two turrets, 44b (Mucklebank) and 45b (Walltown West), were moved out of their measured positions so as to observe better re-entrants in the line of the Wall (Figures 20 and 26). Graeme Stobbs has suggested to me that the requirement for turrets in these locations might imply that there was no patrol walk along the top of the Wall (pers. comm.) We may also note David Woolliscroft's observation that soldiers at the towers maintained communication with the new forts even if it was a little more complicated than before (Woolliscroft 1989: 15).

These changes, the reduction in the size of milecastles and in the width of the Wall, as well as the placing of forts on the Wall line, had the effect of downgrading the importance of the linear barrier within the framework of military deployment across the northern frontier. This was also the effect of another change to the original plan, the construction of a great earthwork behind the Wall, from Newcastle to Bowness, the Vallum. This consisted of a central ditch with a mound set back on each side (Figure 63). The ditch could only be crossed at forts, though there appear to have been gaps in the north mound at milecastles as if travellers moved along the north berm from forts to milecastles (Figure 96). The important point is that the Vallum tightened control of movement in the frontier zone and downgraded the importance of the linear barrier and of movement through it (Breeze 2015: 25).

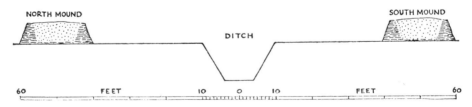

Figure 63. A section across the Vallum, drawn by I.A. Richmond

One facet of the original plan, Plan A, was that the Wall not only got in the way of raiders and more serious enemies, but it also restricted the movement of the Roman army; the new arrangement for forts astride the Wall dealt with that. But was there anything more sinister at play?

Warfare in Britain

There are three elements that we now have to take into account: the evidence for serious warfare in Britain early in Hadrian's reign; the building of the west end of the Wall in turf and the placing to the north of this sector three advance

forts together with the continuation of the pattern of fortlets and towers down the Cumbrian coast; and the construction of the Vallum.

Literary evidence is notoriously difficult to use. If it exists, how far do we trust it? If a statement does not exist in our literary sources, how far does this reflect the lack of actions to report, or merely lack of interest on the part of the reporter? What we do have for Hadrian's reign are about half-a-dozen records of warfare in the province. The first is a report by Hadrian's biographer, 250 years after the event, that at the beginning of his reign 'the Britons could not be kept under Roman control' (*Historia Augusta, Life of Hadrian* 5.2). A coin issue has on its reverse BRITANNIA, described as 'armed and at rest'. All agree that the coin was issued between 119 and 128, but Richard Brickstock, having looked again at the evidence, is content with a date in or close to 119 (pers. comm.). The reverse indicates the successful completion of a military campaign, namely that implied in the biography. The discharge of a large number of soldiers from the army of Britain in the first half of 122 presumably demonstrates that the warfare was over by that date, but it is possible that these soldiers had been retained pending the arrival of reinforcements.

We do not know the reason for the warfare. The strength of the army of Britain had been reduced following the Roman success at the battle of Mons Graupius in 83, with the withdrawal of two legions for action elsewhere. We can see from other frontiers that when Rome relaxed its guard its enemies flexed their muscles. The weakening of the army of Britain in order to support Trajan's campaigns may have been the catalyst for the trouble in the island.

The second observation of warfare in Britain is rather closer to the event than that of Hadrian's 4th century biographer. Cornelius Fronto, consul, senator and courtier, in a letter to the Emperor Marcus Aurelius in 162, compared the loss of troops in Britain in Hadrian's reign to the many killed in the Bar Kochba rebellion in Judaea which broke out in 132; unfortunately, Fronto did not provide an exact date for the event in Britain (Fronto, *On the Parthian War*). The centurion buried at Vindolanda was presumably one of the casualties (*RIB* 3364).

The final pieces of evidence are of a different nature. Two inscriptions refer to an *expeditio Britannica*. This term was normally, though not always, used when an emperor was present, and there was no emperor present in the warfare of 117-119, so the *expeditio* was presumably in 122 and referred to Hadrian's visit of that year. One officer on the *expeditio* was Pontius Sabinus who brought 3000 legionaries to reinforce the army of Britain (*ILS* 2726). Another officer recorded on the *expeditio* was Maenius Agrippa, the commander of the First Spanish cohort based at Maryport (*ILS* 2735 = *CIL* 11 5632) (Figure 64).

Figure 64. An altar of Maenius Agrippa at Maryport

Warfare there was, but we must be careful in relating this to the building of Hadrian's Wall. As Horsley remarked in 1732 the Wall would not have been built until the Romans 'had driven the enemy so far to the north, as to render them incapable of giving any interruption to the Romans when carrying on the work' (Horsley 1732: 124). We should not envisage Hadrian's Wall being erected during warfare, but only on its completion (Dobson 2009; Tacitus, *Agricola* 20).

The construction of the western end in turf has often been seen as indicating pressure on that area and a requirement for a quick fix to deal with it (e.g. Graaftstal 2012: 136-8; Hodgson 2017: 53, 67). Other explanations, however, have been offered, including the lack of limestone required to help build a stone wall west of the Red Rock Fault, that is about MC 53, and the lack of appropriate timber in a landscape farmed for four millennia (Richmond and Simpson 1935: 15; Breeze 2009: 92).

There are two problems with regarding the Turf Wall as an urgent measure intended to deal with security issues in the west. First, the Roman army would have dealt with any trouble in advance, as we have already noted. Second, the size of some of the stones used in building the milecastles in the stone sector was substantial (Figure 65). They were larger than were necessary and emphasise that the Wall was seen as a permanent structure. It would seem strange to build part of the Wall at speed and the rest at leisure.

The choice of turf or stone may simply have related to availability. It seems likely that appropriately sized timber was scarce across the whole region. In the wetter west, however, turf was readily available, while in the central sector, where the underlying rock was close to the surface, turf would have been scrappy but stone was plentiful. In the east, four millennia of cultivation would have reduced the availability of turf but again stone was available. It is also worth noting that the Romans were not ashamed to build in turf as the ancient reference to the Antonine Wall being constructed of turf demonstrates (*Historia Augusta, Life of Antoninus* 5, 4).

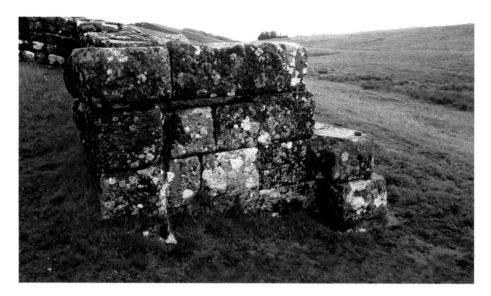

Figure 65. The south gate of MC 42 (Cawfields) showing the large stones used in its construction

North of the Turf Wall are three outpost or advance forts. Various reasons have been offered for their existence, including that they protected part of the state of the Brigantes left isolated beyond the Wall (Breeze and Dobson 2000: 46). The continuation of fortlets and towers down the Cumbrian coast to modern Maryport suggests a threat was perceived from beyond the Solway (Figure 66). The bottom line is that we don't know the reason for the advance forts nor for the extension down the Solway coast; it may be relevant that most elements along the coast were not reinstated on the return from the Antonine Wall, implying the lack of a threat. One might regard the Cumbrian coast installations as an over-reaction, as indeed in some ways is the whole of Hadrian's Wall.

The final element in this part of the discussion is the Vallum (Figure 67). Many reasons have been offered for the addition of the Vallum to the portfolio of installations which make up Hadrian's Wall (Breeze 2015: 22-26 lists the suggestions). These include that it was a second line of defence, though I do not see why that would have been required (see Luttwak 2016: 75-6 on the value of the Wall and its ditch as a formidable obstacle to attacking cavalry and the uselessness of the Vallum as a second line of defence). That it was to prevent cattle rustling, though I would have thought that the Wall and its ditch would have been an effective deterrent. That it was to protect the military zone. That it was a temporary measure, though it would have been a rather substantial temporary work. If we look at the effect of the creation of the Vallum, it was to increase frontier control, restricting the number of crossing points from

Figure 66. Criffel from Maryport, with the modern look-out tower to the left

Figure 67. The Wall and Vallum at Cawfields looking east, the Wall runs along the ridge to the left while the Vallum takes the lower ground to the right

an original 82 to 13; surely that is relevant, especially within the framework of the build-up of military deployment along the frontier. If that was the case, the construction of the Vallum may have been a reaction to events in the area, perhaps opposition to the construction of the Wall. Otherwise it is difficult to construe archaeological evidence as indicating that the Romans experienced any problems when it came to building the Wall. Why and how did the decision to implement Plan B come about?

Hadrian and his Wall

Hadrian's Wall is distinctive in two ways. First is the regularity in its planning, and second is the unusual features. The regularity in planning is reflecting in the spacing of the milecastles and structures throughout the 100 miles from Wallsend to Maryport. This hints at a plan prepared somewhere else. The unusual features include not only this regularity, but the invention of the milecastle, the placing of the forts astride the Wall and the construction of the Vallum. As C.E. Stevens remarked, they all point to the involvement of Hadrian and his fertile imagination (Stevens 1955).

One problem has been that the unusual features relate to both Plan A and Plan B. The suggestion of Peter Hill that little work had been done before the fort decision allowed, for a time, the possibility that the Wall was started and the changes made during Hadrian's visit. Several factors have effectively destroyed that scenario.

The dating of the timbers used to build the German frontier is one element. These were felled in the winter of 119/120, over a year before Hadrian's visit and point to advanced planning (Schallmayer 2017: 802). The same planning is reflected in the three milestones in Britain dating to the early years of the reign of Hadrian which probable reflect preparations for the imperial visit two years ahead of the event (Graafstal 2018: 89). Imperial visits cannot be arranged overnight. In the case of Hadrian's arrival in Britain in 122 it had to articulate with his visit to Germany beforehand and Spain afterwards. We are probably looking at the decisions to visit the north-western provinces of the Roman empire and to build frontiers being taken at least two years before the event. How does that relate to other activities?

Hadrian succeeded his cousin Trajan in August 117 (for background to the following discussion see: Birley 1997: 84-86; 2006: 114-124; Graafstal 2018). The army's control over Trajan's recent conquests was unravelling and the situation was exacerbated by an uprising of the Jews in the Eastern provinces. Hadrian took quick action. Trajan's newly acquired provinces were abandoned. The new emperor then travelled across modern Turkey to the Lower Danube where, in

118, he ordered the abandonment of some of Trajan's conquests across that river in the face of an uprising by the Sarmatians and Roxolani. The governor of this province was Pompeius Falco, an experienced officer, and it seems highly likely that Hadrian personally communicated his transfer to Britain. Falco retired from his British governorship in the first half of 122. A normal term of office of three years would have brought him to the island in 119. The dates fit. In the spring of 118 Hadrian met Falco and gave him his new orders. It would take Falco some months to travel across the empire, so 119 was probably the first year of campaigning. Three years in the province would lead to retirement in the winter of 121/122.

Hadrian's decisions to abandon Trajan's eastern conquests and the territory across the Lower Danube were taken in the early months of his reign. As we have seen, the dating evidence relating to the planning for the German and British frontiers indicates that the decision to build them was taken at about the same time. These decisions, the abandonment of territory too troublesome to hold and the construction of barriers elsewhere, were an unmistakable announcement of Hadrian's new policy of containment. As we have noted, it may be no coincidence that the decision was taken in the Greek East, an area familiar with long walls and within a milieu where some of the elite eschewed militarism. It is entering the realms of speculation to suggest that Hadrian sketched out a plan for the Wall at the meeting with Falco, but the original plan for the Wall does look as though it was drawn up somewhere other than on the spot and emperors normally did issue specific instructions to governors on their appointment (Breeze and Dobson 1976: 38: Graafstal 2012: 133; 2018: 87).

We cannot tie down the exact date of the arrival of the new governor Pompeius Falco in Britain, nor any details of his governorship. The evidence, such as we have it, suggests that he had dealt with the trouble recorded at the beginning of Hadrian's reign by the end of 121 at the latest. And it is likely that, following surveying and troop movements, he started building the new frontier before the imperial visit in the following year. This is indicated by an inscription found near MC 47 (Chapel House). The inscription does not bear the name of the governor recorded elsewhere at work on the Wall and also lists the titles of Hadrian in a fuller form than usual (*RIB* 1852). Graafstal has suggested that the inscription is not later in Hadrian's reign, as long supposed, but earlier, as on structural grounds is the milecastle (Graafstal 2018: 97). His conclusion is that this stretch of Wall, early in form, was built in advance of the imperial visit probably to show the emperor what his Wall would look like. Be that is it may, it seems highly likely that the radical change which I have called Plan B made so early in the building programme resulted from the emperor's visit and his appraisal of the military situation in north Britain. Ironically, in view of Hadrian's decision to halt the

expansion of the Empire, Hadrian's Wall was turned from a defensive barrier into an offensive line, a springboard for military operations north of the Wall, as Bruce appreciated 150 years ago. Perhaps Hadrian just thought that attack was the best means of defence, and in that he would be reflecting Roman military traditions. Luttwak called them the tactics of forward defence (Luttwak 2016: 68-9).

The statement by Cornelius Fronto on the scale of Roman losses in Britain is surely pertinent here. Although we have no figure assigned to Roman deaths, Cassius Dio stated that 580,000 Jews perished, and it is possible that the war led to the annihilation or disbanding of the Roman legion XXII Deiotariana. This was a serious war and the event in Britain was compared to it. It would seem likely that it is against this background we should see the initiation of Plan B. Perhaps Hadrian, 2500km away on the Lower Danube, thought that his Wall could deal with the problem. On the spot, I suggest that realism kicked in and a more aggressive solution was adopted.

Plan B involved considerable additional work, the abandonment of 21 forts, the construction of 21 new forts and the move of 21 regiments, and progress may have been hindered by the transfer of some British units to participate in the Bar Kochba uprising in the 130s (Birley 2006: 132; 2014: 254). It is possible that the great discharge of auxiliary soldiers in 122 was part of the process of moving so many regiments (*CIL* 16 69). No wonder there is evidence for a long hiatus at various places during the building programme. This takes several forms (Breeze 2012: 75). In at least two places, the foundation laid down by the original builders for the Broad Wall was ignored by their successors who erected their Narrow Wall on a new line. At Peel Gap work was abandoned long enough for the foundations to be overgrown before the soldiers returned and completed this section to the narrow gauge (Figure 68). Debris accumulated in the Wall ditch at Chesters between work on the turret and its replacement by the fort. At Birdoswald, Wilmott recorded a layer of soil covering unfinished buildings within the fort. The sequence also appears to be lengthy at Great Chesters with MC 43 built on the site, occupied, with work on the fort ditches started but abandoned before soldiers returned to demolish the milecastle and build a smaller fort. Welfare has pointed to the incomplete state of the Wall ditch in parts of the central sector (Welfare 2004; 2013). Nor was the upcast mound to the north of the ditch always smoothed off (Figure 69). In some areas, the building programme seems to have got so out of kilter that the Vallum may have been constructed before the adjacent Wall.

Dating the Wall

There are few inscriptions to help us date the building of Hadrian's Wall. The name of the governor Platorius Nepos, who arrived in July 122, probably with

Figure 68. The extra tower in Peel Gap looking east

Figure 69. The unfinished upcast mound near MC 24 (Wall Fell)

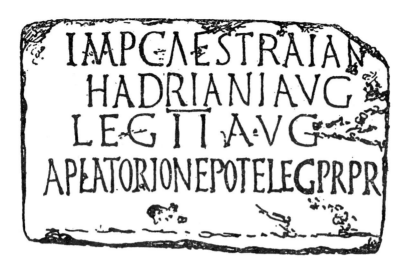

Figure 70. A milecastle inscription (*RIB* 1638)

Hadrian, and may have still been here in 126 or 127, appears on inscriptions at four milecastles, and also on inscriptions at the forts of Benwell and Halton Chesters which are likely to have been amongst the first to have been built following the implementation of Plan B (*RIB* 1634; 1637; 1638; 1666; 1935; 1340; 1427) (Figures 34 and 70). Other inscriptions attest building work at the advance forts and on the Cumbrian coast during the reign (*RIB* 974; 995; 801). One of the last may have been Great Chesters, which has produced an inscription dating to between 128 and 138 while building work was in progress at its neighbouring fort at Carvoran in 136/7 (*RIB* 1736; 1778; 1818; 1820). In this scenario, work on the Wall, the building of which was conceived at the very beginning of Hadrian's reign, was still in progress at the very end.

There is evidence that it continued beyond Hadrian's reign (Breeze 2012: 75-76). Tony Wilmott dated digging of the fort ditches at Birdoswald to after the return from the Antonine Wall, that is in the 160s, while he was unable to locate any granaries there before those erected in the early 3rd century (Wilmott 1997: 109-110). The 160s also witnessed building work at other forts; possibly some of their buildings had not been completed during Hadrian's reign (*RIB* 1737 and 2026). Finally, there is the evidence from the Wall itself, where there are a number of building stones which date to the years following the return from the Antonine Wall. It is possible that they record repairs to the Wall, which had been abandoned for a couple of decades, or completion of the building project aborted when Antoninus Pius took the decision to move the frontier to the Forth-Clyde line (Mann 1992; Hodgson 2011).

Summary

To recap, Plan A comprised a linear barrier of massive proportions, supplemented by a new invention, a milecastle, and with a regular series of towers, fronted by a wide and deep ditch. Both wall and ditch were larger than any other such features on Rome's frontiers. This plan bears all the hallmarks of a scheme devised at some distance from northern Britain. The time required for instructions to cross the empire, for planning, surveying, the marking out of the landscape and the assembling of the building force would allow for the initial decision to be taken by Hadrian when considering a wide range of foreign policy and frontier actions on his journey from the Eastern provinces to Rome in the early months of his reign. The very location of the decision to build the Wall, the Greek East, may have directed the Philhellene emperor to Greek parallels, long walls, the city walls of Athens, while his thoughts may have been affected by the attitude of certain Greek to expansion, or rather the lack of it.

Yet, as implemented, Hadrian's Wall was not intended to be a quick fix. The very size of the stones used in the milecastles of the Stone Wall demonstrates that. Moreover, to build a frontier like this while undertaking campaigning would fly in the face of normal Roman practice which was first to defeat the enemy in the field. Hadrian's Wall was built after a Roman victory.

Hadrian came to Britain in 122 and it is hard to escape the conclusion that it was the emperor himself who took the far-reaching decision to undertake a radical change through the abandonment of at least 20 forts to the south and the building of a similar number of new forts along the line of the Wall and down the Cumbrian coast, supplemented at that time or immediately after by the construction of the Vallum all the way behind the Wall from Newcastle to Bowness. These additions led inexorably to a slowing down of work on the original plan, to changes like the narrowing of the Wall, and probably to a reduction in the number of soldiers in the milecastles and therefore the size of these structures. It is equally difficult to avoid the conclusion that Hadrian was impressed by his own assessment of the military situation on the northern frontier. Plan A, we can believe, was conceived far from northern Britain, perhaps even before the full scale of the troubles in Britain were appreciated. There is much to be said for accepting that Plan B was a reaction to the very serious warfare that Fronto mentioned and which may have been the result of the weakening of the army of Britain in order to provide troops for Trajan's wars.

His decision, Plan B, may have led to a slowing down of progress on the building programme, but it is worth noting that the basics remained the same: the Wall might be narrowed but it remained substantial; the milecastles and turrets were

completed though some might be moved out of their measured positions; the use of large stones in gateways continued. Whether the Wall was completed at the emperor's death is a moot point. How long it took for the army to appreciate the implications of Plan B for Plan A will be considered in the next chapter.

The Wall after Hadrian: changing functions?

The great advantage of studying the original plan for Hadrian's Wall and its immediate successor is that we can observe and interpret the original proposal, Plan A, and we can observe and interpret a very different successor plan, B, and through this compare-and-contrast process move towards an understanding of the purpose of the frontier and the way the army intended it to operate. Once we move away from that brief period we are faced with a number of problems.

The first issue is dating the changes to the frontier and the second the lack of modern excavations. Over the last 50 years only seven turrets have been excavated and only two milecastles, though only one has been published. The lack of excavations has been compounded by the destruction of the upper layers of several turrets, so we work from partial evidence. There have been extensive excavations at several forts and smaller investigations at others as well as sections cut across the Vallum. What we have not done is much by way of investigations of areas outside the military compounds. Here the main exception is Vindolanda where fort, extra-mural settlement and cemetery have all been, and continue to be, excavated. We will come to the work there in the next chapter. In the meantime, we have to make sense of what information we have to illuminate the history of the Wall and any changing patterns in the way it operated.

Hadrian's successor, Antoninus Pius, at the very beginning of his reign in 138, took a decision to move the frontier forward in Britain (Figure 71). I remain firm in the belief that the reason was political (on this event see Birley 2005: 136-140; Breeze 2006: 12-14). The new emperor, who had never served in the army, required military prestige and, like Claudius 100 years before, he chose to obtain it

in Britain. Within months of his accession plans had been prepared, as indicated by the building work at Corbridge on the main eastern route north. By the summer of 142, victory had been achieved and a start made on building the Antonine Wall (Breeze 2006: 20-24). The life of this frontier was short as an inscription demonstrates the rebuilding of Hadrian's Wall in 158 (*RIB* 1389: Hodgson 2011) (Figure 72). The details of the Antonine Wall do not concern us, but the effect on Hadrian's Wall does.

Figure 71. A coin of Antoninus Pius

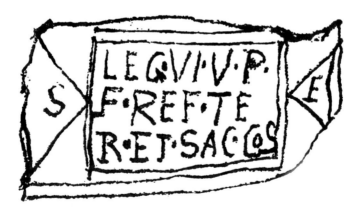

Figure 72. A rebuilding inscription (*RIB* 1389)

The re-occupation of Hadrian's Wall

In their excavation of MC 48 (Poltross Burn) in 1909 Gibson and Simpson found in the debris between the first and second phases of occupation two worn but broken pivot stones. As no earlier pivot stones were found, they inferred that these came from the lowest level of the gateway, the damage resulting from

their removal. About the same time, the gaps in the mounds of the Vallum were recognised and it became realised that this earthwork had been slighted. In short, when Hadrian's Wall was abandoned in favour of its northern successor, measures were taken to allow traffic to proceed across the military zone. This in itself indicates that the army was not concerned with internal security.

On the return from the Antonine Wall steps were taken to put Hadrian's Wall back in working order. New pivots were placed in milecastle passage ways to allow gates to be rehung; turrets were reoccupied as were forts, if they had been previously abandoned; and a start was made on restoring the Vallum to its original purpose. The main change at this time appears to have been on the Cumbrian coast. We can point to no tower that was re-occupied though there is a little evidence for structural changes at some of the fortlets, believed to have been at this time. No milefortlet is known to have remained occupied beyond the end of the 2nd century (Figure 73). The only new element appears to have been the creation of a road along the Wall, the Military Way.

The invasion of 182/3 and its aftermath

There was a catastrophic event in the early 180s when the tribes crossed the Wall that divided them from the Roman forts, did a great deal of damage

Figure 73. Milefortlet 21 (Swarthy Hill) looking west

and defeated a Roman army, killing its general, probably the governor of the province (Birley 2005: 166). Cassius Dio stated that this was the greatest war of the reign of Commodus (Cassius Dio, *History of Rome* 72, 8, 1). This is a remarkable statement. The only other war which Dio mentioned in the reign of Commodus was with barbarians beyond Dacia, but the British war occurred just a couple of years after the end of the long-running struggle on the Danube for which Commodus had taken the title of Imperator three times. The British war clearly was very serious.

The evidence for destruction at various sites along the Wall is related to this event (Gillam 1974: 10). What is more significant to the operation of Hadrian's Wall are the changes which were made to the frontier in the following years. These have been recognised in turrets, milecastles and in the units based in the forts.

The most significant change was the near wholescale abandonment of turrets, a conclusion based on the lack of late 2nd century pottery at most structures. Indeed, there is so little late 2nd century pottery at most turrets that it is possible that they had been abandoned even before the 180s (Table 3). This is remarkable, but perhaps not as surprising as might appear at first sight. We know of no certain towers on the Antonine Wall. We have assumed that we have been unable to find

Turrets producing only 2nd century pottery: 10a (but recess not blocked); 12a (a couple of possible 3rd century sherds); 13a; 18b; 19a; 19b; 25b; 26a; 29b; 33b; 34a; 35a; 35b; 37a; 39a; Peel Gap tower; 39b; 45a; 51a (but not demolished); 51b (but not demolished); 54a.

Turrets with blocked recesses: 19a; 25b?; 33b; 34a; 35a; 37a; 39a; 39b; 40a; 40b; 41a; 50a; 54a.

Turrets demolished to the lowest courses: 33b; 34a; 35a; 37a; 39a; Peel Gap tower; 39b; 40a; 40b; 41a; 41b; 50a; 54a.

Turrets with evidence for occupation in the 4th century: 7b; 29a; 44b; 45b; 48a; 48b; 49b; 50b; 52a; 53a.

Milecastles with narrowed or blocked north gates: 13?; 19; 22 (blocked); 35 (blocked); 36; 37; 38; 39; 48; 49; 50; 52.

Milecastles with evidence for occupation in the 4th century: 9; 13; 32; 35; 37; 38; 39; 40, 48; 51; 54; 55; 79.

Table 3. The occupation of turrets and milecastles

them. But if Plan B for Hadrian's Wall reduced the value of the towers along that frontier, the next step may have been the complete abandonment of the concept on the Antonine Wall. The return to Hadrian's Wall resulted in the abandonment of the towers along the Cumbrian coast, with those on the Wall following later. This was remarkable. The tower was one of the staple elements in the military portfolio throughout the whole of the period of the Western Empire and, of course, beyond in the Eastern. To eliminate nearly all the towers from Hadrian's Wall is not what we would expect. What were the implications?

The purpose of towers was observation and/or signalling, that is, assuming that they are not just glorified sentry boxes. On Hadrian's Wall we assume that their primary purpose was observation. As we have seen, the work of David Woolliscroft on the close relationship between the milecastles on the Wall and the troops based to the south in the forts along the Stanegate implies a method of communication between the two. This further implies that the soldiers in the turrets were occupied in observing any movement in the lands to the north and, when necessary, sending back a message. If there is any traction in this argument, the placing of forts on the Wall line will have ended this arrangement as the soldiers would now have to send a message along the Wall.

In itself this does not mean that the purpose of the turrets was at an end. What is more likely to have led to an appreciation that they were surplus to requirements was the placing of the forts on the Wall with the clear implication from their positions that the army intended to be involved in operations to the north. We might presume that in the future observation was to be mainly undertaken in the field and not from the towers on the Wall.

The abandonment of the turrets appears to have taken place in two stages. At first the door may have been blocked up (e.g. Miket and Maxfield 1970: 149) (Figure 74). This is indicated at some by courses of stone placed on the door thresholds, but we cannot always be certain that these do not relate to a raising of the threshold. The second and more definitive stage was the demolition of the turret and the infilling of the recess where the turret was formerly embedded in the Wall. This latter action has caused considerable discussion.

Why were the recesses blocked up? It could be argued that it was to ensure the stability of that section of the Wall, but the north wall of the turret was 5 feet / 1.6 m wide and faced on both sides, so capable of remaining standing. Another suggestion is that the infilling of the recess was to support a wall-walk (for discussion see Bidwell 2008a: 133). But one would then expect a uniform blocking of recesses, which was not the case, as here are half-a-dozen instances where the recesses was not infilled. A couple of planks thrown across the gap would have

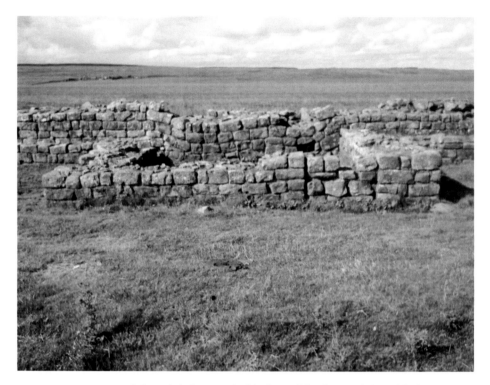

Figure 74. Turret 33b (Coesike) showing the blocking of the door and the infilled recess

maintained a wall-walk, assuming one existed, but we are unlikely ever to know whether this occurred (Hill and Dobson 1992: 28). The blocking of recesses does not seem to me to offer unqualifying support to the existence of a wall-walk.

It should be noted that at least nine turrets were not demolished though it is not easy to see why these survived. The only area with any uniformity of approach was the central sector. From 33b through to 41b, each turret was demolished and, where the evidence survives, the recess was blocked up. East of the crags it is a different story. Three or four turrets appear not to have been demolished nor have their recess blocked up. In Wall mile 19 the recess was infilled at one turret while that at its neighbour was not. West of the crags, the situation is similar with one turret demolished and recess blocked up, while three in the same area were not demolished. There was no uniformity of approach; perhaps the army simply responded to local circumstances.

To turn to milecastles. The signal change here was the narrowing of the north (and sometimes the south) gate passages at several milecastles and the blocking of one gate completely (Table 3. Figure 75). It might be thought that such action in the crags sector where there was a drop in front of the gate would be no more than an

Figure 75. The north gate of milecastle 48 (Poltross Burn) with part of the passage blocked

acceptance of reality, but not all these milecastles stood on a cliff. There is some evidence that the narrowing was the natural next step in the use of milecastles. There are cases where the original gate pivot stones were well worn, but those of the second phase were not so worn, indicating less use. In such instances, the next step would appear to have been to restrict the use of the gate even more. Welfare has suggested that it is likely that most of the causeways over the Wall ditch in front of the milecastle gates were removed at the same time, thereby further reducing the value of the gates (Welfare 2004: 18).

What we can conclude from this discussion of the turrets and milecastles is a reduction in the importance of these minor installations along the barrier. Many towers were dispensed with and it would appear that it was now no longer possible for vehicular traffic to pass through the Wall at milecastles and no longer possible to cross the ditch at this point. The Wall had simply become a barrier. Perhaps it should then come as no surprise to observe that the Vallum was falling out of use, at least around the forts, as we can see from the spread of civil settlements over its earthworks. What then of the forts themselves?

Septimius Severus in Britain

Most of our evidence for the regiments based at the forts in the frontier zone dates to the early 3rd century, the reign of Septimius Severus and his immediate

successors, homologated in most cases through the record of the *Notitia Dignitatum*, a document recording the officials of the Roman Empire in about 400. As we have seen, Severus is credited in the ancient sources with building the Wall, so we can only presume that he did something, but what?

There is little direct evidence. An inscription in a quarry near Castlesteads provides a consular date for work here in 207, but we have no idea where the stone was used (*RIB* 1009). It is frequently stated that the hard, white mortar used in the Extra Narrow Wall is Severan in date, but this is not necessarily the case for Bidwell and Holbrook recognised the earlier use of the same mortar at Willowford Bridge in a late 2nd century context (Bidwell and Holbrook 1989: 81) (Figure 76). The Severan date for this hard, white mortar goes back to 1911 when Simpson in the publication of MC 48 referred to 'the Severan re-build of the Wall', specifically relating it to 'the ancient record' and the date has simply stuck (Simpson 1976: 77; Breeze 2014a: 100). We have no archaeological evidence for any activities on the Wall under Severus.

The ancient sources, however, may provide a clue to Severus' actions (Figure 77). There is no literary reference to Hadrian's Wall before the arrival in

Figure 76. The curtain wall at Sewingshields, the Narrow Wall sitting on top of the Broad Foundation

Figure 77. A coin of Septimius Severus

Britain of the imperial family in 208. The single reference to Britain between 197 and 208 is that, probably in 206, Severus was angry that wars were being won in Britain while he could not capture a bandit in Italy (Cassius Dio, *History of Rome* 76, 10, 6). Inscriptions are testimony to the activities of his governors. While they were at work on the Wall and at an outpost fort, they also restored military buildings at forts in the hinterland, as far south as Ribchester, and in Wales. They were energetic; perhaps there had been a lack of maintenance. Further, this activity continued into the 230s. There was clearly work to be done for gates were restored from their foundations, buildings collapsed through old age were rebuilt, and new facilities provided (*RIB* 430; 605; 730; 1234; 1465; 1706; 1738). The work was a continual process through the reigns of all the emperors of the Severan dynasty.

It is against this background that we should measure the literary sources. It is unfortunate that neither of our principal sources, the closest to the events they were describing, Cassius Dio and Herodian, mention the building of a Wall. There is only one later source, repeated many times, which recorded that Severus led, for that is the verb used, a wall across the island. This action is placed after his campaigning. This has led Tony Birley to suggest that his son and successor 'Caracalla magnified the importance of the reconstruction of Hadrian's Wall, having abandoned the conquests in Scotland after Severus' death' (Birley 2005: 198). Cassius Dio stated that Caracalla 'made treaties with the enemy, evacuated their territory, and abandoned the forts' (Cassius Dio, *History of Rome* 77, 1, 1). What his army returned to after three years of activity in the north was Hadrian's Wall. Perhaps our single late source is merely acknowledging this.

This excursus has revealed that we actually have no evidence that Severus did anything to Hadrian's Wall other than leave his governors to undertake repairs at some forts. Analysis of epigraphic evidence reveals several regiments in forts on and behind the Wall both before and after the Severan campaigns, some from as early as the 180s (Table 4). To support this evidence for continuity from the 180s there is no evidence for changes of particular regiments between those two

periods, though it must be stated that the evidence for the army of the Wall in the 180s is sparse.

A map of military deployment in northern Britain in the early 3rd century is particularly interesting (Figure 78). It is at this time that we have the most evidence for the disposition of units. There are four cavalry units on the Wall. To

Fort	Occupation			
	pre 197	197-208	211+	*Notitia*
Benwell	Y	Y		Y
Chesters	Y	Y		Y
Birdoswald		Y	Y	Y
Ravenglass	Y			Y
Old Carlisle	Y		Y	
Old Penrith	Y		Y	
Risingham		Y	Y	

Table 4. 'Continuity of regiments in forts in north Britain before and after the Severan campaigns

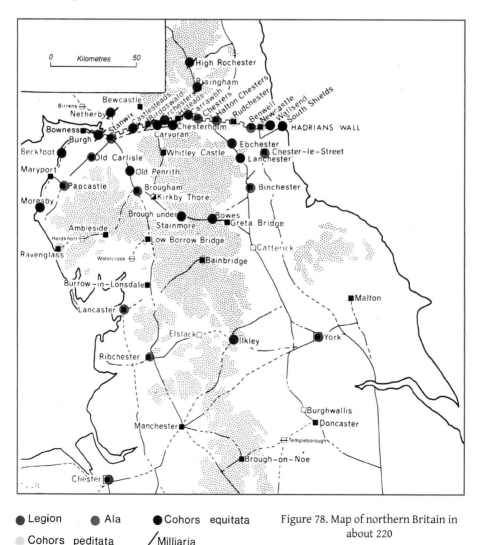

● Legion ● Ala ● Cohors equitata

● Cohors peditata / Milliaria

Figure 78. Map of northern Britain in about 220

the south, in the west, three cavalry regiments are based in the forts leading north to Carlisle and Stanwix while in the east there are two more, one on each road south. This is unlikely to be the result of happenstance, but a carefully arranged pattern of military deployment. Further south, at Lancaster and Ribchester, there were also cavalry regiments and they were placed where they were able to move north swiftly should they be required on the frontier.

Plan C

The evidence that we have points to the major changes on the Wall, including the abandonment of turrets and the narrowing of milecastle gates, together with amendments to military deployment taking place in the aftermath of the invasion of the early 180s. The result was that the importance of the Wall itself, and the minor installations along its line, was downgraded. The placing of the forts on the Wall line and the strengthening of military deployment in the frontier zone, started under Hadrian, reached its maturity in the late 2nd century even though we might only see the new pattern clearly in the early decades of the following century.

The significant addition to the military dispositions of the late 2nd century, which we can also only see clearly in the early 3rd century, are the outpost or advance forts. In Hadrian's Plan B for the Wall, there were three outpost forts, all to the west, Bewcastle, Netherby and Birrens. Only Birrens continued in occupation when the Antonine Wall was built. Bewcastle and Netherby were re-occupied on the return from the Antonine Wall but Birrens was abandoned in the 180s. The remaining two advance forts were supplemented by Risingham and High Rochester in the east (Figures 78 and 79).

Risingham and High Rochester shared with some of the Wall forts a phenomenon recognised through inscriptions of the early 3rd century, the addition of other units to their basic complement (Breeze and Dobson 2000: 256-276). At Housesteads were based Notfried's regiment and a unit of Frisians. Two units fortified the regiment at Burgh-by-Sands, one of Moors and the other another group of Frisians. Great Chesters appears to have acquired a group of Raetian Spearmen. Another unit of Raetian Spearmen, or perhaps the same regiment, is recorded at Risingham. Here also were based the Scouts of Risingham. At High Rochester the additional unit was the Scouts of *Bremenium*. The soldiers recorded at these forts roamed into the lands across the Cheviots leaving altars which were reused in the monastery at Jedburgh (*RIB* 2117; 2118). To the west, the name of Netherby was *Castra Exploratorum*, the Fort of the Scouts.

We cannot explain the specific requirement for forts along the Wall to be strengthened by the stationing there of additional units, that is, apart from

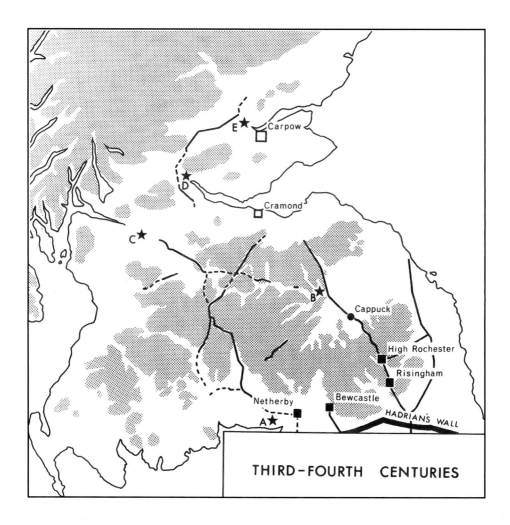

Figure 79. Outpost forts and possible *loca* (A-E) in the 3rd-4th centuries. Carpow and Cramond date only to the Severan period

a desire of the Romans to protect the province and impose their will beyond the frontier, in relation to which the involvement of scouts at three of the four outpost forts is certainly understandable. Involvement by Rome in the affairs of the states beyond her borders had long been a significant activity. They deposed kings and appointed new ones at will. They sought to control access to the lands immediately beyond the frontier as attested on the Rhine and the Danube. In one treaty between the Romans and the Marcomanni, there was a stipulation that the Marcomanni in their own lands 'should not assemble often nor in many parts of the country, but only once each month and in one place, and in the presence of a Roman centurion' (Cassius Dio, *History of Rome* 73, 2, 4). Richmond interpreted the phrase *diversa loca*, 'odd places', listed in the *Ravenna*

Cosmography lying north of Hadrian's Wall, as indicating such meeting places, though not all agree with this interpretation (Richmond 1940: 97; Rivet and Smith 1979: 212; Mann 1992).

The point is not of great importance because more definite evidence reminds us of the existence of treaties in Britain between Rome and her neighbours. The treaties which the Caledonians and Maeatae broke in 197 had presumably been established in the aftermath of the 184 victory and it was these treaties which were renewed when Caracalla abandoned his father's conquests in 211. 150 years later, in 360, 'the savage tribes of the Scots and Picts ... disrupted the agreed peace' (Ammianus Marcellinus, *History of Rome* 20, 1, 1); note that there appears to have been a treaty with the Scots presumably still in Ireland. Seven years later there was the so-called 'Barbarian Conspiracy'. This may have been no worse than the events of 360, it was just that the Roman counter-attack was led by the father of the emperor under whom the narrator, Ammianus, was writing. But his account contains a crucial piece of evidence, 'the areani [a word we cannot translate] ... was an organisation founded in early times. ... Their official duty was to range backwards and forwards over long distances with information for our generals about disturbances among neighbouring nations', a classic description of scouts (Ammianus Marcellinus, *History of Rome* 28, 3, 7). The problem was that in 367 they had been bribed with promises of plunder to reveal the Romans' plans to the enemy.

Briberies – subsidies depending on your point-of-view – was another Roman weapon. We have already seen that peace had to be purchased in 197 by the payment of a considerable sum. Presumably the coin hoards in Scotland dating to the reign of Severus relate to this or subsequent payments (Figure 80). Interestingly six hoards all lie north of the Tay in the lands of the Caledonians, one of the troublemakers of 197. After the withdrawal from Severus' northern conquests the hoards of the next 25 years all hoards lie in southern Scotland, a reversion to the distribution before Severus (Hunter 2012: 262). There appears to be a long-running policy of keeping sweet the peoples living in the lands stretching up to the Tay.

The pattern that we have been creating for the operation of the frontier zone in the late 2nd century and early 3rd century is a down-grading of the Wall itself, the strengthening of the forces at many of the forts on the Wall line, the creation of what might be termed a mobile support framework in the hinterland forts, the establishment of a system of scouting to the north of the Wall based on four outpost or advance forts, subsidies for the peoples living in southern Scotland and treaty relationships with those beyond. This is the pattern which continues into the late 3rd century and, in some elements, well beyond that. We might call it Plan C.

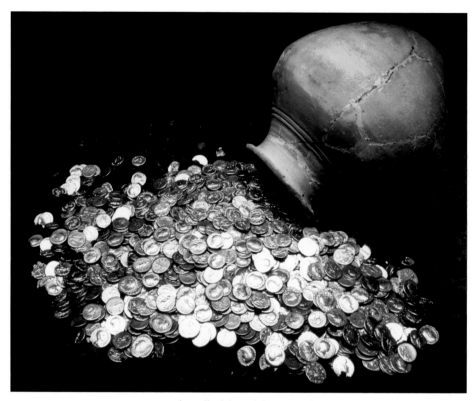

Figure 80. The Falkirk hoard dating to about 235

In some ways we can see Plan C as a developed version of Plan B which saw a significant increase in the number of forts in the frontier zone with the placing of forts astride the Wall signalling an intention to operate beyond its barrier. In Plan C yet more troops were based on the Wall, supported by cavalry regiments to the south, and with greater strengthening of military capabilities to the north. As John Mann pointed out, it is interesting that the Roman frontier now appears to have lain on the Cheviots, roughly the border between the later kingdoms of Scotland and England (Mann pers. comm.).

We should not be overly surprised at this. There had been two serious wars in Britain within 50 years, in one the army suffering a notable loss of men, in the second a general being killed.

The significance of this latter defeat may not have been forgotten by a future emperor and general in Britain, Septimius Severus, then a legionary legate in Syria. While contemporary writers offer various reasons for the campaigns of Severus in Britain, what is notable is that his intention according to Cassius Dio was to conquer the whole of the island, in other words to do away with the

frontier altogether. He pushed forward the frontier in the East in order for his new conquest to act as a bulwark against the Parthians, so there is no reason to doubt that his strategic sense could have been brought to bear on the issue of the British frontier. His death ended his vision and Plan C remained in operation.

The 3rd century and beyond

The 3rd century is one of the problem periods in the history of the northern frontier. We have no literary references after the return to Rome of Caracalla in 211. The run of building inscriptions slows to a trickle after the end of the Severan dynasty in 235, concluding with one recording the rebuilding of the bath-house and basilica at Lancaster in the mid-260s (*RIB* 605) (Figure 81). There are other

Figure 81. The bath-house at Lancaster cut by the ditch of the later fort

inscriptions which demonstrate continuing military presences at several forts at least into the 280s, but after Lancaster we have to wait for another 40 years or thereabouts before another building inscription. Around 300, the commander's house, headquarters building and bath-house at Birdoswald, which had been covered with earth and fallen into ruin, were restored (*RIB* 1912). At some time in the 3rd century the Wall immediately west of the fort was demolished and a ditch cut across its line (Breeze 2006: 299). In some ways this was a physical manifestation of the deterioration of the status of the Wall itself, now just one element in a wide military zone stretching from York and Chester to the Cheviots and beyond.

Severus divided the former large province of *Britannia* into two, Upper Britain in the south and Lower Britain in the north. As amended, it would appear by Caracalla, the governor of Lower Britain controlled the legion at York where he had his capital, and most of the auxiliary units in the island, but the other two legions lay in the Upper Province at Chester and Caerleon (Mann and Jarrett 1967). In some ways this does not appear to have mattered over much as we do have evidence for the two southern legions operating in the north (Breeze 2002). In spite of the smaller forces available to the governor of the north, we know of no disturbances on the frontier from the time of Caracalla in 211 almost through to the end of the century when the Picts first appear in the literature. This is not to say that nothing happened, the so-called peace may just reflect the paucity of our sources. Between 273 and 285 four emperors took the title *Britannicus,* Aurelian, the brothers Carinus and Numerian, and Diocletian. The first may have been to mark the re-absorption of the breakaway Gallic Empire into central authority, and Diocletian may have taken the title to strengthen his authority. Carinus was briefly emperor from 283 to 285 in the west but, apart from the title, the only hint at campaigning in Britain is a poetic reference to a successful war under the north star, while his brother Numerian only held the title as his co-emperor (Birley 2005: 367-8). In short, we do not know the reasons for these acclamations.

One of the most imaginative approaches to the 3rd century was taken by John Mann in his paper on the northern frontier after 367 published in 1974 (Mann 1974b). In this, he analysed the army list for Britain in the *Notitia Dignitatum,* a list of officers in the Empire dating to about 400. Mann drew a distinction between the regiments of the early Empire, cohorts and *alae* often named after their place of origin, and the units created in the 4th century with bland names such as the *numerus defensorum.* Mann noted that while many of the units of the early Empire continued to be recorded at the forts along the Wall and the Cumbrian coast, those in the hinterland were occupied by the new style units, in some instances clearly replacing the unit attested there in the early 3rd

century. He noted that the units on the Wall survived so it could not be that the hinterland units had been wiped out in an invasion. Rather, he argued they had been disbanded or withdrawn for service elsewhere. We do not know when this happened, though it was presumably after the mid-260s. Mann argued that the new-style units had arrived in Britain by 326 because one had the epithet *Crispiani*, which he linked to Crispus, the son of Constantine I, murdered by his father in that year. Unfortunately for our attempt at dating, Roger Tomlin has suggested that the word derived from the town of *Crispiana* in Pannonia. We do know, however, that while some new-style units started to be created in the late 3rd century, it appears to have been Diocletian, emperor from 284 to 305, who raised new units and distributed them along the frontiers. Among these would appear to be the 13 regiments sent to or raised in Britain.

It would be helpful to Mann's thesis if we could point to forts which were unoccupied sometime from, say, the 260s through to the 320s, or later, but this is difficult. There has been little or no excavation at most forts in the hinterland of the Wall to help answer the question. On top of that are the difficulties of interpreting both coin loss and pottery patterns at sites which have been excavated. As was noted in the report on the excavation at Low Borrowbridge, the pottery indicated occupation throughout the Roman period, but it was 'not possible to determine whether there were intervals in the tenure of the site' (Hildyard and Gillam 1951: 55). And then there may be difficulties in determining who was living in a fort. Could forts be maintained with a caretaker detachment? What might happen on abandonment? Destruction of the buildings, or the locking of the front door? Did someone else move in? Paul Buckland reviewed the evidence for Malton and concluded that it 'was possible that the fort ... was either completely abandoned or held by only a caretaker garrison from the mid-third century until early in the fourth' (Buckland 1982:58). On the evidence from Doncaster, he said that although it remained a military site 'inactivity brought a decline in standards and the nature of later third century occupation remains enigmatic' (Buckland 1986: 13). In size it could have been 'a fort or a small, defended civil settlement ... none of the internal structures being diagnostic and the presence of late Roman military equipment would not be unusual in a town'.

In the face of these archaeological problems, I prefer to accept the analysis of John Mann, a scholar who had studied the literary and documentary sources, even though his conclusions were dismissed by Sheppard Frere as 'frankly unbelievable' (Frere 1987: 180, n. 64). After all, what is the alternative? That a diktat was issued stating that about half of the regiments forming the army of Britain should change their names overnight? The answer is that across the Roman Empire new units with strange names were created and assigned to the frontier

regions and this happened in Britain as elsewhere.

Can we seek occasions when the forts in the Pennines might have been abandoned? For John Mann, the reason behind the reduction in the army of Britain was the long period of peace in the frontier regions from 211 onwards (Mann 1974b: 38). We could suggest two occasions unrelated to peace in Britain when troops might have been withdrawn from the island. The first was the 50 years of civil wars and invasions throughout the empire from the death of

Figure 82. A coin of Constantine I

Severus Alexander in 235 to the accession of Diocletian in 284. In these years, troops might have been withdrawn from Britain to feed the frantic struggles on the continent. The 260s and 270s in particular were years of crisis with Dacia across the Danube and the Agri Decumates between the headwaters of the Rhine and Danube abandoned followed by southern Mauretania Tingitana in the later 280s. The end of the coin series at sites along Hadrian's Wall in the 270s might reflect troop withdrawals in these particular crises.

The second possible occasion was the period of civil war following the abdication of Diocletian in 305. At one point in the years between 306 and 326 there were no less than six emperors. The eventual winner was Constantine I. The victory which turned the tide in his favour was the battle of the Milvian Bridge in October 312, when Constantine placed the Christian symbol on the military flags (Figure 82). It has been argued, on the basis of the coinage, that in preparing for that battle Constantine came to Britain and abandoned the outpost forts so as to incorporate their regiments into his army (Casey and Savage 1980). It is perhaps unlikely that Constantine would go to so much trouble for just four units, even though they were probably all thousand-strong regiments, so it is possible that he swept up more into his army.

Plan D

To return to slightly more solid ground, Plan D, in so far as it was a plan and not just a reaction to imperial requirements, appears to have been a running-down

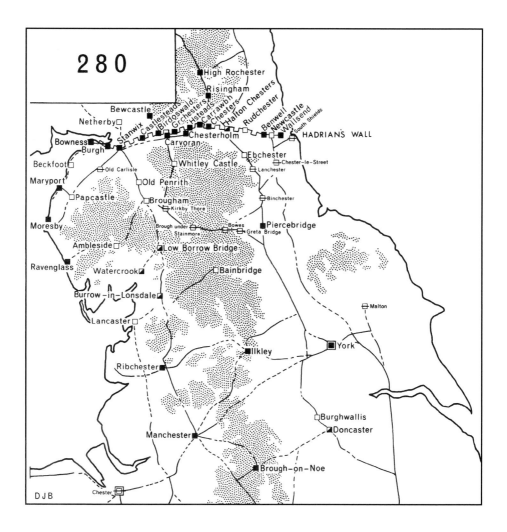

Figure 83. Map of northern Britain about 280

of the army of Britain, with regiments in the hinterland forts either disbanded or moved elsewhere and perhaps detachments withdrawn from other forts leaving smaller forces based there (Figure 83). The *Notitia* list indicates that the legion survived at York and most of the units along the Wall and down the Cumbrian coast as far as Ravenglass, together with Ribchester and a couple of unlocated units further south. Mann suggested that the forts along the western seaboard may have been retained owing to raiding from Ireland as implied in the Panegyric of Constantius Chlorus in 297 when the Hibernians were stated to be a threat to the province (Mann 1974b: 38).

Military deployment in Plan D was thin. Whether this was the result of peace on the northern frontier or requirements for troops elsewhere is a moot point. What we can acknowledge is that when Rome let slip her guard, when she was preoccupied with problems elsewhere, her enemies frequently took advantage of the situation. In time Plan D came face-to-face with reality, the threats posed to the British provinces throughout the 4th century.

Shortly before the year 300 we have the first references to the Picts and Hibernians (*Pan. Lat. Vet.* VIII, 11, 4). In 305 the Emperor Constantius and his son Constantine came to Britain and campaigned against the Picts, victory being acclaimed on 7 January 306 (*AE* 1961, 240). We must assume that the situation was serious as it brought Constantius, newly acclaimed emperor, to the outer fringes of the Empire. Although Constantius had been Caesar, that is nominated successor, to the western emperor, for 12 years, the announcement of the succession to the reigning emperors Diocletian and Maximian on 1 May 305 did not go according to plan. In Milan, Constantius was duly declared emperor, but in the East his son Constantine was passed over for the appointment of Caesar. The situation was tense. Constantine was allowed to go to his father then in Gaul, and together they crossed to Britain to campaign against the Picts. This must have taken place late in 305 and that underlines the seriousness of the situation on the northern frontier for in a tense political situation it is unwise to banish yourself to the edge of the world without due cause. In this case, had the Picts and the Hibernians recognised the weakness of the Roman army in Britain? Six months after the announcement of victory, Constantius still in Britain, died on 25 July 306 and his son Constantine was proclaimed emperor in York (*Anonymous Valesianus* 2, 4).

Perhaps the victory was successful enough to allow for regiments to be withdrawn from Britain, possibly when Constantine left for Gaul. Thereafter, there is another gap in our sources, with the exception of Constantine taking the title *Britannicus Maximus* in 315, though whether this was to mark the tenth anniversary of his earlier acclamation or related to further campaigning is uncertain; the former is perhaps more likely.

The final frontier

In the winter of 342/3 there was such a serious situation that it brought Constans, son of Constantine, to Britain where 'the Briton quailed before the face of an unexpected emperor' (Julius Firmicus Maternus, *On the errors of profane religions* 28, 6). The visit was recorded by Ammianus in a lost book but his later reference to the event does include mention of the Picts and the Scots (Ammianus Marcellinus, *History of Rome* 20, 1, 1). The gap in references to Britain between

Figure 84. A coin of Valentinian I

305 and 342 may reflect a period of peace following the campaign of Constantius and Constantine, and the same could be said for the gap between 343 and 360.

The 360s were a difficult decade for Britain. In 360 the Picts and the Scots attacked; in 364 the Picts, Saxons, Scots and Attacotti are listed and in 367 the Picts, Scots and Attacotti attacked (Ammianus Marcellinus, *History of Rome* 20, 1, 1; 26, 4, 5; 27) (Figure 84) In 382 the usurper Magnus Maximus campaigned against the Picts and the Scots, defeating them (*Chronicler of 452*). About 400 Stilicho, ruler of the Empire under the effete Honorius, did something of an uncertain nature to protect the island, and about this time a field army was dispatched to reinforce the army of Britain (Claudian, *On the Consulship of Stilicho* 2, 247-255; *Notitia Dignitatum*, chapter 7). This in itself was a reflection not only of the seriousness of the pressures on the frontiers of Britain but of the intention to retain the island.

It is presumably this attitude which had led to the reinforcement of the army of Britain through the dispatch there of new style units earlier in the century. If we look at a map of occupied forts we can see that military deployment in north Britain was similar to that in the 2nd century, based on the roads leading to the northern frontier (Figure 91). There is no evidence that the people living south of the Wall were restless at any time during the Roman period therefore requiring close supervision. There is, however, a new issue to contend with, the size of the regiments in the late Roman army.

This is a troublesome subject because we have so little evidence. About the only agreement that we can achieve is that regiments were smaller than before. The strength of a legion was reduced from about 5000 to about 1000 while the size of some regiments appears to have been less than 100 (Hodgson 1991). Archaeological evidence is not as helpful as we would like. At South Shields, Wallsend, Housesteads and probably Vindolanda barracks with four, five and six rooms have been recorded instead of the earlier eight, nine or ten (Hodgson

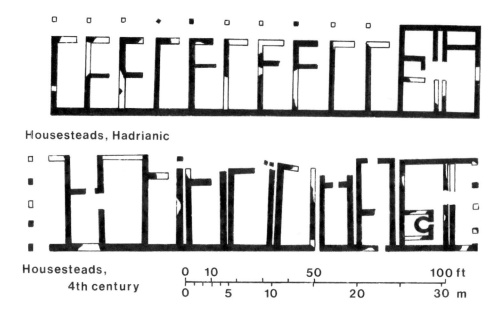

Housesteads, Hadrianic

Housesteads,
4th century

Figure 85. Barrack-blocks at Housesteads; the upper barrack dates to the Hadrianic period while the lower to the late 3rd or early 4th century

and Bidwell 2004). This type of barracks first appears in the 230s and 240s but any suggestion that they imply reduced numbers of men must be treated with caution for when the total floor area of the six barrack-rooms at 4th century Housesteads are compared with the ten rooms of their 2nd century predecessor they are almost the same (Figure 85).

Smaller units, of course, had an effect on the size of the whole army, and, by implication, on the size of the enemy forces it faced. It is noteworthy that while the newly-built forts of the late Empire had high walls and were strongly defended none of these features were introduced to the Hadrian's Wall forts. Many fort gates were completely blocked by the later 4th century, and wide ditches were dug, but the latest known repairs to forts walls produced earthen banks. We might conclude from this that the enemies that the Romans faced on the northern frontier were not as troublesome as those harassing the west and southern coasts of Britain. We do have references to the activities of the Picts in the last decades of the 4th century, but no references to them attacking the Wall (Claudian, *On the Consulship of Stilicho*, 2, 247-255; *On the Gothic War* 404-418). For all we know, the Picts sailed down the east coast by-passing the Wall altogether in 367 which might have been the reason for the construction of the fortlets-cum-towers along the Yorkshire coast shortly after this date (Figure 87). Yet this is a conundrum: how do we relate the literary evidence for warfare with the lack of modern military architecture?

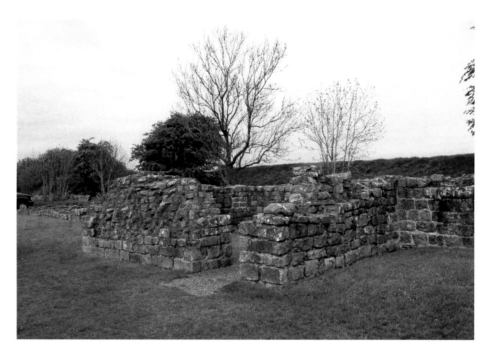

Figure 86. Turret 52a (Banks East) which was still occupied in the late 4th century

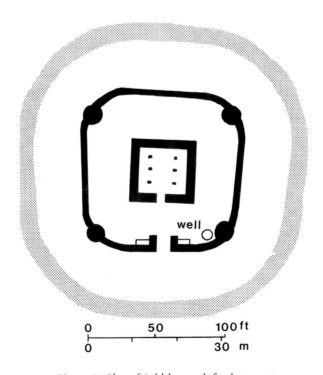

Figure 87. Plan of Goldsborough fortlet-cum-tower

What about Hadrian's Wall itself? At least ten milecastles are known to have remained occupied into the 4th century (Table 4). We have already seen that most turrets had been abandoned; only three can be shown to have been occupied into the later years of the 4th century (Figure 86). A hut appears to have been built in one turret. It is normally assumed to be civilian in nature, but we cannot be sure. As for the Wall itself, there is little that we can say. Bede records it still standing 12 feet high, presumably at the east end, and on Highshields Crags excavation revealed a Wall standing 10.5 feet / 3.3 m high to a level mortared flat top (Figure 88). This in itself, however, does not imply a regular maintenance programme for the Wall, just that the Wall was sturdy enough to survive.

It is often assumed that, somehow, the Wall was run down in its last years, but there is little evidence for this. Collins and Hodgson have drawn attention to changes in the late 4th century, including to the arrangements within barracks and houses, to the appearance of areas of crude paving, to a lack of maintenance of roads, but buildings were replaced, as at Birdoswald, and fort walls repaired, though in a less formal style (Collins 2012: 75-101; Hodgson 2017: 144-150) (Figure 89). Nor should we necessarily mistake crudeness for decadence. As Mark Savage

Figure 88. The Wall on Highshields Crags showing the flat top surviving for several metres

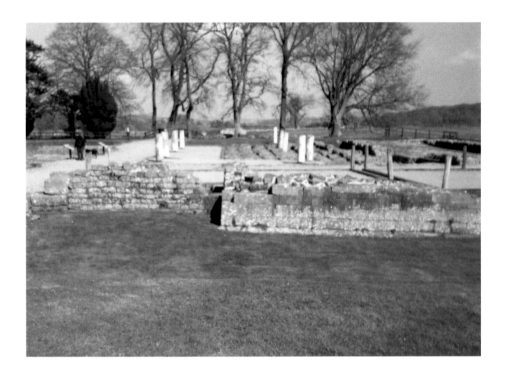

Figure 89. The late timber hall at Birdoswald; the main uprights are represented
by modern posts

pointed out in the report of his excavation of MC 35 (Sewingshields), 'regarded in isolation, the fourth century at Sewingshields represented something of a decline in the style of life on the site, or at least its structures seem more crude than their predecessors. The metal-working deposits indicate, however, that life was far from basic' (Haigh and Savage 1984: 51).

Coins too might be taken into account as evidence for activity even into the 5th century for it was presumably through the army that these coins arrived on the Wall. It is believed that little bronze coinage was sent to Britain after 395; soldiers were no

Figure 90. A coin dating to 406-408 found at
Great Whittington

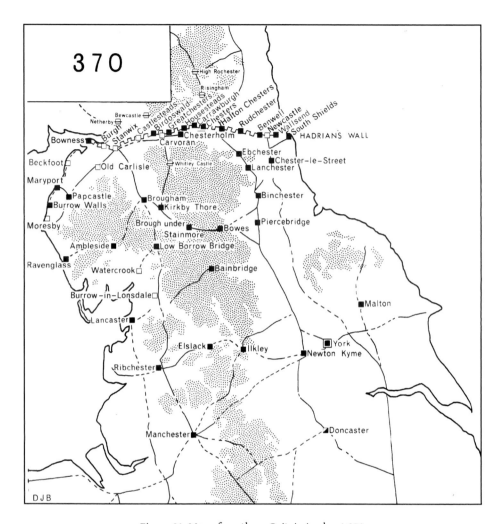

Figure 91. Map of northern Britain in about 370

longer paid in specie but in kind. Some later coins have been found at northern sites but worn, slightly earlier coins have been recovered from other sites. Rob Collins has recently published a small group, perhaps the contents of a purse, found at Great Whittington 2km north of Halton Chesters (Collins 2008). The latest of the eight coins dates to 406-8 (Figure 90). Nor is it alone. A hoard at Heddon-on-the-Wall included a coin of Arcadius, the Eastern emperor, issued between 404 and 408.

What we might regard as the last plan for Hadrian's Wall, Plan E, dating to the last years of the 4th century and presumably continuing into the early 5th, was not so different from its late 2nd century predecessor (Figure 91). The Wall itself survived with some milecastles in use, but hardly any towers, at least so

far as we can see. Although the outpost forts had been abandoned, there was a wide military zone to the south with regiments focussed on the two main gates through the Wall. What is different is the smaller number of troops involved. Hitherto, the legions had provided a back-up force, but they had either been removed or considerably reduced in size. To replace them, a new mobile force was required and this is what had been provided almost as the clock struck midnight.

Five plans

I have identified, at least to my satisfaction, five different 'plans' – I use the term loosely – for Hadrian's Wall over the near 300 years of its occupation. The first plan was for a simple barrier with gates at every mile and towers every third of a Roman mile along its entire length and, beyond it in the west, placed in front of an existing line of forts. A relatively small force spread along its line would have been charged with the duty of frontier control while the defence of the province lay with the regiments spread across the country to the south. This was of its day. I would argue that it developed out of the measures Trajan undertook to protect frontiers so as to allow him to undertake wars elsewhere, coupled with Hadrian's obvious intention to avoid further expansion.

Before this scheme was completed, 20 or so regiments were moved into the frontier zone and dispersed along the line from near the mouth of the Tyne to Ravenglass on the Cumbrian coast. Control was tightened by the construction of the Vallum running along nearly the whole length of the Wall immediately to its south. This was Plan B. We might see it as a reflection of reality. A wall would not stop an army – and it was an army which had given the Romans a bloody nose – only men would do that and this underpins Hadrian's action in transferring so many regiments into the frontier zone, so many, too, intended to operate north of the Wall, and sealing off this new military zone by the creation of the Vallum to the south.

The Antonine Wall came and went but it seems to have been the major invasion of the early 180s that led to a reappraisal of the Wall. Again, we can see a strategic reaction to the threat from the north. More troops were based at the Wall forts, military deployment to the south was carefully arranged so that cavalry units were focussed on the two main roads through the Wall, and advance forts were occupied with at least three serving as the bases of scouts with soldiers operating beyond the Cheviots. The measures undertaken for the defence of the Empire were pushed closer to the enemy. Military dispositions were supplemented by treaties with the Caledonians and Maeatae, recorded in the late 2nd century, and the payment of subsidies. The result was that the

role of the Wall and its structures was reduced. The towers along the Cumbrian coast had already been abandoned, now, many, perhaps most, turrets on the Wall were abandoned. Milecastles survived – and into the 4th century – but had their north gates narrowed and most causeways across the Wall ditch removed. This was Plan C.

This plan lasted well into the 3rd century and its very success may have been the cause of its decline. It may have been the peace which seems to have lasted through most of the century that led to the disappearance of many units from the hinterland of the Wall, but equally possible was the requirement of emperors for troops for their wars, as has been argued for the abandonment of the advance forts. The units along the frontier zone from South Shields to Ravenglass remained but it seems probable that they contained fewer soldiers. Milecastles continued in use, but the separation of the fort at Birdoswald from the Wall is telling. This was Plan D.

Sometime in the 4th century a dozen new-style units were sent to Britain, occupying the forts in the hinterland abandoned earlier, but not the advance forts. These new regiments may have served the same function as their late 2nd and 3rd century predecessors, that of support for the troops on the Wall. The flanks of the Wall were protected by some forts along the west coast and the fortlets along the eastern littoral. At the very end of the 4th century the army of Britain was strengthened by the addition of a field army. This was Plan E and again we should see it as relating to the threat from the north and now the west.

These 'plans' represent an organic development lasting over a period of nearly 300 years. In effect, no *new* plan for Hadrian's Wall was created after the first, that which may have been cooked up in a palace on the Lower Danube. Each new plan was an adaptation of its predecessor. Nothing else was possible without the total destruction of the Wall to create a *tabula rasa* for a totally new frontier and that did not happen, except for the creation of the Antnnine Wall.

It is therefore not surprising that the pattern of military deployment and the occupation of the Wall installations in its last days was so similar to that of the 'mature' Wall 200 years before. After all the same geographical rules applied and the threat came from the same place.

Here lie the roots of the northern frontier of Roman Britain; the failure to conquer the whole island. What happened, or rather failed to happen in Britain, was part of the general failure of the Romans to complete their destiny and conquer the known world. Perhaps at no other time was this more manifest than the reign of Trajan. His attempts to protect Rome's frontiers while indulging in costly,

and in the case of Parthia unsuccessful, warfare can be identified in Britain as in Germany. In the case of the Tyne-Solway isthmus, it was the addition of forts, small forts and towers to the existing few bases. The next step was the construction of substantial linear barriers. With hindsight we can see that proactive warfare could only be carried out if all activities elsewhere were closed down – as Claudius had earlier realised – and protective measures undertaken. Here was the genesis of Hadrian's Wall. Thereafter, the pattern was set.

The most notable change is that of the late 2nd century. As in so much of life, it appears to have taken some years for the penny to drop, for it to be realised that once troops were placed on the Wall line much of the original plan was redundant. Hence the abandonment of so many towers, the restrictions in the use of milecastles, and the abandonment of the Vallum, at least round forts. The Wall remained a strong visible feature in the landscape, but what actually did it do? The front line lay far to the north, the increase in the number of soldiers in several of the Wall forts points to proactive military activity. This underlines the position of Collingwood and Mann that the Wall was irrelevant to military defence. At the end of *Hadrian's Wall* Brian and I wrote, 'there is little evidence for Saxons – and none for Picts or Scots – on Hadrian's Wall, and the Wall can therefore truly be said to have successfully served its purpose'. But what did we mean by 'the Wall'? Surely not the bare stone barrier. It was the soldiers in the forts which happened to be placed on the Wall that achieved its purpose. What effect these had on the surrounding people is another matter and this the subject of my next chapter.

The impact of Rome:
life on and around the frontier

Hadrian's Wall was a major feature in the landscape. It crossed the entire island and was part of an intensely occupied military strip in places up to 2km wide, itself sitting within a military zone over 240km deep. But it was more than that. It was a statement of imperial power, of the ability of a state to impose its will not only on the landscape but on the people living within it (Figure 92). It is easy to say that it must have had an effect on the people living within its shadow – and beyond – but more difficult to determine that effect.

The sources

There are several possible sources of evidence: any archaeological evidence provided by the indigenous population; the distribution of Roman artefacts; Roman literary and epigraphic testimonies; Roman military deployment. Unfortunately, the first, if not mute, might be described as quiet. It is difficult to point to any physical evidence for hostilities within the archaeological databases relating to the peoples within the frontier zone and beyond it (Figure 93). Roman artefacts certainly provide evidence for contacts, but not the specific nature of those contacts, which are, of course, open to interpretation.

Roman literary sources describe warfare but can be infuriatingly vague. Agricola certainly fought the Caledonians, but the enemy in Hadrian's reign and in that of Commodus is not named. We can only presume that it is the Caledonians. In 197 it is the Maeatae who are the trouble makers, then defended by the Caledonians, but the Maeatae disappear from history quickly leaving

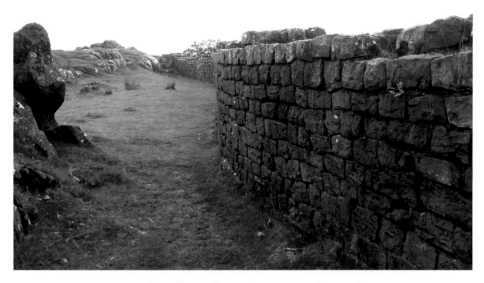

Figure 92. The wall at Walltown, a statement of imperial power

Figure 93. The Deskford carnyx, the head of a Caledonian war trumpet

only the record that they lived close to the wall that divided the empire into two halves; which wall is not stated (Cassius Dio, *History of Rome* 72, 8, 2; 75, 5, 4; 76, 12, 1). We cite place-name evidence to suggest that they lived in the region of Stirling (Dum Myot and Myot Hill: Breeze 1982: 130, Figure 28) (Figure 94). A hundred years later, the Picts appear on the scene and remain the stated enemy into the 5th century (e.g. *Panegyric of Constantius* 11, 4; Ammianus Marcellinus, *History of Rome* 20, 1, 1; 26, 4, 5; 27, 8, 5: Claudian, *On the Gothic War*). It is worth

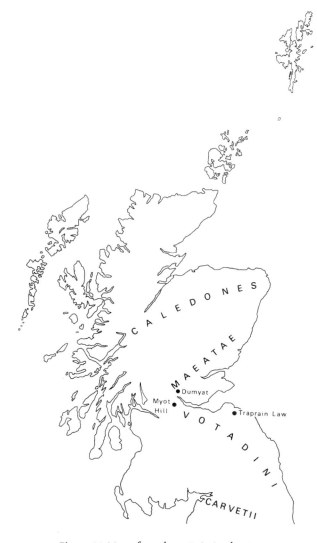

Figure 94. Map of northern Britain about 200

emphasising that there is no record of the peoples living between the Walls or in the hinterland causing any trouble. All the literary evidence which we have points to Rome's enemy being the Caledonians and their successors the Picts.

The Romans were not coy at recording that buildings had to be restored because of adverse circumstances, for example, in Cyrenaica owing to the fact that they had been destroyed and burnt down in the Jewish disturbance of 117 (Birley 1997: 152). In Britain, we have no such records. The burial of a centurion at Vindolanda killed in a British war in the early 2nd century is a useful, if rare, corroboration of an event recorded in literature (*RIB* 3364).

Figure 95. Military deployment in Dacia

In seeking an understanding of the northern frontier in Britain, therefore, the nature of military deployment is of considerable value. Perhaps the first observation is that it is unique. In no other frontier region is there such a depth of deployment. Along the Rhine and Danube, the Euphrates and across North Africa, the frontier is in effect a thin red line. There is certainly a pattern of fortlets and towers in the Eastern Desert of Egypt, but these are to protect transportation along the roads connecting the Red Sea ports and the Nile. There is also a distinctive pattern to military deployment in Dacia, but the placing of regiments back from the frontier was, we may presume, to allow them to move up to whichever pass was attacked (Breeze 2011: 133-137) (Figure 95).

Military deployment in Britain is different. It forms a deep zone, in the 3rd century stretching for 240 km from the Cheviots to Chester. There are, I suggest, three reasons for this: the narrowness of the front line; the size of the provincial army; the threat from the north. The narrowness of the Tyne-Solway isthmus led to troops being spread across the country to the south, as Brian Dobson pointed out 50 years ago (Dobson 1970: 34). The size of the army presumably related to the threat from the north, but perhaps also to the difficulties of sending reinforcements. The size of the army also brought the most senior military men in the imperial service to command it. The third element is the threat from the north and we might expect military deployment along Hadrian's Wall and in its foreland and hinterland to reflect the waxing and waning of that threat. The presence or absence of army units, we might assume, was reflected in the archaeological record. It is to that we must turn to learn more about the impact of Rome on the peoples of northern Britain.

Crossing the Wall

To start with the Wall itself, Plan A entailed 80 gates at milecastles and two others at special gates on the roads north. A traveller would only have had to walk half-a-mile to pass through the frontier. This, however, is assuming that the gates were available for civilian use. The necessity for the army to pass through the barrier to engage with an enemy to the north suggests that the gates were primarily provided for the use of the military. It is worth emphasising that so many gates were unusual for Roman frontiers. Whatever the original intention, it was superseded when the Vallum was constructed. This had the effect of restricting movement across the frontier. Now all traffic whether military or civilian had to pass under the eyes of the soldiers based at the forts. Here causeways of earth left across the Vallum ditch supported a gate (Figure 96).

Figure 96. The Vallum crossing at Benwell: the ditch was originally twice as deep

On passing through this gate, we have little evidence for what travellers were expected to do next. It would appear that there were three options: they could walk across the countryside between the Vallum and the Wall; follow the track beside the Wall which has been recorded in a couple of places, assuming that it already existed and if they were allowed to; or move along the north berm of the Vallum, where a metalled surface has been recorded in several places, to then pass through a gap in the north mound and proceed to a milecastle (Breeze 2015: 6-8).

We have already reviewed the evidence from other frontiers for admission to the empire. This was possible, but movement in the frontier zone was carefully controlled with permits issued to travellers while groups had to travel under military escort to specified markets. Since the records of such control stretch from the Eastern Desert of Egypt to the Lower Rhine we must assume that such control extended as far as the northern frontier of Britain.

Who might have been such travellers in north Britain? Farmers moving their livestock, diplomats, refugees, soldiers returning home after service in the army, or traders? There are plentiful references to Roman traders operating outside the Empire, though the sources are often recording their death at foreign hands. Strabo writing at the time of Augustus stated that trade existed between southern Britain and the Empire. The Britons exported cattle, gold, silver, slaves and hunting dogs, and received in exchange ivory bracelets and necklaces, amber glassware, and similar 'petty trifles' (Strabo, *Geography* 4, 5, 3). There is plentiful evidence for Roman traders living beyond the boundaries of the Roman state (Austin and Rankov 1995: 94)

More pertinently Tacitus tells us that the interior of Ireland was known through the activities of merchants (*Agricola* 24). The knowledge did not just embrace tribal or state names but encompassed place-names (Figure 97). Thus on *a priori* grounds we might expect there to have been Roman traders operating north of the Wall. Distribution maps suggest, as we might have expected, that most artefacts travelled by sea. So far as we can see, few people lived in the Highlands, reflected in the lack of Roman finds there. Elsewhere, nearly every excavated settlement produces at least one object dating to the 2nd century when the Empire extended to the Highland Line; those of the 3rd and 4th centuries are rarer, an issue to which we will return.

It is difficult to trace trade in reverse in any detail. Traprain Law has produced moulds for dress fasteners and Lindsay Allason-Jones has drawn attention to the number of objects with Celtic antecedents including terrets, torcs, brooches, ring-headed pins and so-called weaving combs (Allason-Jones 1980: 2-3). It is

Figure 97. Ptolemy's map of Ireland

difficult – impossible at present – to know where most of these objects were manufactured, but Allason-Jones has emphasised that the economic hot-spot that was Hadrian's Wall is as likely to have drawn in craftsmen and traders from north as much as south of the frontier (Allason-Jones 1980: 4).

When we come to look at the direct impact of the construction of the Wall on the frontier area, we have a major problem in the lack of excavations of the settlements of the indigenous population and our inability to date closely those sites that have been excavated. One settlement lay between the Wall and the Vallum at Milking Gap, close to MC 38 (Hotbank). This was excavated by Kilbride-Jones in 1937 (Figure 98). The date of its occupation has excited interest over a considerable period (Kilbride-Jones 1938). The excavator stated that the pottery, a brooch and glass bangles all dated to the 2nd century. Three sherds

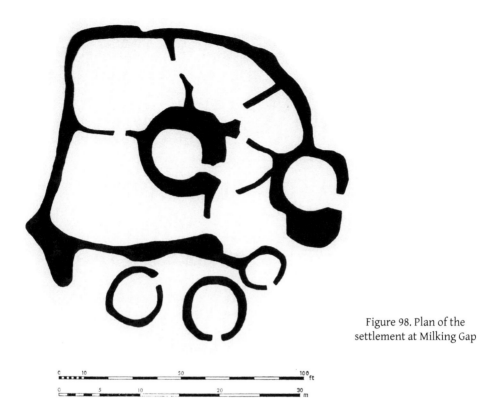

Figure 98. Plan of the
settlement at Milking Gap

of pottery were of early 2nd century date, but the excavator doubted that the site was occupied so early. The conclusion was that the settlement was founded after the abandonment of the Wall about 142 with the extreme possible end of its life being 180. In 1958, John Gillam reviewed the finds and proposed that the life of the settlement ended when the Vallum was dug, say, in the late 120s. Eric Birley, who had written the original pot report 20 years earlier, reaffirmed his dating, stating that 'owing to a misunderstanding, Mr J. P. Gillam' had suggested something contrary (Birley 1961: 275, note).

What we also need to take into account was the complexity of the settlement. Its growth from an enclosure containing one house to a village of five houses, two outside the perimeter wall suggests a longer life than a generation. If the pottery dates to the early-mid 2nd century this suggests an occupation starting in the late 1st century, perhaps earlier, and therefore possibly a settlement forcibly abandoned when the Vallum created a military zone.

I have spent some time on this one settlement largely because we have little other evidence for such sites along the Wall corridor but also because even when we do have an approximate date for a site – and all dates have to be

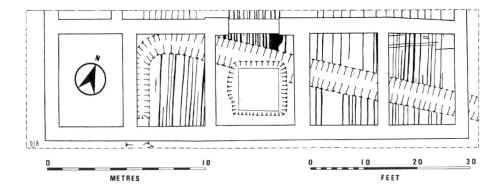

Figure 99. Plough marks under the headquarters building of the fort at Carrawburgh

approximate - it is not always easy to place it within a wider context. Several other potentially Romano-British settlements have been recognised in the same area on both sides of the Wall, and cord-rig cultivation, believed to date to the same period, has been recorded, but no other settlement has been excavated. Yet, plough marks have also been identified under nearly every Roman layer from Carrawburgh eastwards, as well as at Carlisle (Figure 99). This was a settled farming landscape several millennia old and it is difficult to imagine that some people were not dispossessed by the building of the Wall.

It is across this cultivated landscape that the Romans drew a line. There is a lot of discussion about the terminology of frontiers, including the definition of the words 'frontier' and 'border', and also the fact that the frontier sat within a broad zone which was affected by the existence of the frontier. The Romans were an ordered and legally minded people and their space had defined borders, whether they were cities or provinces, marked by boundary stones. They even had a god of the border. The borders of the Empire were defined and the Romans knew when they had crossed them into 'barbaricum'. At the same time, they had no inhibitions about operating beyond them; they acted as imperial powers do today, interfering in the territory of their neighbours if they wished to do so. In Britain, we can see the military frontier but we are not sure where the legal frontier lay. The economic and social effect of the border is another issue. The same issue operates today. How far would a motorist drive into another country in order to obtain cheaper petrol or obtain better bread? We might regard this as one definition of the frontier zone. Did the people of the north pop in and out of the Empire to shop as did those living just beyond the Rhine and Danube? We should not assume that this did not happen simply because we have no evidence.

It is clear that Rome spilled out in the other direction. Water came to the forts at Halton Chesters and Great Chesters through aqueducts tapping streams to the north of the Wall. At Wallsend space was so limited south of the Wall that occupation spread to the north of the barrier and possible civilian buildings have been recorded north of the Wall at Chesters and Birdowald (Breeze 2006: 84). North of Newcastle, fields have been identified, as they have been beyond the Antonine Wall. In Newcastle small numbers of abraded sherds hint at manuring with refuse from the adjacent fort and settlement, though we must not ignore the possibility of pre-Roman creation of these fields in view of the strong evidence for early agriculture along the Wall (Heslop 2009: 13).

So, we must expect that the first plan for the Wall had a direct effect on the people living in its shadow. We might expect that the concentration of two dozen forts in the frontier zone as part of Plan B would have had a more intense effect. There were many more thousands of mouths to feed now and the army liked to obtain as many as possible of its supplies locally. It may be for that reason that many forts were placed in areas of good farmland, though this, of course, is also where the people lived (Higham 1981: 108-109). The existence of the army is also likely to have stimulated the settlements recently recognised south of the Wall in County Durham (Proctor 2012). There is also significant new evidence from north of the Wall.

Impact in the Foreland

Several settlements of prehistoric and Roman date have been examined between the northern outskirts of Newcastle and Morpeth. Occupation began at some in the late Bronze Age, continuing into the Roman period. Early settlements were unenclosed, but around 400 to 200 BC settlements were more usually enclosed, as occurred elsewhere between the Tees and the Forth. Hodgson has drawn attention to the 'close and consistent spacing of contemporary sites in the landscape' (Hodgson 2012: 191); this was an intensively farmed landscape. Within the farms space was tentatively identified for herding, grain storage and metalworking. Wheat and barley were cultivated. Evidence for cattle, sheep/ goats and pig were recorded, together with horses. To the north of Morpeth, at Pegswood, an unenclosed farmstead settlement was established in about 400 BC (Proctor 2009: 66-67). This was succeeded by a larger settlement which would merit the description of a village, surrounded by a network of extensive enclosures. There were areas for habitation, storage, manufacturing and processing with enclosures for stock and a lane or drove road.

The dating evidence indicates that all these sites were abandoned in the late 1st to early 2nd centuries. At the three settlements south of Morpeth, Hodgson

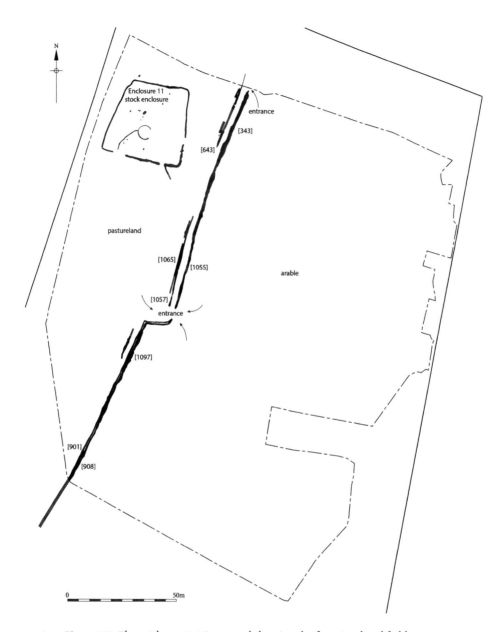

Figure 100. The settlement at Pegswood showing the farmstead and field system

argued for abandonment between about 120 and 140 on the basis of the near absence of Roman objects supported by the radiocarbon dates (Hodgson *et al.* 2012: 213-215). They had no identifiable successors. At Pegswood, Proctor has suggested that it was probably in the late 1st century that the village was replaced by a large timber enclosure and a substantial field boundary (Proctor 2009: 98) (Figure 100).

In his careful analysis of the evidence, Hodgson has offered several possible explanations (Hodgson *et al.* 2012: 216-220). He argued that depopulation through military recruitment, a proposition in favour fifty years ago, seems unlikely, as does transfer into slavery. These actions might have been taken when the area was conquered, but not two generations later. Another possible reason offered by Hodgson was deliberate clearance of the area in front of the Wall. We have already touched on the treaties on the Lower Danube in the 170s whereby the Romans sought to control the occupation of the zone to the north of the river. A hundred years before, Tacitus commented on uninhabited land across the Lower Rhine, retained for the use of the army (Tacitus, *Annals* 15, 54). Hodgson's tentative conclusion was that the Romans in Britain cleared settlements from a wide zone in front of the Wall (Hodgson *et al.* 2012: 217).

A more positive view of the evidence, offered by Hodgson and before him Jenny Proctor on the basis of her excavations at Pegswood, is that the abandonment of the settlements and the creation of a substantial field boundary, part of a possible stock enclosure, on an entirely different alignment may have reflected a response to the prodigious requirements of the Roman army, not least for cattle (Proctor 2009: 100-101; Hodgson *et al.* 2012: 219).

On the west coast, there have been attempts to demonstrate that Hadrian's Wall was a great divide. Jones and Walker (1983) sought to use aerial survey to identify distinctions between the types of settlements on each side of the Wall. They noted that settlements north of the Solway tended to be more defensive than those south, while the density of settlement to the north was also less, with fewer related field systems. Their conclusion was that the erection of the Wall allowed the development of a more prosperous and stable agricultural economy to its south. This may have been the case, but practically all of the sites are undated and there have been few excavations since 1983 to help us confirm – or challenge – the conclusion.

One project, however, has allowed a more in-depth view of what might have been happening to the north of the Wall to the west. Roger Mercer recently published the report on his excavations at Castle O'er and Over Rig in the valley of the river Esk some 30km north of Bowness-on-Solway, two sites in a densely settled landscape (Mercer 2018). Mercer offered a detailed discussion of the requirements of the army for cattle, to be used not only for meat, but leather and horn, and related these to the size of the army on the Wall and realities of supply, arguing that supplies would be most likely to have been obtained locally. He concluded that the annexes at Castle O'er may have been pens for cattle and/or ponies bred for sale to the Roman army.

This conclusion, and that of Proctor to the east, fits well with the approach taken by Sue Stallibrass (2009). Stallibrass has drawn attention to the preponderance of cattle bones on the sites of the military community. The skeletal element in the collections implies that the animals arrived on the hoof. She noted that the requirements of the army in the Wall's hinterland may have resulted in a lack of surplus for export to the frontier forts, and that the densely occupied agricultural land of southern Britain was better suited to growing crops, some of which we know were exported to the continental armies.

Stallibrass observed that the 'area between the two Walls is an area of upland that is well suited to cattle and sheep farming' and asked whether this 'could have been an additional production area for military meat supplies?' (Stallibrass 2009: 104). In seeking to answer the question, Stallibrass cited as comparison the droving of cattle south from Scotland to southern markets from the 1660s through to the middle of the 19th century. Stallibrass cited the reference by Pliny the Elder to geese being driven to Rome from northern Italy as a useful example from the Roman period (Pliny, *Natural History* 2, 27, 499).

Stallibrass acknowledged the lack of evidence from Britain. She did, however, point to the existence of the outpost forts to the north of the western end of the Wall and asked whether they might have played a part in droving, not least as Bewcastle was on a post-medieval droving route (Stallibrass 2009: 108). She also noted the suggestion of Bill Hanson that in the late first century the compounds at Elginhaugh were used as a collection point for animals (Hanson 2007: 699). Isotope analysis may provide an answer to the question posed by Stallibrass (2009: 109). In the meantime, we can see that theory and field investigations are on a similar trajectory.

We have so far been considering a relatively narrow strip of land north of Hadrian's Wall. If we broaden our horizons we can acknowledge that one archaeological characteristic of all the land up to the Forth is our inability to recognise all but a few settlements of the 3rd and 4th centuries. The wide social spread of artefacts in the 2nd century has gone and most 3rd and 4th century material is found on hill forts such as Traprain Law, Eildon Hill North, Edinburgh Castle Rock and Dumbarton Rock (Hunter 2010: 96) (Figure 101). There is material elsewhere, for example, in Tweeddale just north of the Cheviots and at Huckhoe in the Wansbeck Valley closer to the Wall. Here sherds from at least five vessels of late 3rd to 4th century date were recovered (Gillam 1959: 256-7). The fact that Roman pottery could reach some sites emphasises its absence elsewhere.

Fraser Hunter has noted a link between quality Roman objects and the social hierarchy (Hunter 2007: 37). Perhaps Huckhoe falls into the same category.

Figure 101. Two brooches found on Edinburgh Castle rock

While writing up the pottery from the settlement at Crosby Garrett, some 50km south of the Wall in modern Cumbria, Paul Bidwell drew a parallel between the late 3rd and 4th century pottery there and the material at Huckhoe (Bidwell 2018: 67). The point is, Crosby Garrett settlement is where the Roman 'sports' helmet was found (Figure 102). On anyone's calculation, this settlement was of some significance and heightens our appreciation of Huckhoe.

The duration of Plan C is important in assessing the impact of Rome. Now, there were major bases in advance of the Wall, evidence for operations beyond the Cheviots through a physical military presence, the existence of the scouts, cavalry back-up, together with the treaties and the subsidies, all revealing how the northern frontier was controlled. In trying to assess Rome's impact on the northern frontier we should ignore Hadrian's Wall. It was not the frontier and the paucity of Roman material in the land between the Tyne and the Forth cannot be put down to its situation beyond the frontier for at least part of it did lie within the province and the remainder in its shadow. The transformation in the landscape recorded by Hodgson and Proctor occurred, to all intents and purposes, within the province, or at least within a zone of impact which stretched for 120 km beyond the Wall to the Forth. Within this zone, the lack of Roman artefacts in rural settlements from the 180s onwards can potentially be explained by the widespread change in farming practices identified on the Northumberland Plain, in response to the Roman army's voracious appetite.

The change in farming practices appears not only to have swept away farmsteads but, I suggest, may have focussed economic power into fewer hands, those of the people whose settlements have produced 3rd and 4th century pottery and artefacts, the social elite, perhaps simply the entrepreneurs. The former farmers are likely to have lost not only their farms, but their position in society (compare

Figure 102. The Crosby Garrett helmet after restoration

the Clearances and enclosures). It may be that they lost their interest in Roman objects. That may be too simplistic a proposition. The Wroxeter environs project has demonstrated that the people of its countryside 'were much less interested in the material culture of Rome, especially away from the road network' and this is also reflected, to an extent, in east Yorkshire (White 2014: 11; Millett 2014: 19). The lack of Roman material culture on rural sites has sometimes been interpreted as indicating a rejection of Rome, but we should be cautious of this model; other explanations are possible. The poor material culture of rural settlements in the Lower Rhineland has been explained by Carol van Driel-Murray as relating to the absence of local men on service in the Roman army and the survival of their women within a subsistence economy with no money to buy Roman goods

(van Driel-Murray 2008). In other words, the lack of Roman artefacts was not a conscious decision but an enforced one. What we can say is that the local people were sucked into the new entrepreneurial life style of the frontier region.

They may also have been sucked into the Roman taxation system. This was based on the census such as that carried out by Haterius Nepos within the territory of the Anavonensian Britons, presumably Annandale (*ILS* 1338; cf *Tab. Vindol.* 611; Birley 2001) Taxes were normally paid in cash, but the poorer tribes of the frontier regions could pay in kind, as did the Frisii north of the Rhine and the Batavians of the Rhine delta, the former in ox-hides and the latter in recruits to the army (Tacitus, *Annals* 4, 72; *Histories* 5, 25). As the Roman army sought to source its supplies locally we should be aware of that potential symbiotic relationship.

Civilians on the Wall

It was not just the army that required feeding. In a memorable phrase, Lindsay Allason-Jones likened the appearance of Hadrian's Wall in the landscape with its enormous garrison and trail of civilians to the equivalent of the Klondyke (Allason-Jones 1980: 4). People were attracted to this north-west frontier from as far away as Palmyra on the Eastern frontier and Mauretania to the south.

The existence of extra-mural settlements has long been recognised. Excavations have been few in number, but our knowledge of the environs of forts was completely revolutionised through geophysical surveys, in particular those by Alan Biggins and David Taylor of TimeScape (Figure 103). Extensive remains were planned, spreading over a wider area than the fort.

In the main, the buildings, mostly strip houses, within these extra-mural settlements lay to both sides of the roads leading east and west from the fort gates. Some, such as those outside the south gate of Housesteads, appear to be shops (Figure 104). Here also a workshop and shrines have been recognised, and of course temples are known outside several forts (Figure 105). Granaries have been identified, presumably for the civilian community and some of the larger buildings may have served as storehouses. Literary sources include merchants, priests, craftsmen, publicans and prostitutes as members of the military community. At Birdoswald a long, wide triangular open space west of the fort has been identified as a possible market place. The geophysical surveys reveal stone buildings, but these would have required timber for roofs and remind us of another major requirement; to which we can add firewood. We know nothing of the effect of these major requirements for timber on the countryside around forts and their extra-mural settlements.

Figure 103. Geophysical survey of Birdoswald fort and its extra-mural settlement by TimeScape

Figure 104. The buildings outside the south gate of Housesteads

Figure 105. The mithraeum at Carrawburgh

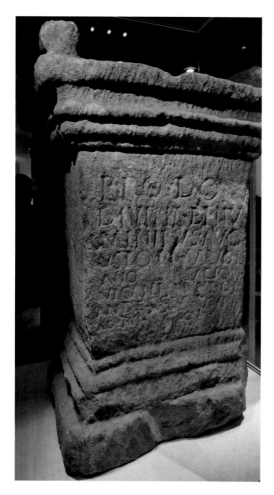

Figure 106. An inscription recording the vicani
Vindolandenses at Vindolanda

The plans are wonderful, but the buildings they record are mostly undated. Little too is known about the inhabitants of the buildings. Inscriptions are one source of information, but these are restricted in the information they provide as most are tombstones of the wives, children and other relatives of soldiers, members of the military community. Two inscriptions record that the people of Housesteads and Vindolanda had acquired self-governing rights, but more interesting is such a record from the Antonine Wall, a frontier only occupied for a generation (*RIB* 1616; 1700; 3503) (Figure 106).

In seeking to determine the nature and status of the people living in the extra-mural settlement, we should acknowledge that the Roman army even on campaign was accompanied by camp followers. Caesar makes clear that these were excluded from the military compound, the camp, unless the situation deteriorated seriously (e.g. Caesar, *The Gallic War*, VI, 37). Such camp followers would have accompanied the soldiers when they moved to permanent bases, and when the regiment moved on, so did the camp followers. There was no point in them staying at the abandoned fort; there was nothing there for them.

There is an interesting inscription in Spain recording that the Emperor Vespasian allowed a community moving from their *oppidum* to a new site on the plain to take their privileges with them (*ILS* 6092). The point is that the privileges related to the people not to the place. We can see, therefore, that a new regiment arriving on Hadrian's Wall would have been accompanied by followers probably

already in possession of a certificate of privileges. We have tended to assume that many inhabitants of the extra-mural settlements, and indeed recruits for the army, came from the surrounding countryside, and perhaps some did, but the army itself travelled with its own civil community and its own ready source of recruits, the sons of soldiers. If country boys were recruited for service in the Roman army, they did not send souvenirs home to their mothers as the paucity of Roman material on rural farmsteads demonstrates.

The heyday of the extra-mural settlements at forts appears to have been the 2nd century and on to the late 3rd century. Sometime towards the end of that century what we perceive through geophysical surveys as thriving communities came to an end. At the extra-mural settlements at Vindolanda and Housesteads the coin sequences end in or about the early 270s (Brickstock 2010: 86). In addition, the excavated areas outside Wallsend, Newcastle and Burgh-by-Sands on the Wall, Maryport and Ravenglass on the Cumbrian coast, and eight sites in the hinterland of the Wall have failed to produce evidence for occupation continuing after the late 3rd century (Bidwell and Hodgson 2009: 33-34; Hodgson 2009: 35-6; Loach 2013: 118) (Figure 107). The situation is particularly interesting at South Shields. Here, there is a suggestion that at least in one area buildings in the extra-mural settlement were systematically dismantled (Snape *et al* 2010: 63). Later 3rd and 4th century coins and small quantities of 4th century pottery were recovered from all the larger excavated areas, but in each case by this stage the land had been given over to agricultural activities (Snape *et al* 2010: 127).

The abandonment of civilian settlements on the frontier in the late 3rd century can be paralleled at several sites on the Middle Danube, both legionary and auxiliary, from Vienna to Mursa (Láng 2018: 165-166). At Brigetio, where coins, samian and amphora end in the middle of the 3rd century, Linda Dobusi has used almost the same words, systematic abandonment, to describe the situation (pers. comm.). In this case, however, Dobosi has concluded that the inhabitants simply abandoned their homes (Figure 108). We appear to have a phenomenon which is not unique to Britain and therefore we must consider our evidence in a wider context.

The fifty years from 235 to 284 were turbulent with civil wars and invasions a constant theme. As we have seen, in the 260s Dacia north of the Danube was abandoned as was the land between the upper reaches of the Rhine and Danube followed by southern Mauretania Tingitana in the 280s. There are several possible reasons for the abandonment of settlements outside forts at about the same time. Pressures on the frontier may have led to the civilians moving inside the forts (Láng 2018: 165). The withdrawal of troops from the frontier

Figure 107. A house at Maryport excavated by Oxford Archaeology Ltd

forts to serve in the field armies would have led to a crisis in the extra-mural settlements with fewer soldiers with families, fewer soldiers to service and fewer mouths to feed (Bidwell and Hodgson 2009: 33). The economic crisis of the 3rd century led to a decline in the spending power of the individual soldier and the introduction of payment-in-kind. This would have led to less money being available to buy goods from the traders and possibly soldiers having to give up their slaves, but not to the abandonment of families. The bottom line is that if the soldiers survived in their forts, and we see no reason to believe that this did not happen even though numbers were smaller, then there were women and children somewhere close.

Figure 108. Houses in the civil settlement at Brigetio abandoned in the late 3rd century

What can we make of the evidence from Britain? In 1980 Daniels, following his own excavations at Wallsend, during which he examined a considerable part of the fort and traced its history, offered an explanation for the striking change in the planning of the fort from the 2nd and 3rd centuries to the 4th century (Daniels 1980: 189-191). He suggested that the reason was that the regiment at Wallsend, together with others, had been withdrawn for service in southern Britain and departed accompanied by their families, and that when they returned men, women and children all moved into the forts, each family occupying one of the new chalets. Unfortunately, we have no evidence to determine whether this model has any validity. In fact, in the final report on Daniels' excavations it is stated that little evidence for the presence of females was found in the fort, except in the commander's house, though the number of female items compares well with the items of military equipment (Rushworth and Croom 2016: 208-209).

Daniels was basing his premise on the assumption that the chalet barracks were introduced into the forts of northern Britain sometime around 300. The discovery of chalets at Vindolanda by Paul Bidwell challenged that interpretation for these were dated to about 60 years earlier (Bidwell 1985; Hodgson and Bidwell 2004). Further work at Wallsend by Hodgson led to a revision of the dating of the

Figure 109: Barracks at South Shields,
a. in the early 3rd century, b in the mid
3rd century

chalet barracks there to about the same time, the 230s (Hodgson 2003: 16). These barracks each contained only five barrack-rooms, the same number as at South Shields. In short, new styles of barracks were introduced to the north forty years before the purported abandonment of the extra-mural settlements (Figure 109).

Artefacts were brought into the discussion to help determine whether there was any evidence for civilians inside forts. In her report on the small finds from Housesteads Lindsay Allason-Jones noted that no unequivocal female objects were found in the chalets in the north-east corner of the fort, though they were in the centurion's quarters (Allason-Jones 2009: 431).

The story at Vindolanda appears to be different (Birley 2013). The extensive excavations here have allowed detailed analysis of the artefacts found in both the fort and the extra-mural settlement. There is a striking change in the distribution of loom weights, spindle whorls, beads, bracelets and hairpins, all objects with civilian connotations, between the 3rd and the 4th centuries (Figure 110). For each item, the overwhelming concentration in the 3rd century is in the civil settlement while in the 4th it is in the fort. In his review of the evidence, Andrew Birley acknowledges that the barracks may have been cleaned more thoroughly in the 3rd century resulting in fewer female artefacts found within the fort. He concluded that women did live in the fort in the 3rd century but that the number of adult women there increased substantially in the 4th century. What is equally interesting is the distribution of military equipment. In the 3rd century, excavation of the civil settlement yielded more sling shot, scabbard fittings, shield bosses

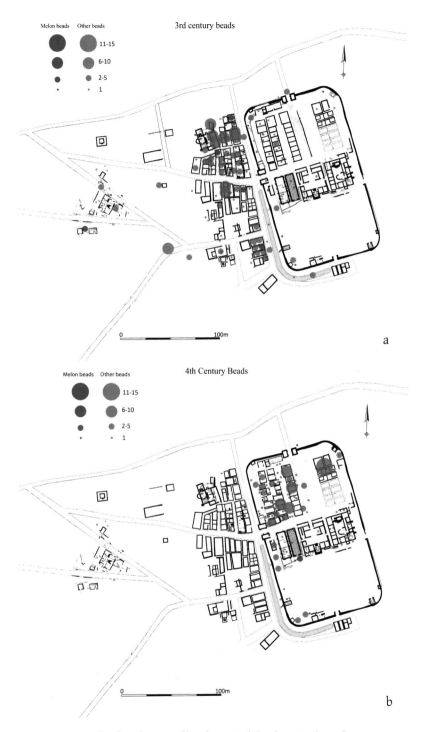

Figure 110. The distribution of beads at Vindolanda, a. in the 3rd century, b. in the 4th century, indicating a radical change in the settlement pattern

and shield fittings and fragments of armour than the fort. Birley concluded that 'the fort walls at 3rd-c. Vindolanda did not constitute a "great divide" [and] we should beware of using simple contrasting terms such as "civilian" or "military" when describing the occupation within an extramural settlement or a fort. We must consider the possibility that a more fluid pattern existed' (Birley 2013: 103). This is part of a pattern emerging across the Empire, with evidence for civilians being identified within forts, for example, at Vindonissa in Switzerland where have been identified a bar and an inn within the walls with women working and possibly living within the legionary fortress (Speidel 1996: 55, 80).

The different stories at Housesteads and Vindolanda are part of a wider pattern of differences between forts along the Wall. Chalet-style barrack-blocks have been recognised at some seven forts in the north, but they are often different from each other. Daniels (1980) identified ten different types of late barracks with striking differences even within the same fort. The relative uniformity of planning recognisable in the 2nd century barracks seems to have ended. Further, the chalet style of barrack has not been found in every fort, not at Carlisle and South Shields for example. In such circumstances it is difficult to produce a single interpretation which fits all the evidence.

There were many other changes in the 4th century, in the planning of forts as well as to individual buildings such as granaries and headquarters buildings. At South Shields, a large courtyard house was erected in one corner of the fort rather than its traditional location in the central range (Figure 111). These changes all relate to the use of individual buildings in forts and they appear to reflect different actions. This point was made by Lucien Roach: 'the lack of standardisation suggests that the modifications did not stem from a refurbishment drive dictated by Rome; rather, they seem to reflect *ad hoc* maintenance and responses to the changing needs of individual forts' (Roach 2013: 109). We have come a long way from the straitjacket of the Wall periods. We now don't even have regionalisation, we have truly moved to a position whereby the history of each fort has to be judged on its own merits. The old certainties have disappeared. The interiors of forts varied with implications for how they were used and we have only excavated a tiny proportion. It is more difficult than before to extrapolate from an excavation in one part of the fort to the rest, or from one fort to another.

Can we put everything together to make a viable model? I am not sure that we can. There are simply too many imponderables. So, what can we say? There seems to be good evidence that extra-mural settlements were abandoned in the late 3rd century, the 270s being the crucial decade. This was part of a wider phenomenon. There is disagreement about where their occupants went. The

Figure 111. Part of the reconstructed house at South Shields

lack of evidence for female-style artefacts in the men's quarters at Housesteads argues against the movement of women and children into the barracks at that fort; the evidence from Vindolanda, 3km distant, is in direct contrast. It has been suggested that some civilians drifted to the towns of the frontier region. Little can be said about Corbridge owing to the early date of its excavation, but while Carlisle continued in occupation we are not in a position to offer a view on any ebb or flow in the size of its population. In the hinterland, the villages at Catcote near Hartlepool and East Park, Sedgefield, continued to be occupied, but again we can do little more than acknowledge that (Proctor 2012: 176). But whatever happened, if the soldiers survived on the Wall, and it appears that they did, there would be, somewhere close, their women folk, traders, thieves, vagabonds and all the other people who lived off and with the army; we simply cannot see them, yet. And, when we look at the size of the extra-mural settlements along the Wall as revealed by geophysical survey, these are large numbers of people to have disappeared, or they are lurking in parts of these settlements which we have not yet examined?

New traders

It is something of an irony that while archaeologists have been grappling with the implications of the abandonment of extra-mural settlements, a new phenomenon should have been recognised in Hadrian's Wall forts, the market place (Collins 2013: 127, 131). This was first proposed as the interpretation of the

cluster of some 64 small coins at the junction of the two main roads in front of the headquarters building in the fort at Newcastle (Snape and Bidwell 2002: 275). The coins ranged from about 270 through to about 360 with a concentration in the 340s and 350s. The conclusion was that 'the casual loss of large numbers of coins seems best explained by money changing hands in some form of market'. A similar situation was recognized at Carlisle where the range of coins, found in the same location in that fort, was very similar to that at Newcastle (Zant 2009: 341). At Wallsend a concentration of 4th century coins, ending again about 370, were found 'in the area of the passageway through the Minor West Gate and the immediately adjacent area of the *intervallum* street to the north' with the conclusion that this represented some form of marketing (Hodgson 2003: 166-167). Hodgson emphasised that the area was restricted in size and may have been where individual traders or pedlars arrived to sell their wares (Figure 112). At Vindolanda there is an old record of nearly 300 coins of the 340s and 350s being found inside the main west gate of the fort (Birley, R.E. 2009: 150).

We have always assumed that traders in earlier centuries lived in the extra-mural settlements, not just because it appears to be so obvious but also because we have literary evidence for merchants being amongst the army's camp followers. On the other hand, a letter from a soldier in Syria stated that merchants came to his fort every day (*P.Mich.* 466). We might envisage that some traders were peripatetic, constantly moving around the military landscape of Hadrian's Wall. They would need to collect items to sell and the obvious places to serve as supply points would be the towns of Carlisle and Corbridge as well as South Shields at the mouth of the Tyne, possibly even Maryport on the west coast. The Vindolanda writing tablets 200 years earlier demonstrated that Catterick was an important supply point (*Tab. Vindol.*185; 343; 670).

While there appear to have been market places at four frontier forts in the middle of the 4th century, other sites have not yielded such evidence. Perhaps we have been looking in the wrong place. An obvious location for a market outside a fort would be beside the Portgate at the top of Stagshaw Bank, the location of a famous fair in the middle ages. Is it coincidental that the latest coins from Hadrian's Wall were found close to here at Great Whittington (Collins 2008)?

At least these coins hint at a relationship between the Romans on the Wall and those of the states to the north. John Mann denied such a relationship, pointing to the absence of Roman pottery of the late 4th century, so abundant within the province, and also coins, and concluded that the peoples of southern Scotland at this time were not friendly to Rome (Mann 1974: 218-219). This was part of his challenge to Richmond's 1940 hypothesis that Rome created buffer states to the north of the Wall in the aftermath of the Barbarian Conspiracy of 367

with the purpose of defending the province (Richmond 1940: 112-116)

Richmond based his interpretation on the supposed Roman names of the early kings of the states of the Scottish Lowlands, names which included Patern Pesrut, translated as Paternus of the Red Cloak, which Richmond saw as representing Roman investment of authority. Unfortunately, Pesrut means red shirt not red cloak and, as John Peter Wild has pointed out, red was a common die at Vindolanda (pers. comm.). If any colour was going to be used for investiture it would have been

Figure 112. The distribution of coins at the west gate of Wallsend fort

purple, in the manner of the tunic given to Clovis on receiving an honorary consulship.

Earlier, Kenneth Jackson had challenged the Richmond model, pointing out the unreliability of the source material, the early medieval genealogies (Jackson 1955). This statement by the expert on the period was dismissed by Richmond as 'a conservative view' (Richmond 1958: 125). Mann's interpretation of the Roman style names was that they reflected conversion to Christianity, the Roman religion, thereby leading to the adoption of Roman names (Mann 1974: 225). In short, Richmond's hypothesis has no foundation.

As always, at the end of the northern frontier we are left with Traprain Law (Hunter and Painter 2013). The coin series here runs to the very end of the

Figure 113. Part of the Traprain Treasure

4th century, the date of the treasure, and there are some fragments of late glass vessels. While in the past, the Traprain Treasure was seen as loot, today's interpretation is that it was a payment to one of Rome's neighbours to maintain their friendliness (Figure 113). We need to see this scenario in relation to the problems with the Picts which continued at least up to the end of the 4th century. It was also a method used elsewhere in these islands as indicated by the Coleraine Hoard in Ireland where two of Rome's enemies lived, the Scots and the Attacotti.

In some ways Traprain Law and Coleraine are the perfect end to Roman Britain. They reflect Rome's continuing policy of seeking to succour friends and influence peoples beyond their borders in order to maintain peace on the frontier. They are an integral part of Plan E, but more than that, they acknowledge the continuation of Rome's Grand Strategy for its northern frontier in Britain. It is research strategies that I should like to consider in my final lecture.

Hadrian's Wall today and in the future

In the opening paragraphs of his paper, 'After the Wall periods', Nick Hodgson offers his own premises in approaching the subject. He states, 'I accept certain hypotheses, such as the outpost forts being given up and most of the *vici* being abandoned by the early-fourth century. It might be objected that there is insufficient proof to do this. But these hypotheses have been advanced, with good supporting evidence, and no-one has seriously challenged them, and few have sought to test them further, over a period of many years.' (Hodgson 2008: 14). This statement carries two implications: we have to accept the school solution as it stands unless we wish to undertake the research to review it ourselves and that the current orthodoxies do require regular challenging.

Factors affecting out interpretations

The review of any aspect of Hadrian's Wall can be seen as a daunting prospect. There is a large archaeological data base to consult, the product of nearly 200 years of excavations, not to mention the previous 300 years of field observations (Figure 114). Then there are the texts, in Latin and Greek, which have been translated, but may need to be interrogated again as exercises in literary criticism. There is new documentary material constantly coming on line, not least through the Vindolanda writing tablets which cast light on the army and its activities in the immediate pre-Wall period. Some of these documents are near impossible to interpret. I once sat through a seminar in Oxford when we were trying to determine what was the purpose of a list of chickens, eating or sacrificing (*Tab. Vindol.* 581). But one of the most important aspects of these tablets is that so many are so similar to military documents from the eastern

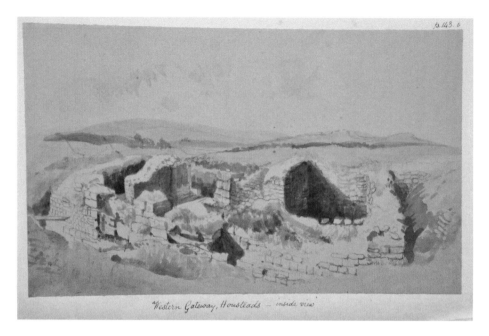

Figure 114. The west gate at Housesteads before clearance in the early 19th century

provinces that we can now use that eastern material to cast light on life on the northern frontiers of Europe which we were afraid to do in the past.

There are also the changing concepts. In order to review an aspect of the Wall we have to understand what everyone believed from 1929 to 1976, and some onwards from then, about the Wall periods. For over forty years, every excavation report interpreted its results within the framework of the Wall periods, and that included those who worked on the south coast. In order to rethink a report published between 1929 and 1976, the dating evidence has to be reviewed within the current more flexible framework.

And then there are our own biases and prejudices to cope with. They lie deep inside us and when we think we are free of bias we just fool ourselves. Many of our prejudices were taken in with our mother's milk or are the result of university teaching. We can also be quite wilful at pushing aside or supressing evidence we do not like. For my part, I like the statement attributed to Dorothy L. Sayers, along the lines of one happening is an event, two are a coincidence, three are a fact. It is difficult for us to do much with a single piece of evidence; our hope for understanding lies with an appreciation of all the evidence and a healthy scepticism at the interpretation of a single clue. So it is with any attempt to determine the purpose of Hadrian's Wall and how it actually worked.

Figure 115. The Roman Northern Frontier Seminar inspecting MC 37 (Housesteads)

How often do we review our own research? Infrequently, at best, I would suggest. We tinker, but don't go back to basics, to the beginning. And, of course, on top of that, most of us bristle at criticism. After all, we are only human and it takes a Gordon Childe to acknowledge we have got it wrong (Figure 115).

The location of the interpreter, in this case of Hadrian's Wall, is also of some consequence. The citizens of Newcastle, or perhaps better Tyneside, have always played a large part in the study of Hadrian's Wall. Is it any surprise therefore that for decades they took the view that the Wall was built westwards from Newcastle? I was struck in preparing the 14th edition of the *Handbook to the Roman Wall* that the further I progressed from Newcastle, the thinner the description of the Wall was in previous editions. This is perhaps not surprising considering that 12 of the 13 previous editions from 1863 to 1978 had been written by archaeologists based on Tyneside.

The role of zeitgeist is perhaps even more pernicious because it is more difficult to discern. Yet it is there, not always visible though sometimes obvious. We live in a post-colonial world, but when I was born the British Empire was still complete and many of those studying the Roman Empire were educated in public schools together with boys destined for a life in the imperial civil service. It was easy to succumb to the equation of British = Romans = good guys; the rest = bad guys. This easily leads on to an assumption, perhaps subconscious only but still there, that the others, the bad guys, the barbarians, were stupid. It seemed

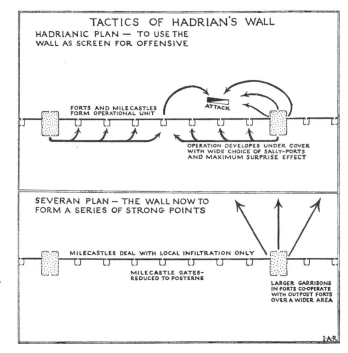

Figure 116. Richmond's
plan illustrating the
operation of
Hadrian's Wall

to Brian Dobson that this was implicit in Richmond's diagram of how Hadrian's Wall was intended to work (Figure 116). He felt that once Rome's enemies had been caught in Richmond's pincer movement it is unlikely they would allow themselves to be so trapped again (Dobson 1972: 192). Brian did not believe that the attackers would be so asinine. In passing, we should also note that Roman military writers clearly stated that the concept of this type of pincer movement was not sensible as men with nowhere to escape would sell their lives dearly; it is when they turn to flee that they are cut down from behind (Frontinus, *Stratagems* 2, 6: Vegetius, *Epitome of Military Science* 3, 21).

Another example of zeitgeist may be seen in Eric Birley's suggestion in 1956 that the Wall was a shield to protect the provincials and allow economic development within its shadow (Birley 1956: 28). This interpretation of the purpose of Roman frontiers coincided with the time when the American shield in Europe was at its strongest. It took the fall of the Iron Curtain 30 or more years later, and thereby the reduction in the importance of the American military shield, for us to appreciate that Birley might have been reflecting the spirit of his times when the protection afforded by the American army was so essential to the rebuilding and revitalisation of Western Europe.

The individual's experience of war is similar to zeitgeist, though it is different. The challenge of different experiences throws up new views, sometimes rather

quirky. In the First World War, Robert Forster suggested that the Vallum was a training scheme invented by the Romans to toughen up its soldiers (Forster 1915: 188). In his 1950 review of recent work on the Wall, Richmond stated in relation to the purpose of the Vallum, 'perhaps an analogy from recent conditions may help? In war-time Britain, where, in default of invasion, nothing worse than sabotage by enemy agents or more serious than unauthorised entry and exit was feared, installations of military importance were regularly screened by formidable hedges of barbed wire, impossible to jump and difficult to penetrate' (Richmond 1950: 52). I would have to admit that I personally incline to this interpretation through an anecdote of my father. Towards the end of the Second World War his ship tied up at a Greek island one evening and a jeep was unloaded onto the dock side. In the morning it was gone and in spite of a search of the island it was not found. It reminds us that we should not forget non-military activities in our explanations.

The trench warfare of the First World War is another aspect that has cast a long shadow in British archaeology. It led to a particular view of the way the Roman army operated, advancing, seizing territory, and consolidating its hold by building forts before moving on to claim the next bite of land. This led to Richmond's argument that Agricola advanced northwards from the Forth-Clyde isthmus towards Mons Graupius building forts in the mouths of the glens as he went so as to protect his flank, and presumably arriving at the battle field with just his batman (Richmond 1944: 41). The Romans knew better and kept the army together and did not disperse it on garrison duty until the war was won. It is a lesson that Napoleon failed to learn, discovering after his defeats in 1813 that his best troops were on garrison duty in central and eastern Europe and trapped there (Esdaile 2007:404).

Terminology is something to which we should pay more attention (Breeze 2014b). Richmond described the forts placed in the mouths of the Highland glens in the late first century as glen-blockers (Richmond 1944: 41). There is a clear defensive element to the term. More recently, the phrase 'garrison settlements' has come into fashion to describe extra-mural settlements at forts. The word 'garrison', however, has traditionally been used to describe a body of troops placed in a certain location in order to guard it. This was not the purpose of a Roman fort. Another phrase is more pertinent to this discussion, 'outpost forts'. The term implies that they are outposts of a particular line, and in Britain that line is Hadrian's Wall, with the further implication that the line is the frontier. The outpost forts were then in a sort of no-man's land. It seems doubtful that this was the case. We would expect that the land encompassed by the outpost forts was actually within the province and in that case the provincial boundary lay more-or-less on the Cheviots. This distinction is important because we can

no longer argue that the lack of 3rd and 4th century pottery north of Hadrian's Wall was due to the fact that these lands lay beyond the province; some lay within it. The alternative explanation for the paucity of pottery is that the farming pattern was changed and with it the social structure as Hodgson and Proctor have argued. We need another term for the outpost forts. The Romans called the area a *praetensio* (Speidel 1998), but that will not do. The German word is Vorland, but that is probably not satisfactory; in English, this would be Foreland, again not the best, but perhaps the best so far.

Today, we live in a Europe, in lands once part of the Roman Empire, that is seeking to control access to its space. In the circumstances it is hardly surprising that some, myself included, promote the references to the Roman control of entry to their Empire as a major reason for the existence of frontiers like Hadrian's Wall. Another modern activity is mass tourism which has various effects on our archaeological remains, including damage to monuments through over visiting, the creation of hard surface paths and car parks, pollution of the countryside through the erection of unsympathetic visitor centres and so many notice boards, and the skewing of archaeological activities, including excavation, in order to meet the requirements of the tourist industry. Polemic over, but how does modern tourism and the requirement for souvenirs affect our interpretation of the little vessels found along Hadrian's Wall? (Figure 117).

In his memorable account of the evidence for the study of Roman Britain, Leo Rivet included 'the opinions of modern scholars' (Rivet 1958: 28-32). These are

Figure 117. The Ilam pan

Figure 118. Graffito of the fort at Bu Ngem, Libya, with the towers
standing two storeys above the fort walls

certainly influential, and also very difficult to cast off, lingering in text books long after they have been challenged and should have been discarded. For example, the concept of a Brigantian Revolt in the 150s, advanced by Haverfield in 1904, was effectively challenged by Brian Dobson in 1976, yet it remains in Frere's *Britannia*, is not quite denounced in David Mattingly's book on Roman Britain, and lurks behind an allusion to unrest in the 150s in Nick Higham's 2018 book on Arthur (Haverfield 1904; Breeze and Dobson 1976: 105-108; Frere 2002: 136; Mattingly 2006: 101-102; Higham 2018: 54: for a wider discussion of similar phenomena see Breeze 2014b). As Nick Hodgson has pointed out, the 'event' was concocted to explain an inscription recently found in the river Tyne which is now interpreted differently (Hodgson 2017:77).

Figure 119. Brooch from Chieming, Bavaria, showing a fort gate with two storeys above

What Rivet did not explicitly include was the power of illustrations, which are, of course, based on the opinions of modern scholars. On practically every artist's impression of Hadrian's Wall the turrets are too squat, at least in my opinion. One of the most recent exciting developments in frontier studies lies in the field of military architecture, contra Hugh Elton's disparaging remarks 20 years ago about the value of studying Roman military architecture (Elton 1996: viii). We now appreciate that many of the towers forming part of Roman fort gates were probably taller, by one or more storeys, than we have hitherto been prepared to accept (Figures 118 and 119). Some have seen this as reflecting a wish on the part of the

Romans to overawe their enemies. That might be, but in practical terms it has a direct relevance on how we see Hadrian's Wall operating. In short, if there were tall towers, was there a necessity for a wall-walk? If we start producing artists' reconstructions of Hadrian's Wall with taller towers, how long will it take for this to have an impact on interpretative panels?

Several possible functions for Hadrian's Wall

In the third and fourth chapters I concentrated on three primary functions for Hadrian's Wall, military defence, protection against raiding and frontier control. These are but three of the twenty functions or more that have been ascribed to Hadrian's Wall. They include severely practical purposes, such as controlling transhumance, protecting the soldiers and an exercise to keep the troops busy, as well as more abstract suggestions, such as the creation of a symbol to intimidate the enemy, a symbolic act of building and a statement of Hadrian's commitment to imperial containment (Breeze 2018: 3-4; for strict military purposes see Luttwak 2016: 67-89).

Nor are any of these explanations mutually exclusive. John Mann argued that the construction of frontiers by the Romans was a reflection of their failure to achieve their aim of conquering the world, an aim enunciated by the Augustan court poets (Mann 1974a: 508). We can accept Mann's assertion and at the same time his statement that the Wall was of no help in defending the province from attack but, on the contrary, if under hostile pressure, the Roman army would have moved out of its forts into the field to fight in its traditional manner knowing that its superior training, discipline and weapons were most likely to give it victory (Mann 1990: 54). Mann went so far as to say that if a sizeable enemy force managed to approach the Wall itself, as it did in the early 180s when it was crossed, then the system had failed. That system for Mann included patrolling, supervision of meeting places and subsidies to the peoples north of the Wall. For Mann, Hadrian's Wall was but one part of a wider foreign policy.

One explanation which keeps being offered for the construction of Roman frontiers is that this was simply a means of keeping the troops busy. Tacitus describes two instances when it was specifically stated that actions were undertaken to keep soldiers occupied, though they were useful actions such as cutting a canal, while the mutineers in the year 14 complained that they were sometimes put to work as a precaution against leisure (Tacitus, *Annals* 1, 35; 11, 20). But it seems to me that the complex building history of Hadrian's Wall most strongly indicates that this was not a mere displacement exercise but a building project designed to ensure the appropriate protection of the province. We are back to the importance of minutiae.

We can see this through the patient unravelling of its building history over many years. The changes during its construction reflected an appreciation of the realities on the ground. The greatest single change, the addition of 20 or so forts to the frontier zone, was not simply a ploy to keep the soldiers out of mischief. And it is through these changes to that simple first plan that we can understand the way the frontier installations were intended to operate. Study of the minutiae of the changes is not an exercise in a vacuum. Rather, these minutiae are the pixels which coalesce to form a larger picture, the function of Hadrian's Wall.

Models, hypotheses and theoretical archaeology

One aspect of the study of Hadrian's Wall is conspicuous by its near absence, theoretical archaeology. Only Richard Hingley has sought to explore this aspect (Hingley 2008). This is strange as Hadrian's Wall not only offers an interesting subject but a body of evidence against which theories can be tested. It might be argued that such an approach requires the accumulation of a large body of evidence, but Hadrian's Wall can be chopped into bite-sized pieces and then the evidence is not so difficult to acquire. Matt Symonds came to Hadrian's Wall through his BA dissertation in which he analysed the plans of milecastles, David Woolliscroft through examining the position of milecastles and turrets in relation to the Stanegate sites, and John Poulter through some basic footwork to allow him to understand how Hadrian's Wall was surveyed. These projects in effect all sprang from good ideas and did not require decades of advance study.

What is important is the ability to check results in the field. Woolliscroft (1989) argued that some milecastles on the Wall were pulled out of their measured positions in order to allow their occupants to retain contact with the forts on the Stanegate. It is possible to go to MC 42 at Cawfields and observe that if you walk a few paces to one side, into the gap now occupied by the access path, the fort at Haltwhistle Burn disappears from view (Figure 120). This has always been a persuasive argument for me in accepting the Woolliscroft thesis on the intervisibility of the towers along the Wall and the forts behind. So too the spark for Poulter's work was observations of the position of the Wall in the landscape, not least in driving along the 18th century Military Road where the road turns at the high points along its line (Poulter 2009: 1).

The Frontiers of the Roman Empire World Heritage Site and the National Trail

It is for these reasons – understanding Hadrian's Wall in its landscape setting - that the designation of Hadrian's Wall as a World Heritage Site in 1987 is to be welcomed. The highest level of protection is thereby given to the whole

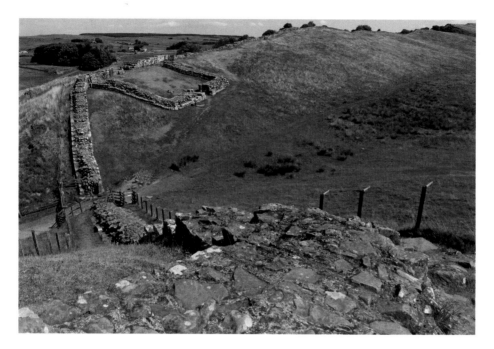

Figure 120. MC 42 (Cawfields) with, to the left, the gap which was
the measured location of the milecastle

monument from South Shields in the east to Ravenglass in the south-west. And
this protection extends beyond the archaeological remains to the immediate
environs of the frontier through the identification of buffer zones. Sixty years
ago, in promulgating amenity zones for the Antonine Wall, Iain MacIvor stated
that it was important that sufficient open land survived around the frontier so
that we could still understand why the Roman surveyors placed their ranging
rods where they did (pers. comm.). This is true for every Roman frontier.

In 2005, there was a particular change in the status of Hadrian's Wall. When the
Upper German and Raetian Frontier was inscribed as a World Heritage Site in that
year, it was accompanied by the incorporation of Hadrian's Wall and the German
frontier into a new World Heritage Site entitled the Frontiers of the Roman Empire.
In 2008, the Antonine Wall was added to the two earlier inscribed frontiers so that
now all three of the land or artificial frontiers of Europe are part of the one World
Heritage Site (Breeze and Jilek 2008). Other frontiers are currently being considered
by the World Heritage Committee though these will become part of separate
World Heritage Sites, though connected within the Frontiers of the Roman Empire
framework. This has been achieved through Roman archaeologists operating
together internationally in what is now known as the Bratislava Group. This Group
will ensure that there is common ground in the inscription and management of

further sections of the Roman Frontier. An exciting development for those of us interested in frontiers across the Roman world.

One of the requirements of a World Heritage Site is that it must have a management plan and that plan should contain a research strategy. This was appreciated by those working on the nascent Frontiers of the Roman Empire World Heritage Site nearly twenty years ago. The way forward, it was thought at the time, was through European funding to help create a research strategy for all Roman frontiers. Money was sought and obtained from the Culture 2000 programme and although research was undertaken, it has so far proved to be too difficult to create a strategy for all frontiers.

This exercise will not be without its challenges. The original prospectus for the Frontiers of the Roman Empire World Heritage Site was fairly restricted in its extent. It embraced only the line of the Roman frontier as it existed from Trajan to Severus, that is, from about 100 to about 200, but included military installations of other dates on that line (Figure 121). But the reason for the creation of any particular frontier line can only be understood within a broader framework. It is important in relation to Hadrian's Wall, for example, to appreciate the location of two legionary bases to its rear at Chester and York, as well of course as the other hinterland and advance forts. Similarly, the Upper German frontier was supported by legions at Strasbourg and Vindonissa. In order to understand intellectually how the frontiers worked, the net of research has to be cast far wider than the narrow line of the frontier itself, a tall order for frontiers across the Empire.

In order to understand Roman frontiers, in this case, Hadrian's Wall, we have also to appreciate how they came into being. Although Roman generals of the late Republic created barriers in attempts to prevent the movement of peoples, the first linear barrier on a frontier dates to the reign of Trajan, soon after 100, who also appears to have invented a new type of army unit. The reasons for both actions, it is likely, was to help protect the boundaries of his empire as he prepared for his great wars against the Dacians and the Parthians, two ancestral enemies of Rome. The abandonment by Hadrian of much of his predecessor's conquests was a visible demonstration of the fact that these wars had over-stretched Rome's resources. His action of constructing more linear barriers was the logical next step. In addition, the creation of the linear barriers should have allowed the army of the frontiers to be reduced. We have seen that the number of troops in the frontier zone of Britain was increased during the construction of the Wall, but we also know of at least three units which were transferred abroad at this time (all cavalry regiments, *ala Gallorum et Thracum Classiana*, *ala I Pannoniorum Tampiana* and *ala I Thracum*; Holder 1982: 108-111).

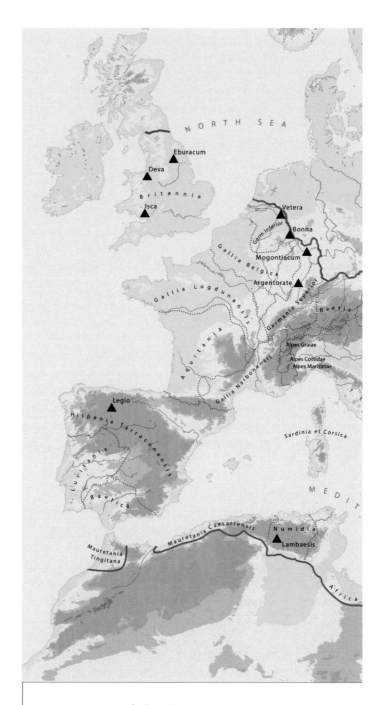

Frontiers of the Roman Empire

Roman provinces and frontiers in the Hadrianic period

Figure 121. Map of the
Roman Empire

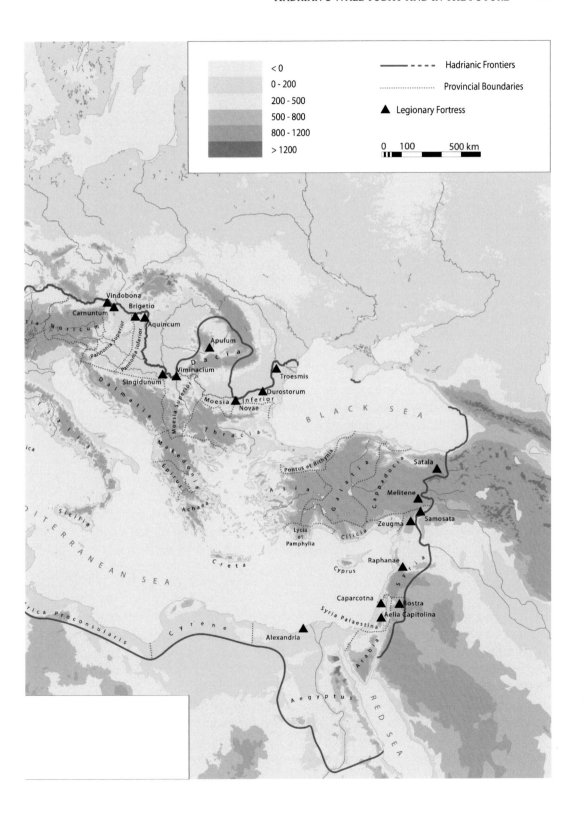

Figure 122. The National Trail on Hadrian's Wall showing wear on the line of the path and the measures taken to combat it

Our problem with World Heritage Sites is that they concentrate on individual sites while to understand Roman frontiers we have to look at them in both time and space. Nor is this the only issue. The definition of what may be included in the World Heritage Site, such as buried remains, lies in the hands of the World Heritage Centre and not the archaeologists, while, within a wider framework, we are living in a definition of a World Heritage Site created 50 years ago which excluded artefacts in museums. For Roman archaeologists, the inscriptions which tell us when, by whom, sometimes why, how much and so on, of the frontier as well as the artefacts which help us understand life on the edge, cannot be included in the World Heritage Site. The creation of an integrated research strategy may help to address the gaps left by the World Heritage Site inscription.

The inscription of an ancient monument or historic building as a World Heritage Site is not without its downside. It is very clear that World Heritage Sites attract increasing numbers of visitors and visitors bring what John Julius Norwich memorably characterised as 'tourism pollution'. This is no less true of Hadrian's Wall than anywhere else. On the Wall, though, it is compounded by the creation of a National Trail along its whole length. Through many miles, the Trail sits on top of the archaeological remains. We can all take some satisfaction that practically all of Hadrian's Wall is open to public viewing, but unfortunately at the same time it has become a target for those wishing to bag another trophy. People want to walk it, run it, cycle it if they could, just to say that they have;

it is the equivalent of Munro bagging. And, needless to say, there is insufficient money to manage the Trail properly. Indeed, almost immediately after its designation promises of appropriate money for maintenance were broken and now, in our age of austerity, the Trail is under pressure again and in days when visitor numbers are higher. The number of staff managing the Trail has been halved.

I used to think it sad that for the most easterly 12 miles of the Wall the Trail did not follow the line of the Wall but took a different path through urban Tyneside: now I welcome that decision.

The Trail was conceived in different days thirty years ago, about the time that Hadrian's Wall became a World Heritage Site. Its promulgation was not a consequence of World Site status though the two actions have increased visitor numbers. Even then, some argued not for a Trail but for access to the countryside so that the visitors could wander freely across the landscape to explore all the archaeological remains, but in vain. It was the Trail or nothing.

Why is this important? Quite simply the tread of thousands of feet destroys the green sward, create ruts biting down into the archaeological remains (Figure 122). As a result, damage at pressure points have led to the creation of laid paths along the monument. It is not just gravel paths that are problematic, but also the laying of paving stones across boggy ground thereby changing the look of an area. Paths can be misleading, as was the path on Highshields Crags which, with its kerbstones, gave the appearance of being a stretch of Wall foundations.

Individual cases are not so problematic, but the issues are incremental. Allow a short length of path there and the next time it will be used as a precedent. What follows next; lights along the path? This may seem unlikely, a joke even, but it was certainly an issue on the Antonine Wall some years ago.

This is not an esoteric problem. For those interested in Roman frontiers, I am talking about their primary resource. These are the remains which we hope in the future will yield secrets and help us understand the monument better. The protection of Hadrian's Wall ought to be a concern to every professional archaeologist because it is their resource which is being degraded and every relaxation that allows an inimical action will be served up next time as a precedent.

The inscription of Hadrian's Wall as a World Heritage Site, as already noted, aids its protection and actions are modulated through its Management Plan. This sets down the ways in which the monument should and can be protected,

conserved, presented to the public and interpreted. The protection offered to the whole Wall coupled with the high cost of excavation means that more than ever archaeological investigations are limited to rescue digs or tourism-related projects. This is in no way to decry such work, but it does mean that the major research questions are only addressed by chance.

Research strategies

It is perhaps for this reason that a Research Assessment and Research Strategy for the Wall, called grandly *Frontiers of Knowledge*, has been promulgated (Symonds and Mason 2009). The introduction states that the purpose of the document is to assess existing knowledge and identify and prioritise key themes for research, not least within the framework of rescue excavation, and for grant giving bodies. The document is therefore useful in bringing together different strands of interest in the Wall as a direct result of the World Heritage Site inscription.

Research strategies, of course, are not a new concept on Hadrian's Wall, but in the past they have related directly to work on the ground. In 1894 Haverfield set down his project for a better understanding of the frontier, and in particular the Vallum, and held to it for a decade. Gibson considered carefully what he wanted to achieve and where he should excavate to answer his questions. Simpson was equally focussed, over a period of forty years. In the study, R.G. Collingwood added his cerebral attention to Hadrian's Wall and its problems. It was a formidable group. So formidable that, as we have noted, one major issue was that once they had answered their own questions, they stated that the problems of Hadrian's Wall had been solved and they were believed. The strength of the current Research Strategy is that it provides a wider framework within which individuals can work and contribute to a bigger picture.

The line between the two research strategies was not straight, life never is. By the end of the Second World War Collingwood was dead, Simpson was in his 60s, Birley's interests had turned to the study of the Roman army and Richmond's interests were directed elsewhere, to Inchtuthil and wider aspects of the Roman Empire; in 1956 he was adlected to the Oxford chair and his direct interest in Hadrian's Wall ended. It should have been a new, younger generation that took up the mantle, but this did not quite happen. It has long seemed to me that there was an issue with the War and immediate post-War generations. The men who came back from the War were still relatively young and stayed in post for a couple more decades or longer. They were in charge and, as former officers, they were used to being in charge; they controlled the purse strings; and they sat on the committees which gave permission for excavations. In short, they

Figure 123. The shrine to Jupiter Dolchenus at Vindolanda

controlled what happened. As I see it, their succeeding generation had a long time to wait to enter their inheritance and, in the meantime, some simply had the stuffing knocked out of them; they lost their commitment might be another way of expressing it. One result was that research excavations dwindled. Those that did take place did not fit into a recognisable research framework. Indeed, it was often less than had been achieved before. Simpson grumbled on one occasion that he had not had time to examine what lay beyond the turret walls; this approach was abandoned. No one seemed to have stood back and asked what we really wanted to know about Hadrian's Wall. Instead, Shorden Brae mausoleum was excavated because it showed up on an aerial photograph; a

turret was sought just to check it was there; my own excavation at Carrawburgh took place simply because the owner wanted it dug. The only long-term project was the excavation at Corbridge which continued into the early 1970s.

This is all rather surprising because there was a research strategy in existence. In 1948, the Council for British Archaeology published a *Survey and Policy for Field Research*. The section on the military zone of Roman Britain was written by Ian Richmond. He started his survey of Hadrian's Wall by stating that the 'spade may now be hailed as having settled the major structural questions on Hadrian's Wall'. He did continue more positively, acknowledging that 'much remains to be learnt of the everyday life of the garrison and its social organisation ...nothing systematic is yet known as to the organisation of the Wall during the Antonine interlude ... the arrangement of the garrisons of the third and fourth centuries also requires intensive study ... the whole question of the treatment of the occupied zone beyond the wall ... calls for more intensive inquiry Finally, the history and social organisation of the *vici* attached to the forts of Hadrian's Wall has yet to be recovered'. It is an interesting mixture of the particular – 'the Antonine interlude' – and the wide ranging, general themes, such as everyday life, social organisation, the garrisons in the 3rd and 4th centuries, the civil settlements, and then questions of what happened beyond the Wall, a strange inclusion because in his 1940 paper in *The Romans in Redesdale*, he had given the authoritative version of events beyond the Wall.

There is plenty of scope in Richmond's list for targeted research excavations, but did they happen? I cannot see that they did, at least not on the Wall. One Newcastle archaeologist buckled down to a long research project, patiently pursued, to consider *inter alia* 'the whole question of the treatment of the occupied zone beyond the wall', George Jobey. Who else rose to the challenge? Richmond himself together with John Gillam undertook work left over from the inter-War years, examining the most westerly known milecastle on the Wall, but nothing followed, at least not from the archaeologists.

The Ministry of Works, the predecessor of English Heritage, deserves credit for initiating the examination of the fort at Housesteads which led to the excavation of the whole of the north-east quadrant, the commanding officer's house and the hospital. Here was a project which set out to answer, for one fort at least, Richmond's challenge to learn more about everyday life and social organisation. Outside the fort, Robin Birley examined part of the civil settlement before turning his attention to the more productive site of Vindolanda (Figure 123).

One part of the frontier not on Richmond's list was the Cumbrian coast. This had last been looked at by Collingwood in 1929 (Collingwood 1929). In 1954, a

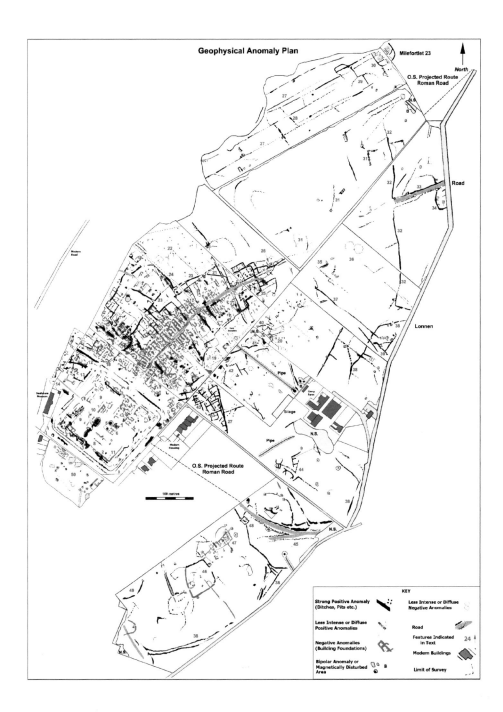

Figure 124. Geophysical survey of the fort, extra-mural settlement and surrounding area at Maryport by Timescape; at the bottom of the plan is a rural farmstead occupied in the Roman period

Figure 125. Geophysical survey of MC 73 (Dykesfield) by TimeScape; the
milecastle is above 42, with two further enclosures to its west

young agricultural officer in Cumberland, Richard Bellhouse, discovered he had
an interest in archaeology and spent the next 45 years almost single-handedly
exploring the milefortlets and towers along the coast. His work remains basic
to our understanding of the western flank of Hadrian's Wall (Bellhouse 1989).

Here it seems is one problem with research strategies; they have to engage with
the individual. So much of the work on Hadrian's Wall has been undertaken by
individuals wishing to answer their own questions. Yet we have in front of us an
example of what sustained work by a committed group can achieve, Vindolanda
(Birley, R.E 2009).

The research framework and strategy, *Frontiers of Knowledge*, published in 2009,
set down what we know and would like to know about Hadrian's Wall and I do
not intend to repeat that here. Instead, I should like to offer a suggestion of my
own. First, though, I should state that there are aspects high on my personal
list, in particular relating to the building of the Wall, that in the general scheme
of things I would not regard of high value and so I am ignoring them. Second,
excavation is expensive. We cannot envisage excavating a complete fort or
extra-mural settlement with research funds, and indeed it could be argued
that there is no need to do so at present as we have the reports on the near

complete excavation of Wallsend, reports on South Shields either published or in preparation, together with major volumes on Housesteads and Birdoswald, as well as Andrew Birley's discussion articles on Vindolanda. Following the production of an extensive geophysical survey, the extra-mural settlement at Maryport has seen three excavations in the last decade, a house plot, the temple complex and a rural settlement immediately beyond the urban fringe (Figure 107). Third, we have to focus on issues where archaeology might be able to provide an answer. Unfortunately, archaeological excavation is often not sophisticated enough to be able to answer all questions with a strong degree of certainty and for a number of reasons. The type of material available to date most structures is likely to be pottery which is not capable of close dating nor attributable to soldiers rather than civilians, especially in the 3rd century. This can be compounded by a relative paucity of dating material: there are very few datable artefacts from the four seasons of excavation on the south-eastern fringes of the civil settlement at Maryport in spite of there being at least two buildings in the area investigated (Figure 124). It would be difficult, therefore, to determine if occupation had moved around within the area of the known settlement. It is obviously difficult to know how many people lived in any one house. Indeed, excavation can rarely determine the function of a building other than generic definitions such as dwelling house or shop.

A future project?

To turn to my own suggestions which relate to the smaller structures on the Wall. There may not be particular value in excavating another turret, but milecastles are a different matter. In the last 70 years seven turrets have been excavated but only two milecastles have been substantially investigated, and one was the re-examination of a structure previously excavated and is, as yet, unpublished. The milecastle is a particular type of military installation only found in Britain on both Hadrian's Wall and the Antonine Wall. It is also a key installation. It appears to serve three functions: it provides a gate through the Wall; accommodation; and, presumably, a tower over the north gate. It would be helpful to acquire more information about each aspect, including whether there had originally been access across the ditch in front of the north gate.

In addition, unlike most turrets, many milecastles continued in occupation into the late 4th century though we know little about the nature of the occupation. Altars dedicated by legionaries have been found at several milecastles; one, to the Mother Goddesses, dedicated by a detachment of the Sixth legion, was found close to MC 73. As we presume that most milecastles – and turrets – were occupied by auxiliaries, it would be interesting to see if we can find anything diagnostic of a legionary presence. That said, the investigation of the interior is

not my primary concern, rather the exterior. An altar found at MC 19 mentioned a shrine; was such a structure outside the milecastle? Geophysical survey of MC 73 has pointed to the existence of enclosures and possibly structures to each side of the military enclosure (Figure 125). Here is a site that might yield interesting results. Examination of such an area would furnish an entirely new dimension to life on Hadrian's Wall. And it would be about the Wall itself and not the occupants of the forts who, I have argued, had a different role in frontier activities. Finally, such an excavation would be affordable. Do we need further justification? An anniversary. In two year' time it will be one hundred years since Collingwood's seminal paper on the function of Hadrian's Wall: that is an event worth marking.

That, however, is not enough. We need to understand Hadrian's Wall in the wider setting of all Roman frontiers. So, if we are to examine a milecastle and its surroundings on Hadrian's Wall, we should include in the project investigation of a similar structure on the Antonine Wall. Beyond our shores, fortlets are known on other frontiers, on the Upper German/Raetian frontier and the *Val lui Traiani* in Romania. Such a wide-ranging international project has the opportunity to enhance our understanding of Hadrian's Wall, its operation and the life of the soldiers and civilians who lived in its shadow, and the Frontiers of the Roman Empire World Heritage Site provides the ideal context to realise such an ambitious project.

One might ask why the detailed study of Hadrian's Wall remains important; haven't we discovered all that there is know, that we need to know? As I have stressed, there is a lot that we do not know about Hadrian's Wall. Moreover, we need to keep challenging our preconceptions by continuing excavation as well as analysis of the database. Understanding the minutiae of the available information enables us to understand its building and history better and through that appreciate its function and purpose and how the Romans intended it to operate at different times. There is one point to add. This discussion of the function and operation of Hadrian's Wall and the changes of plan in relation to perceptions of the local issues points to a flexible outlook on the part of the Roman army. Its officers were able to grasp realities on the ground and change their arrangements in order to best achieve their aims. Hadrian's Wall offers a fascinating insight into why the Roman army was so successful.

As we have seen, Hadrian's Wall continues to offer challenges. Its enormous database remains an inspiration for research. There has been a steady flow of excavation reports over recent years and *Archaeologia Aeliana* rarely fails to contain an article on the frontier so much material is in the public domain and needs re-interrogating in the face of new views. We are, however, missing one

aspect, a theoretical approach to the monument. As previously noted, only Richard Hingley has sought to tackle this aspect. I trust that I am not alone in welcoming the challenge that some theory will offer. Hadrian's Wall deserves some theory. Perhaps theory will stimulate the next steps forward in Hadrian's Wall, and indeed Roman Frontier, studies.

Acknowledgements

My thanks are due to innumerable colleagues and friends with whom I have talked about Hadrian's Wall and Roman frontiers over the last five decades. Their knowledge and challenges have helped shape my own views. The first are my lecturers at Durham University, Eric Birley, John Mann, Brian Dobson and John Gillam. Since then, Lindsay Allason-Jones, Paul Bidwell, Tony Birley, Richard Brickstock, Ian Caruana, Rob Collins, Mark Corby, Jon Coulston, Christof Flügel, Phil Freeman, Erik Graafstal, Bill Hanson, Peter Hill, Nick Hodgson, Fraser Hunter, Sonja Jilek, Rebecca Jones, Lawrence Keppie, Orsolya Láng, Lesley Macinnes, Valerie Maxfield, Roger Mercer, Michael J. Moore, Joyce Moss (née Hooley), John Poulter, Margaret Snape, Sebastian Sommer, Sue Stallibrass, Graeme Stobbs, Matt Symonds, Andreas Thiel, Carol van Driel-Murray, Humphrey Welfare and David Woolliscroft have provided much stimulation. The text of this book has been read either in whole or in part by Tony Birley, Christof Flügel, Erik Graafstal, Kate Guy, Peter Hill, Lesley Macinnes and Matt Symonds. I am grateful to all for their perceptive and helpful comments.

I am grateful to colleagues and institutions for permission to reproduce the following images: Aberdeen Council Museum (93: image © National Museums Scotland); Paul Bidwell (47, 109); Andrew Birley (110); M.C. Bishop (102); BLfD Munich (119); Dr Rob Collins (90); Linda Dobusi (108); English Heritage (14); Brenda Heywood (62): Nick Hodgson (109, 112); Hunterian Museum and Art Gallery, Glasgow University (50, 71, 77, 82, 84); Professor Michael Mackensen (48); National Museum of Scotland (80, 113); Newcastle upon Tyne Hospitals NHS Foundation Trust (5) Oxford Archaeology Ltd (107); John Poulter (42); Pre-Construct archaeology per Jennifer Proctor (100); Peter Savin (front cover, Frontispiece, 66, 73, 117, 120); Senhouse Roman Museum, Maryport (64), Society of Antiquaries of London (7); Society of Antiquaries of Newcastle upon Tyne (52, 60); TimeScape (103; 124, 125); Tyne and Wear Archives and Museums per Alex Croom and Sarah Richardson (1-4, 6, 8, 9, 11, 12a, 13a, 15-20, 22-24, 54, 114). I am also grateful to Kevin Hicks of CFA Archaeology for arranging for the preparation of the colour maps of Hadrian's Wall.

Abbreviations

AA	*Archaeologia Aeliana*
CIL	*Corpus Inscriptionum Latinarum*
CW	*Transactions of the Cumberland and Westmorland Antiquarian and Archaeological Society*
CWAAS	Cumberland and Westmorland Antiquarian and Archaeological Society
ILS	Dessau, H. 1892. *Inscriptiones Latinae Selectae*, Berlin: Weidmannos.
O. Claud.	Bingen, J., Bülow-Jacobsen, A., Cockle, W.E.H., Cugigny, H., Rubinstein, L. and van Rengen, W. 1992. *Mons Claudianus: Ostraca Graeca et Latina.* Cairo: Institut Francais d'Archéologie Orientale.
O. Krok.	Cuvigny, H. 2005. *Ostraca de Krokodilô: La Correspondance Militaire et sa Circulation, O. Krok. 1-151, Praesidia de Désert de Bérénice II.* Cairo: Institut Francais d'Archéologie Orientale.
P. Mich.	Edgar, C.C., Banks, A.E.R., Winter, J.G. *et al.* (eds), *Papyri in the University of Michigan Collection.* Ann Arbour.
RIB	*The Roman Inscriptions of Britain.* Vol. 1. R.G. Collingwood and R.P. Wright (eds), 1965. Oxford: Clarendon. Vol. 3. R.S.O. Tomlin, R.P. Wright and M.W.C. Hassall (eds), 2009. Oxford: Oxbow.
SANT	Society of Antiquaries of Newcastle upon Tyne

Further Reading

Allason-Jones, L. 1980. Roman and Native interaction in Northumberland, in V.A. Maxfield and M.J. Dobson (eds), *Roman Frontier Studies 1989*: 1-5. Exeter: University of Exeter Press.

Allason-Jones, L. 1984. The small objects, in D. Haigh and M. Savage, Sewingshields, *AA* 5 ser., 12: 74-99.

Allason-Jones, L. 1988. 'Small finds' from turrets on Hadrian's Wall, in J.C.N. Coulston, (ed.), *Military equipment and the identity of Roman soldiers. Proceedings of the Fourth Roman Military Equipment Conference* (British Archaeological Reports International Series 394): 197-233. Oxford: BAR.

Allason-Jones, L. 2009. The small finds, in A. Rushworth, *Housesteads Roman Fort – The Grandest Station*: 430-487. Swindon: English Heritage.

Anon. 1906. *Collection of Water Colour Drawings of the Roman Wall by Henry Burdon Richardson.* Newcastle upon Tyne.

Austin, N.J.E and Rankov, N.B 1995. *Exploratio. Military and Political Intelligence in the Roman World from the Second Punic War to the Battle of Adrianople.* London: Routledge.

Bates, J.C. 1895. *The History of Northumberland.* London: Elliot Stock.

Bellhouse, R. 1989. *Roman Sites on the Cumberland Coast. A new schedule of coastal sites*, Kendal; CWAAS Research Series 3.

Bennett, J. 2002. A revised programme and chronology for the building of Hadrian's Wall, in P. Freeman, J. Bennett, Z.T. Fiema and B. Hoffmann (eds), *Limes XVIII* (British Archaeological Reports International Series 1084): 825-34. Oxford: Archaeopress.

Bidwell, P.T. 1985. *The Roman Fort of Vindolanda*, London: Historic Buildings and Monuments Commission for England.

Bidwell, P.T. (ed.) 1999. *Hadrian's Wall 1989-1999.* Kendal: CWAAS and SANT.

Bidwell, P.T. 2008a. Did Hadrian's Wall have a Wall-walk?, in P.T. Bidwell (ed.), *Understanding Hadrian's Wall*: 129-143. The Arbeia Society.

Bidwell, P. T. 2008b. The system of obstacles on Hadrian's Wall: their extent, date, and purpose, *Arbeia J.* 8: 53-75.

Bidwell, P. 2018. The Roman Pottery, in D.J. Breeze (ed.), *The Crosby Garrett Helmet*: 66-68. Kendal: CWAAS Extra Series 48.

Bidwell, P.T. and Hodgson, N. 2009. *The Roman Army in Northern England.* Kendal: The Arbeia Society.

Bidwell, P.T. and Holbrook N. 1989. *Hadrian's Wall Bridges.* London: English Heritage.

Bidwell, P.T. and Speak, S. 1994. *Excavations at South Shields Roman Fort, Volume I*, Newcastle upon Tyne: Society of Antiquaries of Newcastle upon Tyne and Tyne and Wear Museums.

Biggins, J.A., Hall, S. and Taylor, D.J.A. 2004. A geophysical survey of Milecastle 73 and Hadrian's Wall at Burgh-by-Sands, Cumbria. *CW* 3 ser., 4: 55-70.

Birley. A. 2013. The fort wall: a great divide, in R. Collins and M. Symonds (eds), *Breaking down Boundaries: Hadrian's Wall in the 21st Century* (Journal of Roman Archaeology Supplementary Series 93): 85-104. Portsmouth, RI: Journal of Roman Archaeology.

Birley, A.R. 1997. *Hadrian, the restless emperor.* London and New York: Routledge.

Birley, A. R. 2005. *The Roman Government of Britain*, Oxford: OUP.

Birley, A.R. 2011. The Anavionenses, in N.J. Higham (ed.), *Archaeology of the Roman Empire: A Tribute to the Life and Works of Professor Barri Jones* (British Archaeological Reports International Series 940): 15-24. Oxford: Archaeopress.

Birley, A.R. 2013. Britain under Trajan and Hadrian, in T. Opper (ed.), *Hadrian: Art, Politics and Economy*. London: British Museum.

Birley, E. 1930. The Wall periods. *AA* 4 ser., 8: 164-74.

Birley, E. 1949. *The Centenary Pilgrimage of Hadrian's Wall*. Kendal: SANT and CWAAS.

Birley, E. 1956. Hadrianic frontier policy, in E. Swoboda (ed.), *Carnuntina, Römische Forschungen in Niederösterreich* 3: 25-33.

Birley, E. 1961. *Research on Hadrian's Wall*, Kendal: Titus Wilson

Birley, R.E. 2009. *Vindolanda. A Roman Frontier Fort on Hadrian's Wall*. Stroud: Amberley.

Boyle, J.R. 1889. The Roman Wall. *The Archaeological Review* 4: 81-106; 153-83.

Breeze, D.J. 1982. *The Northern Frontiers of Roman Britain*. London: Batsford.

Breeze, D.J. 2002. The Second Augustan Legion in North Britain, in R.J. Brewer (ed.), *The Second Augustan Legion and the Roman Military Machine*: 67-81. Cardiff: National Museum and Galleries of Wales.

Breeze, D.J. 2003a. Auxiliaries, legionaries, and the operation of Hadrian's Wall, in J.J. Wilkes (ed.), *Documenting the Roman Army*: 147-151. London: Institute of Classical Studies, University of London.

Breeze, D.J. 2003b. Warfare in Britain and the Building of Hadrian's Wall. *AA* 5 ser., 31: 13-16.

Breeze, D.J. 2003c. John Collingwood Bruce and the Study of Hadrian's Wall. *Britannia* 34: 1-18.

Breeze, D.J. 2004. Roman military sites on the Cumbrian coast. in R.J.A. Wilson and I.D. Caruana (eds), *Romans on the Solway. Essays in Honour of Richard Bellhouse*: 66-94. Kendal: CWAAS Extra Series 31.

Breeze, D.J. 2006. *J. Collingwood Bruce's Handbook to the Roman Wall*, 14th ed. Newcastle upon Tyne: SANT.

Breeze, D.J. 2009. Did Hadrian design Hadrian's Wall. *AA* 5 ser., 36: 87-103

Breeze, D.J. 2011. *The Frontiers of Imperial Rome*. Barnsley: Pen and Sword.

Breeze, D.J. 2012. The *civitas* stones and the building of Hadrian's Wall. *CW* 3 ser., 12: 69-80.

Breeze, D.J. 2014a. *Hadrian's Wall: A History of Archaeological Thought*. Kendal: CWAAS Extra Series 42.

Breeze, D.J. 2014b. Two Roman Britains. *Archaeological Journal* 171: 97-108.

Breeze, D.J. 2015. The Vallum of Hadrian's Wall. *AA* 5 ser., 44: 1-29.

Breeze, D.J. 2016. *Hadrian's Wall: Paintings by the Richardson Family*. Edinburgh: Birlinn.

Breeze, D.J. 2017. John Collingwood Bruce, Charles Roach Smith and the British Archaeological Association Congress in Chester, 1849. *Journal of the Chester Archaeological Society* new. ser. 87: 137-51.

Breeze, D.J. 2018. The value of studying Roman frontiers. *Theoretical Roman Archaeology Journal* 1.1: 1-17.

Breeze, D.J. and Dobson, B. 1972. Hadrian's Wall: Some Problems. *Britannia* 3: 182-208.

Breeze, D.J. and Dobson, B. 1976. *Hadrian's Wall*, Harmondsworth: Allen Lane.

Breeze, D.J. and Dobson, B. 2000. *Hadrian's Wall*, 4th edition. London: Penguin.

Breeze, D.J. and Jilek, S. 2008. The Frontiers of the Roman Empire World Heritage Site, in D.J. Breeze and S. Jilek (eds.), *Frontiers of the Roan Empire. The European Dimension of a World Heritage Site*: 25-28. Edinburgh: Historic Scotland.

Brickstock, R. 2010. Coins and the frontier troops in the fourth century, in R. Collins and L. Allason-Jones (eds.), *Finds from the Frontier: material culture in the 4th-5th centuries* (CBA Research Report 162): 86-91. York: Council for British Archaeology.

Bruce, G. 1905. *The Life and Letters of John Collingwood Bruce.* Edinburgh and London: William Blackwood & Sons.

Bruce, J.C. 1851a. *The Roman Wall.* London: John Russell Smith.

Bruce, J.C. 1851b. *Views on the line of the Roman Wall in the North of England.* London: Arliss and Tucker.

Bruce, J.C. 1853. *The Roman Wall,* 2nd edition. London: John Russell Smith.

Bruce, J.C. 1855. *Roman Wall Miscellaneous, 1848-52.* Unpublished bound letters, etc, unpaginated. Newcastle upon Tyne.

Bruce, J.C. 1857. Visit to Cilurnum, Borcovicius, etc. *Proceedings of the Society of Antiquaries of Newcastle upon Tyne* 1: 232-7.

Bruce, J.C. 1857. Account of the excavation made at the Roman station of Bremenium during the summer of 1855. *AA* 2 ser., 1: 69-85.

Bruce, J.C. 1863. *Wallet-Book to the Roman Wall.* London: Longman.

Bruce, J.C. 1867. *The Roman Wall,* 3rd edition. London: Longmans; Newcastle upon Tyne: Andrew Reid.

Bruce, J.C. 1875. *Lapidarium Septentrionale.* London: Bernard Quaritch; Newcastle upon Tyne: William Dodd.

Bruce, J.C. 1884. *The Hand-book to the Roman Wall.* 2nd edition. London: Alfred Smith; Newcastle: Andrew Reid.

Bruce, J.C. 1885a. *The Hand-book to the Roman Wall,* 3rd edition. London: Longmans; Newcastle upon Tyne: Andrew Reid.

Bruce, J.C. 1885b. Notes on the recently discovered turrets on the Walltown Crags. *AA* 2 ser., 10: 57-8.

Buckland, P. 1982. The Malton burnt-grain: a cautionary tale. *Yorkshire Archaeological Journal* 54: 53-61.

Buckland, P. 1986. *Roman South Yorkshire; A Source Book.* Sheffield: University of Sheffield.

Camden, W. 1600. *Britannia,* 5th edition. London: G. Bishop.

Casey, J. and Savage, M. 1980. The coins from the excavations at High Rochester in 1852 and 1855. *AA* 4 ser., 8: 75-87.

Collingwood, R.G. 1921a. The Purpose of the Roman Wall. *Vasculum* 8, 1: 4-9

Collingwood, R.G. 1921b. Hadrian's Wall, A history of the problem. *Journal of Roman Studies* 11: 37-66.

Collingwood, R.G. 1929. Roman signal-stations on the Cumberland coast. *CW* 2 ser., 29: 138-165.

Collingwood, R G. 1931a. Hadrian's Wall: 1921-1930. *Journal of Roman Studies* 21: 36-64.

Collingwood, R.G. 1933 *The Handbook to the Roman Wall,* 9th edition. Newcastle upon Tyne: Harold Hill.

Collins, R. 2008. The Latest Roman Coin from Hadrian's Wall: A Small Fifth-century Purse Group. *Britannia* 39: 256-60.

Collins, R. 2012. *Hadrian's Wall and the End of Empire.* London: Routledge.

Collins, R. 2013. Pleading the fifth (century): patterns of coin use at the end of empire, in R. Collins and M. Symonds (eds), *Breaking down Boundaries. Hadrian's Wall in the 21st Century*

(Journal of Roman Archaeology Supplementary Series 93): 123-137. Portsmouth, RI: Journal of Roman Archaeology.

Collins, R. and Symonds, M.F.A. 2019. *Hadrian's Wall 2009-2019*. Kendal: CWAAS and SANT.

Coulston, J. 1985. Roman archery equipment, in M.C. Bishop (ed.), *The Production and Distribution of Roman military equipment. Proceedings of the second Roman military equipment research seminar* (British Archaeological Reports International Series 275): 220-366. Oxford: BAR.

Crow, J.G. 1986. The Function of Hadrian's Wall and the Comparative Evidence of Late Roman Long Walls. *Studien ze den Militärgrenzen Roms III*: 724-729. Stuttgart: Theiss.

Crow, J.G. 1991. A review of current research on the turrets and curtain of Hadrian's Wall. *Britannia* 22: 51-63.

Daniels, C.M. 1978. *Handbook to the Roman Wall*, 13th edition. Newcastle upon Tyne: Harold Hind.

Daniels, C.M. 1980. Excavation at Wallsend and the fourth-century barracks on Hadrian's Wall, in W.S. Hanson and L.J.F. Keppie (eds), *Roman Frontier Studies 1979* (British Archaeological Reports International Series 71): 173-193. Oxford: BAR.

Dobson, B. 1970. Roman Durham. *Transactions of the Architectural and Archaeological Society of Durham and Northumberland* 2: 31-43.

Dobson, B. 1972. The function of Hadrian's Wall, in D.J. Breeze and B. Dobson, Hadrian's Wall: Some Problems. *Britannia* 3: 182-93.

Dobson, B. 1986. The Function of Hadrian's Wall, AA 5 ser., 14: 1-30.

Dobson, B. 2008. Moving the goal posts, in P. Bidwell (ed.), *Understanding Hadrian's Wall*: 5-9. The Arbeia Society.

Dobson, B. 2009. The role of the fort, in W.S. Hanson (ed), *The Army and Frontiers of Rome. Papers offered to David J Breeze* (Journal of Roman Archaeology Supplementary Series 74): 25-32. Portsmouth, RI: Journal of Roman Archaeology.

Dore, J.N. and Gillam, J.P. 1979. *The Roman Fort at South Shields. Excavations 1875-1975*. Newcastle upon Tyne: SANT.

Elton, H. 1996. *Frontiers of the Roman Empire*. London: Batsford.

Esdaile, C. 2007. *Napoleon's Wars*. London: Penguin.

Flügel, C., Meyr, M. and Eingartner, J. 2017. '...ihr habt die Mauern ... um euer Reich herumgefürt, nicht um eure Stadt'. Rom unter die Grenzen des Imperiums auf einem stadtrömischen Relief severischer Zeit. *Römische Mitteilungen* 123: 199-254.

Forster, R. H. 1915. The Vallum: A Suggestion. *Archaeological Journal* 72: 187-9.

Freeman, P.W.M. 2007. *The Best Training-Ground for Archaeologists, Francis Haverfield and the Invention of Romano-British Archaeology*. Oxford: Oxbow.

Frere, S.S. 1987 *Britannia*. London: Routledge, Keegan and Paul.

Frere, S.S. 2002. *Britannia*. London: Pimlico.

Gibson, J.P. 1903a. Mucklebank Turret. AA 2 ser., 24: 13-8.

Gibson, J.P. 1903b. On excavations at Great Chesters (Aesica) in 1894, 1895 and 1897. AA 2 ser., 24: 19-64.

Gibson, J.P. and Simpson, F.G. 1909. The Roman Fort on the Stanegate at Haltwhistle Burn. AA 3 ser., 5: 213-85.

Gibson, J.P. and Simpson, F.G. 1911. The milecastle on the Wall of Hadrian at the Poltross Burn. *CW* 2 ser., 11: 390-461.

Gillam, J.P. 1959. The Roman coarse pottery, in G. Jobey, Excavations at the native settlement at Huckhoe, Northumberland, *AA* 4 ser, 37: 255-258.

Gillam, J.P. 1974. The frontier after Hadrian – a history of the problem. *AA* 5 ser., 2: 1-15.

Gordon, A. 1726. *Itinerarium Septentrionale*. London; privately printed.

Graafstal, E.P. 2012. Hadrian's Haste: A priority programme for the Wall, *AA* 5 ser., 41: 123-184.

Graafstal, E.P. 2018. What happened in the summer of A.D. 122? Hadrian on the British frontier – archaeology, epigraphy and historical agency. *Britannia* 49: 79-111.

Haigh, D. and Savage, M. 1984. Sewingshields. *AA* 5 ser., 12: 33-147.

Hall, M. 1982. *The Artists of Northumbria*, 2nd edition. Bristol: Art Dictionaries Ltd.

Hanson, W.S. 2009. *Elginhaugh. A Flavian Fort and its Annexe*. London: Society for the Promotion of Roman Studies.

Haverfield, F. 1892. Epigraphic evidence as to the date of Hadrian's Wall. *Proceedings of the Society of Antiquaries of London* 15: 44-55.

Haverfield, F. 1894. A new theory of the *Vallum Romanum* and *Murus*, by Prof. Mommsen of Berlin. *Proceedings of the Society of Antiquaries of Newcastle upon Tyne* 2 ser., 6: 223-227.

Haverfield, F. 1895. Report of the Cumberland Excavation Committee, 1894. *CW* 1 ser., 13: 453-469.

Haverfield, F. 1896. Report of the Cumberland Excavation Committee, 1895. *CW* 1 ser., 14: 185-197

Haverfield, F. 1897. Report of the Cumberland Excavation Committee, 1896. *CW* 1 ser., 14: 413-433.

Haverfield, F. 1898. Report of the Cumberland Excavation Committee, 1897. *CW* 1 ser., 15: 172-190.

Haverfield, F. 1899. Five Years Excavation on the Roman Wall, *CW* 1 ser., 15: 337-344.

Haverfield, F. 1901. Report of the Cumberland Excavation Committee for 1900. *CW* 1 ser., 17: 75-92.

Haverfield, F. 1904. Discovery of Roman inscriptions, etc. at Newcastle. *AA* 2 ser., 25: 142-144.

Heslop, D,H. 2009. Newcastle and Gateshead before AD 1080, in D. Newton and A.J. Pollard (eds), *Newcastle and Gateshead before 1700*: 1-22. Chichester: Phillimore.

Higham, N.J. 1981.The Roman impact on rural settlement in Cumbria, in P. Clack and S. Haselgrove (eds), *Rural Settlement in the Roman North*: 105-122. Durham: Council for British Archaeology Group 3.

Higham, N. 2018. *King Arthur. The Making of the Legend*. New Haven and London: Yale.

Hildyard, E.J.W. and Gillam, J.P. 1971. Renewed excavation at Low Borrow Bridge. *CW* 2 ser., 51: 40-66.

Hill, P.R. 2004 *The Construction of Hadrian's Wall* (British Archaeological Reports British Series 375). Oxford: Archaeopress.

Hill, P.R. and Dobson, B. 1992. The design of Hadrian's Wall and its implications. *AA* 5 ser., 20: 27-52.

Hingley, R.C. 2008. Hadrian's Wall in theory: pursuing new agendas? In P. Bidwell (ed), *Understanding Hadrian's Wall*: 25-28. The Arbeia Society.

Hodder, P. 1982. *The Roman Army in Britain*. London: Batsford.

Hodgkin, J. 1903. Excavations on the line of the Roman Wall in Northumberland. 1. Introduction. *AA* 2 ser. 24: 1-12.

Hodgson, J. 1826-40. *History of Northumberland*. Newcastle: privately printed.

Hodgson, Mrs. 1897. Notes on the excavations on the line of the Roman Wall in Cumberland in 1894 and 1895, *CW* 1 ser., 14: 390-412.

Hodgson, Mrs. 1898. Notes on the Excavations on the line of the Roman Wall in Cumberland, in 1896 and 1897. *CW* 1 ser., 17. 201-210.

Hodgson, Mrs. 1899. Notes on the Excavations on the line of the Roman Wall in Cumberland, in 1898. *CW* 1 ser., 17: 365-376.

Hodgson, N. 1991. The *Notitia Dignitatum* and the later Roman garrison of Britain, in V.A. Maxfield and M.J. Dobson (eds), *Roman Frontier Studies 1989*: 84-92. Exeter: University of Exeter Press.

Hodgson, N. 2003. *The Roman Fort at Wallsend (Segedunum): Excavations in 1997-8*, Newcastle upon Tyne: Tyne and Wear Museums Archaeological Monographs 2.

Hodgson, N. 2008. After the Wall-periods: what is out historical framework for Hadrian's Wall in the twenty-first century?, in P. Bidwell (ed.), *Understanding Hadrian's Wall*: 129-143. The Arbeia Society.

Hodgson, N. 2009. *Hadrian's Wall 1999-2009*. Kendal: CWAAS and SANT.

Hodgson, N. 2011. The Provenance of RIB 1389 and the Rebuilding of Hadrian's Wall in AD 158. *Antiquaries Journal* 91: 59-71.

Hodgson, N. and Bidwell, P. 2004. Auxiliary barracks in a new light: recent discoveries on Hadrian's Wall. *Britannia* 35: 121-58.

Hodgson, N., McKelvey, J. and Muncaster, W. 2012. *The Iron Age on the Northumberland Coastal Plain. Excavations in advance of development 2002-2010*. Newcastle upon Tyne: Tyne and Wear Archives and Museums and the Arbeia Society.

Hooley, J. and Breeze, D.J. 1968. The Building of Hadrian's Wall: A Reconsideration. *AA* 4 ser., 46: 97-114.

Horsley, J. 1732. *Britannia Romana*. London: John Osborn and Thomas Longman.

Hull, M. 1926. Excavations at Aesica, 1925 – Interim Report. *AA* 3 ser., 2: 197-202.

Hunter, F. 2007. *Beyond the edge of the empire – Caledonians, Picts and Romans*. Rosemarkie: Groam House.

Hunter F. 2010. Beyond the frontier: interpreting late Roman Iron Age indigenous and imported material culture, in R. Collins and L. Allason-Jones (eds), *Finds from the Frontier. Material Culture in the 4th-5th centuries*: 96-109. York: Council for British Archaeology.

Hunter, F. 2012. The lure of silver: *denarius* hoards and relations across the frontier, in D.J. Breeze, R.H. Jones and I.A. Oltean (eds), *Understanding Roman Frontiers. A Celebration for Professor Bill Hanson*: 251-269. Edinburgh: John Donald.

Hunter, F. and Painter, K. 2013. *Late Roman Silver. The Traprain Treasure in Context*. Edinburgh: Society of Antiquaries of Scotland.

Jackson, K. 1955. The Britons in Southern Scotland. *Antiquity* 114: 77-88.

Jarrett, M.G. 1967. Aktuelle Probleme der Hadriansmauer. *Germania* 45: 96-108.

Jones, G.D.B. and Walker, J. 1983. Towards a minimalist view of Romano-British agricultural settlement in the North-West, in J.C. Chapman and H.C. Mytum (eds), *Settlement in North Britain 1000 BC – AD 1000* (British Archaeological Reports British Series 118): 185-204. Oxford: Archaeopress.

Jones, M.J. 1975. *Roman Fort-Defences to A.D. 117* (British Archaeological Reports 21). Oxford.

Kent, J.P.C. 1951. Coin evidence and the evacuation of Hadrian's Wall. *CW* 2 ser., 51: 4-15.

Kilbride-Jones, H.E. 1938. Excavation of a native settlement at Milking Gap, Northumberland. *AA* 4 ser., 15: 303-350.

Láng, O. 2018. Is that really the end, or what happened in the civil town of Aquincum in the fourth century AD? *Acta Archaeologica Academiae Scientiarum Hungaricae* 69: 143-168.

Leach, S. and Whitworth, A. 2011. *Saving the Wall. The Conservation of Hadrian's Wall 1746-1987.* Stroud: Amberley.

Luttwak, E.N. 1976. *The Grand Strategy of the Roman Empire.* Baltimore: John Hopkins University Press.

Luttwak, E.N. 2016. *The Grand Strategy of the Roman Empire*, 2nd edition. Baltimore: John Hopkins University.

Mackensen, M. 2016. Survey and excavation of the German Archaeological Mission at the Roman fort at Myd(...)/*Gheriat el Garbia* and its vicinity, 2009/2010. *Libya Antiqua* new series 6 (2011-2012): 83:102.

MacLauchlan, H. 1858. *Memoir written during a Survey of the Roman Wall through the Counties of Northumberland and Cumberland in the years 1852-4.* London: privately printed.

Mann, J.C. 1974a.The Frontiers of the Principate. In H. Temporini (ed.), *Aufstieg und Nierdergang der römischen Welt 2, Principat 1*: 508-533. Berlin-New York: Gruyter.

Mann, J.C. 1974b. The northern frontier after AD 369. *Glasgow Archaeological Journal* 3: 34-42.

Mann, J.C. 1990. The function of Hadrian's Wall. *AA* 5 ser., 18: 51-4.

Mann, J.C. 1992. Loca. *AA* 5 ser. 20: 53-6.

Mann, J.C. 1992. A Note on *RIB* 2054. *Britannia* 23: 236-8.

Mann, J.C. and Jarrett, M.G. 1967. The division of Britain. *Britannia* 18: 285-6.

Mattingly, D. 2006. *An Imperial Possession. Britain in the Roman Empire.* London: Allen Lane.

McIntosh, F. 2019. *The Clayton Collection* (British Archaeological Reports British Series forthcoming). Oxford.

Mercer, R. 2018. *Native and Roman on the Northern Frontier. Excavations and survey in a later prehistoric landscape in Upper Eskdale, Dumfriesshire.* Edinburgh: Society of Antiquaries of Scotland.

Miket, R. 1984. John Collingwood Bruce and the Roman Wall Controversy: The Formative Years, in R. Miket and C. Burgess (eds), *Between and Beyond the Walls: Essays on the Prehistory and History of North Britain in Honour of George Jobey*: 243-263. Edinburgh: John Donald.

Miket, R. and Maxfield, V. 1970. The excavation of Turret 33b (Coesike). *AA* 4 ser., 50: 145-178.

Millett, M. 2014. The complexity of Roman impact on a local scale: Studies from East Yorkshire, in D.J. Breeze (ed.), *The Impact of Rome on the British Countryside*: 16-20. London: Royal Archaeological Institute.

Neilson, G. 1912. Obituary Notice of J. P. Gibson, F. S. A., A Vice-President of the Society. *AA* 3 ser., 8: 37-45.

Potter, H.G. 1855. Amboglanna. *AA* 1 ser., 4: 63-75, 141-149.

Proctor, J. 2009. *Pegswood Moor, Morpeth, A Later Iron Age and Romano-British Farmstead Settlement*, Pre-Construct Archaeology Monograph 11.

Proctor, J. 2012. *Faverdale, Darlington. Excavations at a major settlement in the northern frontier zone of Roman Britain.* Pre-Construct Archaeology Monograph 15.

Poulter, J. 2009. *Surveying Roman Military Landscapes across Northern Britain* (British Archaeological Reports British Series 492). Oxford: Archaeopress.

Richmond, I.A. 1940. The Romans in Redesdale. *Northumberland County History* 15: 68-159.

Richmond, I.A. 1944. Gnaeus Julius Agricola. *Journal of Roman Studies* 34: 34-45.

Richmond, I.A. 1950. Hadrian's Wall, 1939-1949. *Journal of Roman Studies* 40: 43-56.

Richmond, I.A. 1947. *Handbook to the Roman Wall,* 10th edition. Newcastle upon Tyne: Harold Hill.

Richmond, I.A. 1958. Roman and native in the fourth century A.D., and after, in I.A. Richmond (ed.), *Roman and Native in North Britain*: 112-130. Edinburgh: Nelson.

Richmond, I.A. and Gillam, J.P. 1952. Milecastle 79 (Solway). *CW* 2 ser., 52: 17-40.

Richmond, I.A. and Simpson, F.G. 1935. The Turf Wall of Hadrian. *Journal of Roman Studies* 25: 1-18.

Rivet, A.L.F. 1958. *Town and Country in Roman Britain*, London: Hutchinson University Library.

Roach, L. 2013. From the Severans to Constantius Chlorus: the lost century, in R. Collins. and M. Symonds (eds), *Breaking down Boundaries. Hadrian's Wall in the 21st Century* (Journal of Roman Archaeology Supplementary Series 93): 105-121. Portsmouth, RI: Journal of Roman Archaeology.

Rushworth, A. 2009. *Housesteads Roman Fort - The Grandest Station: Excavation and Survey at Housesteads, 1954-95, by Charles Daniels, John Gillam, James Crow and others*. Swindon: English Heritage.

Rushworth, A. and Croom, A. 2016. *Segedunum. Excavations by Charles Daniels in the Roman Fort at Wallsend (1975-1984)*. Oxford: Oxbow.

Salway, P. 1965. *The Frontier People of Roman Britain*. Cambridge: Cambridge University Press.

Shannon, W. D. 2007. *Ille murus famosus (that famous wall). Depictions and Descriptions of Hadrian's Wall before Camden*. Kendal: CWAAS Tract Series 22.

Simpson, F.G. 1930. Note, in I.A. Richmond and E.B. Birley, Excavations on Hadrian's Wall, in the Birdoswald-Pike Hill Sector. *CW* 2 ser., 30: 202-205.

Simpson, F.G. 1976. *Watermills and Military Works on Hadrian's Wall: Excavations in Northumberland 1907-1913*, Simpson, G. (ed.). Kendal: Titus Wilson.

Simpson, F.G. and Shaw, R.C. 1922. The purpose and date of the Vallum and is crossings. *CW* 2 ser., 22: 353-433.

Smith, C.R. 1951. Notes of a tour along the Roman Wall. *Gentlemans Magazine* 121: 383-8; 503-7.

Smith, C.R. 1852. *Collectanea Antiqua* 2: 171-202.

Snape, M. and Bidwell, P. T. 2002. *The Roman Fort at Newcastle upon Tyne*, AA 5 ser., 31.

Snape, M., Bidwell, P. and Stobbs, G. 2010. Excavations in the military *vicus* south-west of the Roman fort at South Shields in 1973, 1988 and 2002. *Arbeia Journal* 9: 43-132.

Sommer, C.S. 1999. From conquered territory to Roman province: recent discoveries and debate on the Roman occupation of SW Germany, in J.D. Creighton and R.J.A. Wilson (eds), *Roman Germany. Studies in Cultural Interaction* (Journal of Roman Archaeology Supplementary Series 32): 160-198. Portsmouth, RI: Journal of Roman Archaeology.

Speidel, M.A. 1996. *Die römischen Schreibtafel von Vindonissa*. Veröffentlichungen der Gesellschaft Pro Vindonissa, XII. Baden-Dättwil.

Speidel, M.P. 1998. The Risingham *praetensio*. *Britannia* 29: 356-9.

Stallibrass, S. 2009. The Way to a Roman Soldier's Heart: A Post-Medieval Model for Cattle Droving to the Hadrian's Wall Area, in M. Driessen, S. Heeren, J. Hendriks, F. Kemmers and R. Visser (eds), *TRAC 2008: Proceedings of the Eighteenth Annual Theoretical Roman Archaeology Conference*: 101-112. Oxford: Oxbow Books.

Steer, K. A. 1960/61. Excavations at Mumrills Roman Fort, 1958-60. *Proceedings of the Society of Antiquaries of Scotland* 94: 86-132.

Stevens, C.E. 1955. Hadrian and Hadrian's Wall. *Latomus* 14: 384-403.

Stevens, C E. 1966 *The Building of Hadrian's Wall*, Kendal: CWAAS Extra Series 20.

Stukeley, W. 1776. *Itinerarium Curiosum*. London: Baker and Leigh.

Symonds, M. 2005. The construction order of the milecastles on Hadrian's Wall. *AA* 5 ser., 34: 67-81.

Symonds, M. 2013. Gateways or garrisons? Designing, building and manning the milecastles, in R. Collins and M. Symonds (eds), *Breaking down Boundaries. Hadrian's Wall in the 21st Century* (Journal of Roman Archaeology Supplementary Series 93): 53-70. Portsmouth, RI: Journal of Roman Archaeology.

Symonds, M.F.A. and Mason, D. 2009. *Frontiers of Knowledge. A Research Framework for Hadrian's Wall.* Durham: Durham County Council.

Symonds, M.F.A. and Breeze, D.J. 2016. The building of Hadrian's Wall: a reconsideration. Part 2: the central sector. *AA* 5 ser., 45: 1-16.

van Driel-Murray, C. 2012. Batavians on the move: Emigrants, immigrants and returnees, in M. Duggan, F. McIntosh and D.J. Rhol (eds), *TRAC 2011. Proceedings of the Twenty First Annual Theoretical Roman Archaeology Conference, Newcastle upon Tyne 2011*: 115-122. Oxford: Oxbow.

Warburton, J. 1753. *Vallum Romanum*, London: Millan.

Welfare, H. 2000. Causeways, at Milecastles, across the Ditch of Hadrian's Wall. *AA* 5 ser., 28: 13-25.

Welfare, H. 2004. Variation in the form of the Ditch, and its equivalents, on Hadrian's Wall. *AA* 5 ser., 33: 9-23.

Welfare, H. 2013. A Roman camp, quarries, and the Vallum at Shield-on-the-Wall (Newbrough). *AA* 5 ser., 42: 81-99.

White, R. 2014. The Wroxeter Hinterland Project: Exploring the relationship between country and town, in D.J. Breeze (ed.), *The Impact of Rome on the British Countryside*: 7-11. London: Royal Archaeological Institute.

Whitworth, A. M. 2012. *Hadrian's Wall through Time.* Stroud: Amberley.

Wilmott, T. 1997. *Birdoswald, Excavations of a Roman fort on Hadrian's Wall and its successor settlements: 1987–92.* London: English Heritage.

Wilmott, T. (ed.) 2009. *Hadrian's Wall. Archaeological Research by English Heritage 1976-2000.* Swindon: English Heritage.

Woodside, R. and Crow, J. 1999. *Hadrian's Wall, An Historic Landscape.* The National Trust.

Woolliscroft, D.J. 1989. Signalling and the design of Hadrian's Wall. *AA* 5 ser., 17: 5-19.

Zant, J. 2009. *The Carlisle Millennium Project. Excavations in Carlisle, 1998-2001.* Lancaster: Oxford Archaeology North.

Index

For a wider perspective on Roman frontiers:

Proceedings of the XXI International Congress of Roman Frontier Studies (Limes Congress) held at Newcastle upon Tyne in August 2009 edited by Nick Hodgson, Paul Bidwell and Judith Schachtmann. Archaeopress Roman Archaeology 25. 2017. ISBN 978 178491 590 2

Sixty years after the first Congress, delegates could reflect on how the Congress has grown and changed over six decades and could be heartened at the presence of so many young scholars and a variety of topics and avenues of research into the army and frontiers of the Roman empire that would not have been considered in 1949.

Papers are organised into the same thematic sessions as in the actual conference: Women and Families in the Roman Army; Roman Roads; The Roman Frontier in Wales; The Eastern and North African Frontiers; Smaller Structures: towers and fortlets; Recognising Differences in Lifestyles through Material Culture; Barbaricum; Britain; Roman Frontiers in a Globalised World; Civil Settlements; Death and Commemoration; Danubian and Balkan Provinces; Camps; Logistics and Supply; The Germanies and Augustan and Tiberian Germany; Spain; Frontier Fleets.

This wide-ranging collection of papers enriches the study of Roman frontiers in all their aspects.

Bearsden. The Story of a Roman Fort
Archaeopress 2016. ISBN 978 178491 490 5

The Roman fort at Bearsden and its annexe, together with areas beyond its defences, were extensively excavated from 1973 to 1982. The report on these excavations was published in 2016. This 'popular' account of the discoveries looks at the material recovered from the site in a different way, examining the process of archaeological excavation, the life of the soldiers at the fort based on the results of the excavation as well as material from elsewhere in the Roman Empire, the presentation and interpretation of the bath-house and latrine, and a discussion of possible future work arising out of the excavation. The excavation report was well illustrated with reconstruction drawings and the process of creating these is also discussed.

Maryport: A Roman Fort and Its Community
Archaeopress 2018. ISBN 978 178491 802 6

The collection of Roman inscribed stones and sculpture, together with other Roman objects found at Maryport in Cumbria, is the oldest archaeological collection in Britain still in private hands. Today, it is housed in the Senhouse Roman Museum on Sea Brows to the north of the modern town of Maryport. Beside the museum the earthworks of the Roman fort may still be seen, and beyond it, though not visible, lies a large civil settlement revealed through geophysical survey and the scene of two recent excavations. Maryport: A Roman Fort and its community places the collection in context and describes the history of research at the site. Maryport, although at the north-western edge of the Roman Empire, provides material of international importance for our understanding of the Roman state.